BOOKS BY

# REYNOLDS PRICE

# THINGS
# THEMSELVES

# REYNOLDS PRICE

---

# THINGS THEMSELVES
## ESSAYS & SCENES

NEW YORK

ATHENEUM

1972

FOR

PHYLLIS ABBOTT PEACOCK

# TO THE READER

*This book* marks two anniversaries for me. Twenty years ago I began to write fiction; ten years ago I completed a first novel. During those years, like most novelists, I have written a number of things other than fiction—critical and personal essays, scenes, poems, translations, lectures, reviews, articles—and this book is a drastic selection from those things (a good deal more than this much is omitted). Drastic because I intend more than a personal souvenir, scraps and shavings. I have tried to organize, from material which gathered without apparent plan, a book which would do two things—revise and preserve the pieces which still seemed to stand *and* show that, in fact, a writer's work in forms other than his central form is controlled by the peculiar needs of his kinds of waiting. I think this is, indirectly but elaborately, a book about waiting, some of the techniques of waiting. One writer's anyhow. Or about some of the available kinds of centripetal force.

For one of the most dangerous, permanent and generally ignored problems confronting any writer is how to use the time between books, between seizures. Or how *not* to write when nothing needs writing. A problem, clearly, for all human beings (and especially visible and lethal now among the middle-class young for whom the idea of work has collapsed); but since artists can spend much less than half their adult lives in encounter with their work, the statement holds, I think. And holds so strongly that it's not cheap to claim that a number of the most tragic failures in American letters (and French and all others apparently except Russian, whose great writers seldom have time to wait) can be laid to inability to live between

seizures. Or to take it a truer way, between spells of health—work being the health, waiting the disease.

So this book indicates roughly a third of one American writer's waiting tactics during the first twenty years of his work; and since no one will have got this far who hasn't read some of my fiction, I'll expand in the hope of interest and clarification. (The third gathered here, in roughly chronological order, is visible— like another third, the fiction—and subdivides into two visible parts, studying and teaching. The invisible third is private life, though an uncontrollable amount of that rears up in all the rest—the endless giveaway, desired of course.)

I had thought of myself as a writer, or as someone who would write, from age twelve; but despite the usual torrents of schoolboy verse, I was a college freshman —eighteen—before I wrote a story I could stand behind (or under). And throughout my undergraduate years at Duke, though I knew the goal was a need chosen for me by my faculties and experience and though I wrote an occasional poem or sketch, I threw most of my working energy into what was both required and, then, loved and needed more (rightly, I think)—reading, and writing about the reading. (In my undergraduate career I wrote forty-five pages of serious fiction. I was mostly to be found fastened to the neck of Milton, Tolstoy, Chekhov, James, Twain, Eliot, Hemingway, Welty.) And the intensity of those four years of study was stoked not only by the sense of apprenticeship-in-writing but also in teaching. I'd decided, because of the effect of three or four teachers on what I thought I knew about myself, to be a writer who taught. And the two intentions, which I then saw as related (still do), took me on from Duke to Oxford, where I spent three years, 1955–1958.

My working time there was divided between study of seventeenth-century English literature, with special attention to Milton and *Samson Agonistes,* and the writing of stories and plans for a novel—again an uneven division but tipped heavily by then in the direction of writing, and more reading. There was a scary wait for the stories to appear (I can remember recurrent dreams of large checks and praiseful acceptances from American magazines); but that wait ended in 1958 when *Encounter* published "A Chain of Love." The study of Milton has waited till now—the essay here on *Samson* begins, at least, in the conclusions of my Oxford thesis but has been complicated and buttressed, I hope, by fourteen more years of studying and, above all, teaching the writer who has meant more to my decisions than any other, who has most steadily aroused and satisfied questions, needs, hungers; most consistently and usefully condemned with his mammoth competence and wisdom and charm. The essay in its present form was written in 1971 and attempts finally, out of years of fascinated gratitude, to begin one kind of justice to a poem which—great as any in any language—has been neglected by critics until the last twenty years (or, if used, abused) and which still lacks the understanding and response it has patiently awaited for three centuries now.

The first piece "Dodging Apples" comes directly from my teaching. I returned to Duke in 1958 and have taught there for a part of each year since—most recently Milton's poetry and the composition of narrative. It was first written in 1964 when I was asked to speak to the freshmen students of composition about some short story of my own. I found myself beginning a good way back, or out, with a stripped-down creed—stripped-down partly for the benefit of my audience

but largely because, knowing that many of these students were taught by my 1950s-American-trained colleagues (ferocious structuralists all), I wanted to seize the chance for a passionate public demurrer, to insure that the students would have heard at least a few alternate words on the uses of art, the intentions of poets. I have recently delecturized the piece, expanding it by half, but have tried to retain its original vulnerable directness and vehemence, because I still both feel and believe what I said then, however schematically I put it, and feel a need to go on saying it (after thirteen years of teaching luckless students whose literary education, from grammar school up, might conceivably prove useful to them on a bad day at the watch-factory but hardly in the presence of anything so dangerous as a poem).

Midway through my third year of teaching, I completed the novel I'd planned in England; and in 1962 it was published—*A Long and Happy Life*. The immediate question became "What next?"; but while I was writing the hundred pages of stories that would form a book with those written in college and at Oxford, I began to get the invitations which can inundate a first-novelist who has aroused any notice—seductive offers to arrange one's time. Screenplays, television, reviews, literary journalism, lectures, readings. Money, faces, *ears*. My book of stories, and plans for a second novel, were claiming the energy not already invested in my friends, family and teaching. The teaching provided supplementary money and ears for whatever opinioneering I craved at the time (and by no means incidentally, big returns in more intangible and valuable currencies: the necessity of regular bouts with the most exacting audiences available, students in their early twenties who possess appallingly good—though occa-

sionally slow—devices for the detection of tripe in all its disguises); so for a while I mostly resisted. A few readings but no reviewing, no journalism; and the first two screen attempts on *A Long and Happy Life* proceeded without me. (I don't award myself prizes for the resistance. It was natural to me; what I wanted at the time. Some writers use the offers well. I suspected that I couldn't and I mention them only to indicate the conditions out of which some of these pieces came.)

The screen attempts constitute another, very long, story; but briefly there have been five tries by five producers since 1962 at filming *A Long and Happy Life*. All have failed, for various reasons, mostly spelled *money*; but when on the third try I was again asked to write a screenplay, I accepted. Three main reasons, I think—the producer convinced me that I knew my story in cinematic as well as fictional terms (as well I might, having seen hundreds of movies before the age of twelve); a bad family illness was making it difficult for me to proceed with a novel; and I'd found a country house for sale. There have been several other screenplays of *A Long and Happy Life*, by me and others; but the too-elaborate first draft which I wrote alone in the winter and spring of 1965–66 (in my new house) is still for me the one which most nearly sees a strongly interior novel as a continuous, totally visible picture. I've included here five scenes from that draft, chosen because it may interest readers of the novel to see how I attempted—by invention, expansion, telescoping—to solve such problems as the disinterment of thought and secret emotion and—most difficult—the pervasive silence of Wesley, credible enough in a novel but likely in a film to seem indicative of nothing more than a familiar case of the 1950s sulks. What's more, the appearance of five film-scenes here, in a book made up mostly

of critical and personal essays, is not incongruous. Though I intended the screenplay as an independent whole—ambulatory beyond its base in a novel—writing it involved me in the expenditure of almost as much critical energy as any essay here: the close study of a work of fiction which, almost ten years after its completion, had become mysterious and separate from me again; study in the hope of discovering its centers of power *and* the ways to persuade those centers to metamorphose, to make their current available for different engines—picture and sound. The attempt—in was it Chesterton's words?—to play the Venus de Milo on a trombone. And so the fact that the novel had been written by me seemed finally not to matter; and the chance to convert it gave me—whatever it may give any reader—pleasure, some lasting friendships, my house, a chance to watch the workings of a Hollywood studio in the awful last days of the movies, an at least harmless wait until my novel would start again and, since the novel concerned some of the characters involved in the screenplay, some active preparation.

At about the same time—a little earlier—I agreed to some book-reviewing. Four reasons—ego; difficulties with the novel; the fact that a couple of editors allowed me to read a book before agreeing to a review. (I didn't—still don't—want to discuss books I couldn't like; plenty of volunteers for that. One of my continuing regrets is that the only previous review I'd written —an omnibus notice of novels for *Encounter* in 1957 —contained a wise-guy dismissal of Camus' *The Fall*.) And then the books offered were generally concerned with the South and provided what seemed a chance worth taking—to think directly about realities which my own first books had met indirectly (and therefore, as it turned out, with some hope of honesty). Both

chance and trap—most of the books were concerned with Race and, while I doubt that my own platform deliveries were more foolish than most, I soon saw that The Problem, directly considered, always dissolved into absurd simplicity, half-truths if not lies. I'm tempted to reprint a few samples here—by way of owning-up and because together they state one fact about Southern-white racism which I've never seen stated elsewhere (racism as Shinto, ancestor-worship) —but I'll resist. The two reviews included are here because they bear on longer essays—of Cleanth Brooks' study of Faulkner and of Eudora Welty's *Losing Battles*.

The longer essays, especially the ones about other writers, have given me more pleasure and help than anything else here (except the teaching which lies behind them and which—like its near-sister, acting—has rewards dangerously bound up with audiences). In 1967 it had been ten years since I'd sat down to a steady effort at seeing and writing about another writer. And then I was asked to introduce a Signet edition of *Pylon*. I hesitated—because I didn't know the novel and because I'd spent a certain amount of time in the previous five years fending off (truthfully, I think, but pointlessly) the claim that my own fiction was heavily shaped by Faulkner's. But when I read the small, helpless, beautiful book, hesitation seemed absurd—I had just finished my own third novel, *Love and Work*—so I agreed to write about *Pylon* and, in the process, discovered that an elastic kind of critical-personal essay might well be a useful discipline (hopefully useful to more than me)—an outlet for all the expensive reader's equipment I'd acquired through the years, one more instrument of sight and control (of others and self— centrifugal, centripetal), and a vehicle of thanks to

writers whose works and lives have remained heroic for
me. When other invitations followed, I accepted when
I could—a piece on Eudora Welty for an issue of
*Shenandoah* devoted to her, one on Henry James for a
Merrill edition of *The Wings of the Dove* (the invita-
tion was to introduce a "classic American novel"; when
I asked "What's a classic novel?," I was cheerfully
told, "One in the public domain"), and the piece on
Hemingway for the *New American Review*'s series of
younger-writers-on-older-writers. And so I've been able
to consider at length five writers who are large emblems
for me, four of them as large as any except the Bible
and Tolstoy (I had hoped to write about Tolstoy, and
maybe Thomas Hardy, but am presently balked by the
size of the job). The fact that the five writers, different
as they are, share a central anomaly—lives as instruc-
tive as their work—has only complicated and enriched
the time spent.

Of the several pieces (besides "Dodging Apples")
which I've written about my own work, I include only
one—"News for the Mineshaft," which was, again, so-
licited for a collection called *Afterwords: Novelists on
Their Novels*. I could have refused; but while I was
aware that the dangers of self-absorption and postfacto
confabulation lurk powerfully for any such attempts at
perspective, I was glad of a chance to correct a few mis-
understandings about *A Generous Man*. And my ex-
perience in recently revising some of the testiness out
of the first version was that an occasional look-back of
this sort can clarify future needs and recompenses owed.
Anyone who has read the novel and has cared to come
this far may be rewarded by a few domestic jokes, if
nothing more. The piece "Dodo, Phoenix or Tough
Old Cock?" was written for a collection of essays about
the South, *You Can't Eat Magnolias*; and though it re-

marks on my own work, it is really about the situation in which any American now finds himself if he happens to be a native of the old Confederacy and is compelled to write fiction about it. The piece is personal in that I am a novelist native to, resident in, and concerned with the South; and in that it performs some necessary groundclearing for future work of my own, it serves again as at least harmless waiting, hopefully one of many bridges between work and work.

The hope for bridges is that they will not only bear weight but bear it permanently, for more travelers than the builder, and finally that they will be useful objects alone, things themselves. That these pieces here bear close, numerous relations with my past novels and stories will be clear to anyone who reads both. That they'll lead on is my first hope for them (the final piece here—speculations about some of Rembrandt's pictures of Abraham and Isaac—is only the most recent of a decade of notes for a novel). The second hope, as I've suggested—and the only one that can matter to a reader of these pieces—is that they prove to be work themselves, looks at an exterior world, not just my waiting. Exchangeable work, barter—the waiting being hopefully my business only.

R. P.   *March* 1972

# CONTENTS

# THINGS
# THEMSELVES

# DODGING APPLES

THE MAKING of any work of art is as mysterious as making a child and likely to remain so longer. But the human mind, at least since the eighteenth century, has abhorred mystery. Or maybe not abhorred; our relation to mysteries is far more ambiguous—we love and dread them, therefore strain to solve them in the generally desperate hope of controlling them, of shielding our faces at least from their threats, their claims on us. So hot have men felt these threats to their stability, their continuance as men, that one could write a reasonably full history of the race simply by charting men's raids on and retreats from, their inching victories over and permanent defeats at the hands of such mysteries as invisible God, the visible bodies of outer and inner space, and darkest of all (because most visible)—other men, our daily fellows.

Only very late in the history of man's curiosity however is there evidence of any substantial investigation into the specific mysteries offered by works of art. Mystery was affirmed as the essence of art. Art was a function of God—man's completion of a gesture begun by Him, the gesture of His will that we know Him—and like God, art was acknowledged to be now consoling, now killing, by unpredictable turns. The young Milton, just turned twenty-one (and in the same month as his Nativity Ode), wrote in his *Elegia Sexta*—

Diis etenim sacer est vates, divumque sacerdos,
Spirat et occultum pectus et ora Iovem.
[*Indeed a poet is sacred to the gods, a priest to gods,*
*And from his secret heart and mouth breathes Jove.*]

—not only wrote it but believed it all his life, his literal
credentials (far older than the *Ion* of Plato); and no
one has ever demonstrated he was wrong.

There must have been isolated pioneers from the
first who envied and wondered—sullen watchers
crouched in hair against the walls of caves, wondering
how that one there in the firelight (a figure like them-
selves) could transcribe with only his fingers, ground
earth, juice of berries, a likeness of the awful world, a
vision in which that world of savage beasts, fragile men,
was reduced to visible size, held, even yoked. Then
Aristotle, Longinus, the Alexandrian rhetoricians, the
critics of the Italian renaissance; and always artisans
were passing their discoveries to young apprentices (of-
ten with elaborate secrecy) in manuals of rhetoric, di-
rections for the mixing of pigments, cutting of marble.
But serious investigation by laymen of the methods
of artists, as opposed to response to the arts as quasi-
divine phenomena, began only in the late eighteenth
century, in Germany and England where the scientific
method, so newly won, promised to light all dark cor-
ners, and was first directed at works of sculpture and
painting. Only in the twentieth century did any num-
ber of critics turn their attention to the problems of
the production of literature, the processes that ended
in prose and verse. (Again, I'm referring to laymen,
omitting the essays of Dryden, Coleridge, Wordsworth,
Baudelaire, James, Valéry, Conrad—which, however
much light they release, always deprive us of final reve-
lation, always refuse to make us poets.)

But to break off this simplified, and arguable, history—my point is that the study of methods of literary creation began with the first touching flush of faith in Physical Law and has attempted to continue for the past two centuries as a scientific study—the attempt to apply scientific method to the understanding of works which have continued to deny that they were created in obedience to the laws of that method. (What has not been widely noticed is that the "scientific" method of literary study has often been more nearly theological-expository. A number of the New Critics, for example, were sons of ministers or were reared in strict Protestant-Jewish traditions of scriptural scrutiny—and some of their more extreme techniques resemble nothing so much as the ruthless squeezings given to the book of *Revelation* in thousands of fundamentalist churches today.)

Most scientific investigation has been, at least until the past thirty years, devoted primarily to answering the central question of any onlooker, any creature—How?—to the discovery through observation of how particles behave under various conditions, of how mass achieves effect. And the great majority of students of literary creation since the eighteenth century, and virtually all teachers (certainly in America), have reasoned by seductive analogy and imported the scientist's How? into hostile country. Virtually every serious critic of the past thirty years has devoted himself to one of two questions—"How is this thing built?" and "How does it work?": this tragedy of Shakespeare, ode of Keats, novel of Joyce? And hilariously often their answers imply, "Thus I demonstrate that, given time, I could have made it myself."

Admitted: the question How? is often a possible question, admitting an infinity of answers varying in

interest, validity, usefulness; but at best it is a prelimi-
nary question; and any reader content to rest in its an-
swers has done little more than roll out an apple in the
path of Atalanta (the poem is Atalanta)—to halt the
poem, take it off his tracks, his back, to tame it, defuse
it. Readers rest in How? only when they have silently,
maybe unconsciously, admitted that Why? would open
the gates of their lives to the poem.

For Why? is the thing to dare to ask. Several critics
have specifically denied that valid answers to Why? can
be provided for any poem, least of all by the given poet.
No doubt the question can lead so far into speculation
about intention as to leave one finally mired in silliness
as deep as any encountered by pure structuralists; but
the great theoreticians of physics have never avoided
the question, have even (Newton and Einstein) ac-
knowledged the apparent irrationality of the methods
which ended in their own discoveries (if they are "dis-
coveries" and not, say, poems); so its avoidance by
structuralists seems all the odder, a willful self-maiming
(self-maimings being generally meant as self-protec-
tions).

So, *how* is a poem made (I'm calling all works of
literature poems); what kind of machine is it? Then,
*why* was it made? Why is it this sort of machine, not
some other? Why was it launched at all into a world
gagging on five thousand years of accumulated poems?
Why launched at this time, down these specific ways,
at this specific speed? Then maybe How? again; for once
having dealt with Why?, a reader is likely to find early
answers to How? irrelevant. Until a reader asks that
forked question—however unanswerable—he has not
even begun the trek into the heart of a poem, the
guarded room in which the poet left his unchained
monster, his secret design upon our lives. For the de-

sign, the diet of the monster, is the secret of a poem, not its mechanics (any trained mechanic can diagram those)—the poet's design and the poem's design (often they are different) for altering the life of the reader, the world, by his sonnet, novel, story, his *act*. A poem is an act, as much as a parting wave, a welcoming kiss, the signing of a sentence—life or death.

I believe those things because I believe that all works of art of all sizes—from the Parthenon and *King Lear* to the briefest Elizabethan lyric, the whisk in the Japanese tea ceremony—have kinetic intent. They came into existence in order to change something (or a number of things)—the actions of a friend, the hatred of an enemy, the savagery of man, the course of poetry, the sounds in the air. So—again—do all acts, maybe all atoms.

I believe that for two reasons. First, it is clear from a reading of the life and letters of any great artist (though there is presently a good deal of smiling at the fervent statements of purpose of, say, Beethoven) and, most directly and powerfully, from a study of the works themselves. The "purpose" of Michelangelo's Sistine frescoes is, first, to do a job; fulfill a promise. After eighteen months of agonizing work on the ceiling, he wrote to his father,

*October 1509*
I've finished that chapel I was painting. The Pope is quite satisfied.*

Beyond that, at least one more purpose is clear and usable and demands our response—to bring us, and the painter, to our knees in awe of the beauty and power of

---

* Robert J. Clements, ed. and trans., *Michelangelo, A Self-Portrait* (Prentice-Hall, 1963), p. 144.

man and in dread of the unimaginably greater power of
the God who made man and will someday cancel or re-
make him, to prepare us as fully as possible for that day
when the Son will come flinging Judgment from the
skies. Beyond that, the chance that the frescoes are one
immense petition to a human being, a friend or lover
(maybe pictured there?)—a petition for love, a certifi-
cate of worthiness. However speculative, such guesses—
as long as they touch base with known facts of life—
are not so useless to a witness as they might seem, are
on the contrary among the richest lessons any act can
provide; and a refusal by witnesses to return to works of
art a measure of the response which the artist has de-
manded (explicitly, implicitly) is an act of betrayal.
Like all betrayals, easy and cowardly. Far better aban-
don the witness and study to better-equipped—tougher,
wilder, more vulnerable—men who at least volunteer,
however hopelessly, to change their lives.

Second, I believe in the kinetic intent of works of
art from long and necessarily close observation of my
own motives and purposes as a writer. I'll risk discussing
those. The risk is multiple, for you and me. I risk most
—pomposity, solemnity, self-delusion. But then I am
what I know, of all things in the world (any writer—
any person—who is not the world's authority on him-
self is in serious trouble); and a conviction of the wide
validity of his own knowledge is the final myth upon
which any artist builds his work, any person builds his
life. (The central myth of the artist is surely not Nar-
cissus but Perseus—with the artist in all roles, Perseus
and Medusa and the mirror-shield.) I wouldn't speak,
not publicly, if I didn't believe in the value and urgency
of what I see and think I know. And then I risk lying,
not so much willfully (however much more amusing
that might be) as by simplification, by reducing to bare

formulae motives of considerable and unrecoverable complexity. Lying unconsciously also, for obviously I don't know all the reasons why I write a given story, scene or sentence. I'm worked, like you, by masked puppeteers. Yet there are many motives and intentions of which I am conscious and have been, more or less from the start—age ten or eleven. I think I know why I write—the publicly usable reasons and a number of the central private ones which can be communicated, if at all, only by the work itself—and I think I can discuss a few of those motives, sanely and honestly if a little simplistically.

I write, first, because that seems to be the intention of all my faculties. It is what I can do, as a diver can dive, through grace and practice. Then, given the bent (or is the "bent" produced by the need?), I employ it to understand what is mysterious—in the behavior of the visible world, the behavior of God, of my friends and enemies, strangers, finally of myself. For I've written nothing which is not in its way an attempt to understand something which has happened to me, by me, or through me—something of a certain size, a certain apparent or threatened importance, not only in my life but in the world's. (Aristotle said in the *Poetics* that

beauty consists in magnitude and order; therefore an exceedingly small animal cannot be beautiful, because the vision is confused when it is applied to an object so small as to be almost invisible; nor can a very large animal . . . be beautiful, for the eye does not take it in at once, but it presents no unity and completeness of view to those who look at it. Hence, as it is necessary for bodies and animals to have magnitude, but such as can properly be embraced in one view, so it is necessary for stories to

have size, but such that they can be easily remembered.*

—a more useful passage for a writer to consider than Henry James' famous command to be one of those people "upon whom nothing is lost." Most of what happens should be lost, if not on an artist then certainly in his art—lost or buried, as of no size, no meaning, no truthful, comprehensible magnitude.)

But to say that I write to understand the mysteries impinging upon my life is not to say that I write autobiographically. I generally don't. Some enormous writers have—Tolstoy, Dickens, Proust. But I—! (I set myself beside them for the point)—I've usually found it necessary to study, attempt to circumnavigate, then dissect the mystery which I needed to understand by distancing it, setting it outside my own chaotic life, imagining a set of credible characters, a characteristic action (people and acts most often quite different from me and mine), then lobbing the mystery like a bomb into their midst, witnessing the results and recording them. If that implies cool calculation—me facing a Mystery, then seeking my people and plot by abstraction—then it's misleading. The sense of mystery occasionally comes first—an amorphous curiosity—but much more often, a simple picture in the head: he here, she there; his name is Milo; why does he move thus?

The next intention is joined to the last and has always been for me the most complex and secret intention and (better) the happiest—to offer to explain what I think I've learned about a given mystery, not to "readers" but to one particular person. It's literally true to say that everything I've written till now was written first

* Aristotle, *The Poetics* in Allan H. Gilbert, ed. and trans., *Literary Criticism: Plato to Dryden* (American, 1940), p. 80.

for an audience of one (occasionally two or three) and offered to that person for at least two reasons—to communicate the results of my investigation into some mysterious relation or experience we shared; second, to justify my life to that friend or relation, to earn what that friend had already given. This is nearly impossible to discuss. I'll quote a relevant passage from Stephen Spender then pass on, but not because this motive is less important than any other. On the contrary, of all my conscious motives this is the strongest and most productive of joy. Spender says in his essay "The Making of a Poem,"

> Why are writers so sensitive to criticism? Partly, because it is their business to be sensitive, and they are sensitive about this as about other things. Partly, because every serious creative writer is really in his heart concerned with reputation and not with success. . . . I suspect that every writer is secretly writing for *someone*, probably for a parent or teacher who did not believe in him in childhood. The critic who refuses to "understand" immediately becomes identified with this person, and the understanding of many admirers only adds to the writer's secret bitterness if this one refusal persists.

—To attempt understanding then; to offer explanation (or progress-reports). Finally, to change. I've said, at length, that I know of almost no considerable work of art which does not intend to cause some action (response to *its* action), to work some change. Maybe the only exceptions are works of praise, pure adoration —the psalms of David to God, those sonnets of Shakespeare which seem only still praise of the young friend. But are they, however beautiful, pure and static? Can

any adoration ever be? Surely David—beyond all personal needs for exercising a skill, for maintaining a singer's reputation, for stunning his wives and the dangerous court—intends to convert us, the unbelieving world, to the worship of Yahweh. And such a sonnet as number twenty-six—

*Lord of my love, to whom in vassalage*
*Thy merit hath my duty strongly knit,*
*To thee I send this written ambassage,*
*To witness duty, not to show my wit.*
*Duty so great, which wit so poor as mine*
*May make seem bare, in wanting words to show it,*
*But that I hope some good conceit of thine*
*In thy soul's thought, all naked, will bestow it;*
*Till whatsoever star that guides my moving*
*Points on me graciously with fair aspect,*
*And puts apparel on my tattered loving*
*To show me worthy of thy sweet respect.*
> *Then may I dare to boast how I do love thee;*
> *Till then, not show my head where thou mayst*
> *prove me.*

—lean as it is in its humility, surely it exists in all its only half-veiled firmness to win, or fasten, a love withheld or toyingly given.

My own stories, then. What actions do they seek? Again I've brought you to the brink of my life, to information which even if I could give it, and you could remain awake to hear, would be of no use to the stories or you. The stories, for better or worse, are yours; the life is mine. But I can say truthfully if unspecifically that, so far as I understand my conscious intentions and those of my numerous puppeteers, I have always written in the hope of altering, literally causing movement in, one or two of three possible things—myself, that person

for whom I was writing, or the world at large (though I don't recall ever thinking of the *world* till a piece was done). Whatever my swarm of private dreams, the hope of making the world a better place has not surfaced often enough for recognition. My own life, yes. The lives of a few friends and enemies, though I'd seldom ask them except in stories. Then if anyone else looks in—welcome to whatever meal is laid, if meal at all.

"But," you're thinking, "he conceals more than he says." I do. I said I would. But I also undertook to lie as little as possible. Maybe, though, I can make partial amends by discussing a particular story, one which has an intense but typically distant relation to my life—the first serious story (as opposed to sketch, or mess) I ever wrote and one which has had considerable life in American and foreign anthologies since I began it at age eighteen. I can discuss it largely because it is my first story and because I remember clearly the events of its composition and because I think I know why it was written—some of the usable reasons, at least. I don't know how (I've never known a serious writer who didn't subscribe fairly literally to some notion like Plato's or Milton's of inspiration, uncontrollable or uninvocable afflatus); I never will and don't mind.

There are two kinds of reasons why I wrote "Michael Egerton"—private and public. Public first. I wrote it over a period of four years, my undergraduate years at Duke; and I wrote both the first and final drafts to fill class assignments at the last legal moment. The first version was written in the fall of 1951. The late Philip Williams, my instructor in an especially free section of freshman English, had given me rein to write my next theme in narrative. I'd previously done him a sketch or two which he'd praised with the sort of in-

vigorating salt I'd craved through years of distrusted
total approval; he pointed out, for instance, the odd re-
semblance between the end of my first theme and the
end of A *Farewell to Arms*. I had rearranged my mem-
ories of an aunt's dog's death and concluded with this
departure from the scene—"I just sat there for a long
time thinking, and then I got up and went home. It was
almost supper time."

Now, in November, I was to produce a double-
length narrative (one thousand words). For Monday.
On Sunday night I was of course sitting in a freshman
dormitory that rocked with the now healthy-seeming
violence of the early fifties—firecrackers cannoning in
the halls, lighter-fluid conflagrations on the terrazo,
whole rooms of furniture being transported to the quad
and erected there in place to greet hapless returning
weekenders—and I had no narrative, no serious idea. I
must have clutched at various moments-from-my-life—
I'd had eighteen years of it—but I don't recall the false
starts now. What I do recall is mounting despair as the
night moved on, the awful sense of a head which has
vacated when needed most. Then—on the vacancy and
in the midst of firecrackers and scattering buffoons—a
picture. That dramatically—lo. A literal image in my
head, visible and complete as a lantern slide—an eleven-
year-old boy, blond, large and complete for his age,
standing between two windows, his arms extended
cruciform, bound at the wrists with the exposed cords
of window sashes, ten-pound pig-iron weights excluding
blood from his fingers.

That much—the picture—was inspiration. But
that implies arrival from the exterior. This picture was
only the surfacing of a monster whose presence I had
forgotten, certainly had not specifically implored, would
not in fact (as I came to understand him) have wanted

to call. The picture and its fragmentary story had lain in my unconscious mind for seven years. It was literally "true," had happened in the summer of 1944, the one summer I was sent to camp. The boy in the picture had slept in the bunk above me and had begun the two weeks as my sudden friend and the pride of our cabin, our golden boy who, as suddenly, retreated from me and our cabinmates into private passive grief which he would not or could not explain and which finally aroused our sadism and provoked the final act of punishment—the punishment which had deposited its picture in me, a participant; then had bided its time, its curious revenge.

But that night in 1951, it seemed a plain story, one which I could tell by morning and (being me then) could tell in three pages. So I wrote the pages, described the boy as the glistening friend he'd been, then as the silent victim he became. When Philip Williams read it, he saw at once, and said, that what I'd stated was no story but a mystery, and an unsolved mystery. I had described only what I knew, the visible before-and-after of what had happened. Mystery remained—why had the boy changed utterly in such little time?—and to both Williams and me that seemed the central mystery. If I wanted to make a story, as opposed to telling the limited facts, I must solve the mystery, discover (that is, invent) a reason for the change in the boy. Simple enough. But next week's theme was nearly due; and in any case my energies then were invested in love and the soft-centered poems love was pressing from me, so I set the sketch aside, gladly buried the memory—which insisted on returning. I still have the opening of a second version which I attempted the following summer, more talkative and visually detailed than the first but aborted after three pages, well short of encountering mystery;

and two summers later I worked as a camp counselor in
the North Carolina mountains, hopeful that the final
necessary particles might accrue to the magnet of my
untold story. But the story remained untold. In my
junior year, Elizabeth Bowen visited Duke, asked to
meet some student writers and see their work. I was
one of the called, for my poems presumably; but sus-
pecting that Miss Bowen would rather see prose, I
rooted out my fragmentary sketch and offered that. Her
response was almost the same as Philip Williams'—the
difference being that she stated the problem in techni-
cal terms: my sketch lacked a middle. It had a firm be-
ginning and a strong end but no middle; by then I'd
read enough Aristotle to remember that "A complete
thing is what has a beginning, a middle, and an end"
and that "a middle is that which comes after something
and has something after itself." * And I seemed on the
edge of revelation, of being handed a complete thing—
again from my unconscious—but again I waited. The
middle didn't come and I didn't call it.

Not till the next fall, 1954. I was then a senior and
enrolled in William Blackburn's course in prose narra-
tive (the one such course I ever took); but I was also
deep in other things—editing the local literary maga-
zine, applying for graduate fellowships, beginning my
history honors-thesis on Milton and other course work
—so when the first story was due for Blackburn, I
obeyed one physical law at least (conservation of mat-
ter) and found my first sketch, now three years old, and
set out to make it a middle. It was not called "Michael
Egerton" then but by the name of the real boy. I
changed the name first, knowing I was on my own now,
that if I was going to make a *thing* out of my memory,

* Aristotle in Gilbert, *op. cit.*, p. 79.

I must imagine the middle of those summer weeks, invent the boy's dilemma and grief (Egerton is a name in my mother's family and one of which I was proud then —the Egerton family having commissioned *Arcades* and *Comus* from the young Milton). In fact, to discover and control the nature of this event in my life, to attempt to lay its returning ghost—and to pass my prose course—I was going to have to lie about it, complete it in my head by the addition of what probably never occurred, not to my mysterious friend at least. So I did it one night, beginning without a clear plan for the middle but working as I always have when revising —by beginning to copy my previous draft in longhand. Something in the act of physically forming words has always been my own best prod—ink against paper— and has often made me think that writing is a manual art as surely as sculpture. The hand, writing, balks at the uncompleted (or decorated, obscured) gesture, invents its full plain arc, pauses at the lip of holes in one's early sight and attention. And what mine invented to order that night (or at some prior point in the ten years' waiting) to complete this story was a witnessed encounter—the narrator ("I") sees from a distance and is later informed of a meeting between Michael his friend, Michael's mother and her new husband. My middle was divorce then—and Michael a common victim, the child as shuttlecock. Nothing galvanizing, to a reader at least, but credible and a sufficient stimulus for Michael's scorched response (I've wondered occasionally, hearing the story, if the mother's only speech is impossibly cruel—"Michael, this is your new father. How do you like having two fathers?" —In a country where any morning paper is apt to carry news of one more child-beating, scalding, maiming? In any case, the narrator hears the speech filtered through Michael;

what *he* says she said). A complete thing, beginning, middle, end; of a certain contemplable size. My first story—or the first I'd finished in the expectation of seeing in print, of reading years hence without shame.

Why did I have it? At the time, of course, I wasn't asking (I only wanted to hear, from someone who indubitably knew, precisely how strong it was, how sizable, what it portended for my life and work; and by great luck I heard that spring, when Eudora Welty came to Duke and read it). And maybe I shouldn't be asking now—I've already implied here a number of my more public motives—but I have the time and am interested and am asking, and am now so far from the summer of '44 or its writing in '51 and '54 that I see "Michael Egerton" with the sort of double vision which in this one case no one else on earth possesses (not that any of them minds): maker and audience.

As soon as I had finished that second draft, I knew something I hadn't known before—that the story was not about Michael but the narrator, therefore me. I learned that from the middle which volunteered itself —divorce. Not that I had experienced divorce at close range; I hadn't. But I knew very well at age twenty-one that the central conscious terrors of my own childhood had been dual and related—destitution and abandonment (knew as forcefully and freshly as ever since my father had died nine months before). In the years from my birth till the age of ten ('33–'43), destitution had been a genuine threat, the hand of the Depression. Abandonment wasn't, though I feared it, fantasied frequently about life in orphanages (there were several nearby with real Dickensian orphans—dutchboy haircuts, patched clothes, the steady gaze of the betrayed) and entered passionately into the near-universal child's suspicion that I had already been abandoned, was the

child of unknown parents, merely adopted by the Prices whose lives I now greatly complicated—all experienced so intensely as to suggest a positive yearning for abandonment, betrayal: a story in which "I" am the betrayer, conquering a fear by becoming the fear. Becoming not only a traitor but a cruel and finally cowardly one—all in the face of, because of, mystery (in this case, Michael's response to the mysterious actions of adult parental love).

Asked at the time (I wasn't), I'd no doubt have said that I wrote the story—or that the story had lingered all those years, demanding treatment—in order to tame my own waiting cruelty and to warn the unwarned or oblivious. And I'd have been right, partly. Roughly half-right. Yet could I—can I—expect any reader to come up with such answers, should he ever ask the questions? (Won't they, at least as often—anyone trained in American schools and colleges—come up with questions like these from a letter recently sent me by a highschool English class:

> Is the bathroom Michael retreats to parallel to the Garden of Gethsemane?
> Are we to assume that because Michael did not come out of the bathroom at the end of the story, you believe that Christ did not come out of the tomb?

—The apples of Milanion again; lead apples.)

I could expect answers like my own, yes—and do. The story seems to me still, whatever its size, what a friend of mine said it was—"an arrow to a target," that trim and swift. No reader would need any of the autobiography above to hear the story say, as it does, "Change your life" and to hint at some ways. He only needs the story, and that's on sale or loan.

What I couldn't have foreseen has been one of the real rewards—that readers (my students, age eighteen, the age at which I wrote it) would years later show me other questions whose answers helped me see another half of my intent, a harder and more original half, which may explain what life the story has had, its seductive threat. They asked why the narrator makes so few gestures, emotional or physical, to reach Michael in his silent ordeal, even to offer help? Why does he—"I"—after Michael's awful report of the mother's words lie awake in the bunk beneath Michael: "Once I sat up and started to reach out and touch him but I didn't. I was very tired"? And why, at the end when he has broken away from the other boys and returned to the cabin where he hears Michael behind a bathroom door, does he say, "I started to open the door but I didn't"? What decision does he make between "started" and "didn't"? What statement fills that silence?

Isn't it a chain of questions, not a statement; and aren't they these (in my voice, age twenty-one, nine months after presiding at the death of my father)?—I cannot enter the pain of another human being any more than the pain of a dog, a starling. Maybe I shouldn't try. Maybe weak tries—"started" and "didn't"—only strengthen, prolong the other's pain. Maybe he asks to be abandoned in his pain, accorded the dignity of solitude and silence?—not all human beings, but this one Michael and, since he is human, the others like him. Mustn't I learn to recognize and honor them?

What if all that is lies after all, however innocent or well-intended? Maybe it will be possible within a few years to show that I wrote "Michael Egerton" not for any of the reasons I've mentioned, public or private,

conscious or concealed. Maybe I wrote it because, in November 1951 at the time I was required to produce a freshman theme, a chain of electrochemical events forced out this product—events related maybe not so much to kinetic designs on the world's behavior as to my genetic predispositions, my psychic and physical metabolism, the climate in my dorm, my dread of the Korean draft. Maybe we'll soon be strapping the electrodes onto would-be poets—or literate dockhands—and by accurate stimulation of precise loci within the brain, producing real poems, novels, plays. (Maybe the Crab Nebula is fanned in all directions by a central ring of doves in infinite flight.) What if, what if?

I've plunged too far; no one could answer—though in a culture where what we agree to call good poems could be produced cheaply and rapidly by any literate man who could reach the stimulating equipment, surely few of us would be reading and questioning one another. Why bother?—every man his own Tolstoy; the ultimate pornography. (Every literate man already possesses the apparent raw materials of any good poem— words and life—and most men have probably had more eventful lives than Shakespeare, certainly than Emily Brontë.) In any case, all questions of How? would be answered—by this silver needle, inserted *here*, charged with x volts for y milli-seconds. Wouldn't Why? survive though, a mystery still, the only one? And if there were a poet or electronic novelist whose answer to Why?— "Why do you seek this solitary stimulation?" and "Why has your brain been made to issue *this*?"—would be other than "Fun and profit," mightn't he say above crackling synapses what Prince Genji said in eleventh-century Japan to reassure a lady whom he'd caught reading fiction?—

I have a theory of my own about what this art of
the novel is, and how it came into being. To begin
with, it does not simply consist in the author's tell-
ing a story about the adventures of some other per-
son. On the contrary, it happens because the story-
teller's own experience of men and things, whether
for good or ill—not only what he has passed
through himself, but even events which he has only
witnessed or been told of—has moved him to an
emotion so passionate that he can no longer keep
it shut up in his heart. Again and again something
in his own life or in that around him will seem to
the writer so important that he cannot bear to let
it pass into oblivion. There must never come a
time, he feels, when men do not know about it.*

Till the age of electric inspiration then, my old claims
hold—for me, at least, and for all I've written—and
"Michael Egerton," early and lean as it is, answers the
central question for me, in full and with the clarity of
first-work and in much Prince Genji's way: so that man
(no, a few) should not forget but remember and reply.

*1963, 1971*

---

* Lady Murasaki, *The Tale of Genji,* translated by Arthur
Waley (Random House, 1960), p. 501.

# FIVE SKETCHES FOR
# A SCREENPLAY

1. *The first day—a July Sunday—is ending. Rosacoke and Wesley have gone from the funeral of black Mildred Sutton to the annual picnic-outing of Delight Baptist Church. That has ended. Rosacoke and Wesley are alone—the only two left at Mason's Lake.*

We see from behind ROSACOKE's head across the lake—both her and WESLEY. It is less bright now, still clear but cooler, the water calm. WESLEY stands on, still, water to his waist, right hand holding his own right shoulder, grave eyes set on ROSACOKE, distant.

Then we see ROSACOKE from WESLEY's side—barefoot, bareheaded: the thing he feels, for now, that he needs, must prove, try.

WESLEY

Rosa, you got anything I can drink?

ROSACOKE

What you mean?

WESLEY

I mean I'm thirsty.

ROSACOKE

You are standing in tons of pure spring water.

WESLEY's head falls back, laughs quietly. Then he looks again, slides forward into water and silently strokes to-

ward her (arms underwater, only his cocked head stir-
ring the surface). In the shallows he stands, walks
straight for ROSA, stops at her knees, looks down, smiles.

She smiles and nervously turns away (her hair, darker
now in the evening light, falls in water curves along her
white neck to the groove of her back, still damp
through her dress).

ROSACOKE
The drink stand is closed.

WESLEY nods, extends his hand to her hair, stops short
of a touch and walks the few yards to the bathhouse,
enters.

ROSACOKE thinks they are leaving now, rises, and walks
to the motorcycle, stands by it, waiting. Laid on the seat
are her shoes (brushed clean) and her pocketbook—
left there by MAMA. ROSA takes the cleaned shoes,
smiles. Then she puts the shoes on as WESLEY appears
in the bathhouse door, having added nothing but a
shirt to his trunks—and it half-undone. He does not
come to ROSA.

ROSACOKE
Who stole your pants?

WESLEY pauses, smiles, then gently—as though it were
genuine pleading, not command.

WESLEY
Rosa, come here.

He waves her in toward him and of course she goes,
takes his offered hand and walks with him leftward
around the lake toward the hill and the mules. After a
few steps and silence from WESLEY—

ROSACOKE
Aren't we going home? I mean Mr. Mason has
shut it up and all—maybe we ought to go.

WESLEY

Maybe I can find some drinking water.

ROSACOKE

(Protesting but still walking forward) Wesley, there is water at every service station between here and home. Why have we got to go tearing through some strange somebody's bushes?

WESLEY

Hush, Rosa.

They have come to the base of the low green hill and are stopped by a three-strand barbed-wire fence. ROSA hushes, WESLEY lifts the bottom wire, ROSA stoops, crawls under. He follows her and pauses on the other side to disentangle one long yellow hair from a rusty barb.

ROSACOKE

Is that mine? (Strokes her head)

WESLEY

(Binding it around his finger) It's mine now.

ROSA climbs on ahead, WESLEY follows closely.

ROSACOKE

Well, you can have it. The sun has bleached me out till I look like a hussy.

WESLEY

What do you know about a hussy?

ROSACOKE

I know you don't have to go to Norfolk to find one.

WESLEY

What do you mean?

ROSACOKE

You know who I mean.

WESLEY

If it's Willie Duke Aycock you mean—she'll be in
Norfolk tomorrow morning along with them other
hussies you mentioned.

ROSACOKE stops and turns slightly back to WESLEY.

He also stops, smiles teasingly.

ROSACOKE

What is she going to Norfolk for?

WESLEY

Maybe she's got some friends up there. (Grins
broadly now) No, she's got a job.

ROSACOKE

Doing what?

WESLEY

Curling hair.

ROSACOKE

What does she know about curling hair with that
mess she's got?

WESLEY

I don't know but she's moving up, bag and bag-
gage.

ROSACOKE

What was she asking you about then?

WESLEY

—Would I ride her up.

ROSACOKE

On that motorcycle?

WESLEY

Yes.

ROSACOKE

Then she's crazier than I thought she was. (Climbs a few steps; then, still climbing) Are you taking her?

WESLEY

I don't know yet.

ROSACOKE

When will you know?

WESLEY

(Pauses to decide) By the time I'm home tonight.

They are nearly at the woods on the crest of the hill. The mules graze on toward each other. WESLEY takes ROSA's hand again and leads her to the trees.

They come toward us now through woods and weeds and poison oak so heavy that they walk in near-night.

WESLEY watches only ROSA.

She watches the ground which is soft and dangerous to her high heels but also to test her resistance to WESLEY. At last she pulls back on his hand and stops.

ROSACOKE

Wesley, we will both get poison oak which Milo will never stop laughing at, and you aren't going to find any water tonight.

WESLEY

Maybe water isn't what I'm looking for.

ROSA looks to his face which is so dark now as to be a stranger's. For a moment she fears, then dissolves fear in joking.

ROSACOKE

I don't notice gold dust lying around—

WESLEY does not speak but leads her to a large oak tree, bare around the roots. He sits there and ROSA holds his hand but does not sit.

> ROSACOKE
>
> Night will come and catch us here, and we'll get scratched to pieces stumbling out.

WESLEY looks up at her—no trace of a smile—pulls lightly on her hand.

WESLEY works on awhile, unjoined by her, till she pulls away.

> ROSACOKE
>
> How much else did you learn in the Navy?—harmonica playing, motorcycle riding, gnawing on girls like sides of meat. Uncle Sam got his money's worth in you.

WESLEY stops, sits back. His face is so shadowed we cannot see it, nor can ROSACOKE though she stares.

> ROSACOKE
>
> Wesley, where are you?

> WESLEY
>
> (Pauses) I am here, I guess.

> ROSACOKE
>
> You guess. You *guess?* What else do you guess? Do you guess I am made of brass like Willy to trail behind you and beg for notice? Do you guess I can sit on another six years, wondering who Wesley is and where Wesley is, and is Wesley ever coming home, calming down, resting long enough to have a life? Do you guess I can live on in mystery like this till you finally decide to come out of cover and speak your mind?—say 'Rosa, I am ready to carry

my share' or else 'Rosa, get on home to your
Mama.' All I am asking you to do is *say*. Do you
guess you love me—or that I love you? (Pauses)
Wesley, I do. When I see you, I do. I know this
isn't what I ought to say, but when you have sat
silent six whole years, waiting for somebody you
love to speak—and you don't know one reason *why*
you love them or even what you want them to say
—then it comes a time when you have to speak.
(Pauses, faces WESLEY's dark face) I've spoke and
I'm here.

WESLEY
I knew that, Rosa. Wesley is *here*.

He begins his answer in the way he knows, the way he
can, the way he now thinks ROSACOKE wants—gently
kissing her lips, eyes, neck; then moving downward to
his six-year goal. ROSA at first has accepted, responded;
but when he attempts to enter new country, she re-
treats, holds him back with her hand.

ROSACOKE
Is that all you want out of me?

WESLEY
That's right much. Listen, if you are thinking of
Mildred's trouble, you hadn't got to worry. You'll
be all right. That's why I left the funeral—

ROSACOKE
It is nearly night. (Stands above him) Please take
me home.

WESLEY
Of course it's night. What the hell do you want?—
floodlights?

ROSACOKE

I said, take me home.

WESLEY

(Still sitting) You know I am going to Norfolk tomorrow. You *know* that, don't you?

ROSACOKE

I know that. (Takes a step to leave)

WESLEY

—And that maybe I'm riding Willie Duke up there?

ROSACOKE

(Stops, turns) You can ride Willie Duke to Africa and back if she's what you need. Just make sure she don't have Mildred's trouble.

ROSACOKE leaves, vanishing into trees.

WESLEY rises and follows at considerable distance.

ROSACOKE emerges toward us onto the hill, walks past us out of sight.

Then WESLEY emerges—it is all but night—looks down to ROSA's diminishing figure, the bare calm lake. Then he sees the two mules who are resting now, outlined against the lake, six inches apart from head to tail, facing opposite ways.

WESLEY does not smile but speaks to them as he heads down the hill.

WESLEY

Congratulations, mules.

ROSA waits at the cycle, looking toward the bathhouse which is dark but which lights for a moment at the

open eaves when WESLEY strikes a match inside, then darkness again, an angry stamp on the wooden floor.

WESLEY emerges toward the cycle—still in trunks, with trousers and shoes crumpled in his arms.

#### ROSACOKE
Is riding home naked the style in Norfolk?

#### WESLEY
Hell no, but I ain't hopping around in yonder where it's dark and snaky.

He turns on the powerful light of the cycle and standing only half-turned in its narrow beam, steps out of his damp trunks and into his trousers with only his shirt tail and ROSA's turned face between him and her.

The cycle roars in total dark down the same dirt road; and we see the MUSTIAN house on its mild hill, dark except for the bald porch light.

WESLEY slows to turn and ROSACOKE leans to his ear and speaks.

#### ROSACOKE
Let me off here. Mama may be asleep.

WESLEY stops and kills the motor, waits while ROSACOKE gets herself down, takes what is hers in the saddlebags —hat and pocketbook.

She walks a few steps in total dark, then turns back to WESLEY.

#### ROSACOKE
Please shine your light here so I can see my way.

He does that for her and she walks a little farther in the strong white beam. Then she turns again.

ROSACOKE

Wesley—

WESLEY

What?

But she cannot see him—only his black shape behind
the light. She cannot speak to that.

ROSACOKE

Just have a good trip.

WESLEY

I'll have a good trip.

ROSA walks on upward in his light to the house till she
reaches the range of the weak porch-light. Then she
turns and waves slowly, twice, with her hat. For a
moment there is only the noise of frogs. Then the cycle
fires, the light swerves from her, and WESLEY leaves.

*2. Late afternoon, evening, night—a Saturday in
early November. Wesley has flown home in a pri-
vate plane with Willie Duke Aycock and her
friend; but he has not contacted Rosacoke and, in
flight from Milo's suggestion that she "Pull up her
petticoat, pull down her drawers," she goes toward
the house of Mary Sutton, dead Mildred's mother.*

At a distance we watch ROSACOKE all but running
through the littered yard—the bag of clothes, gripped
against her chest—toward a sparse pine woods behind
the house. She enters the trees; and though we do not

follow, we see her blond hair even in the twilight till that too vanishes in dark.

Then we await her in MARY SUTTON's yard by MARY's house—three wood rooms and a roof, bleached by rain to the color of bone, narrow, high-roofed and thrusting from the packed white ground where nothing else grows. Smoke crawls from the chimney, and a turkey gobbler picks at the ground, looking up to study ROSA as she breaks from the trees on the right, calmer now. She walks a few steps toward the house, then knowing the fierceness of the turkey, stops.

<div align="center">ROSACOKE</div>

Mary?

The turkey decides to let her pass, returns to his picking.

ROSA climbs the sagging steps, calls "Mary?" again, then opens the door and enters the large low room—nearly dark except for the light of a kerosene lamp which dimly shows newspapered walls, a large feather bed, a smaller bed, a few sticks of chairs.

Across the room the kitchen door is open but the kitchen is dark.

ROSA speaks toward there.

<div align="center">ROSACOKE</div>

Mary, I've brought Mildred's baby some clothes.

She pauses, no answer; so she moves to the big bed to lay the clothes there.

MILDRED's baby is asleep on his back on a pad of newspapers, head twisted left, fists clenched to his ears. He has kicked off his thin cotton blanket; and his dress has worked up above his waist, leaving him bare to the cold of the room.

ROSACOKE shivers once herself, lays the clothes gently on the bed and leans above him to hear his breath.

We hear it loudly—from his mouth, nose, throbbing in the unshielded top of his skull, in his rising belly, knobby navel and faintly beneath in his tight-budded genitals.

With frightened care ROSA tries to cover him—pulling down his dress, lifting his blanket—but even her gentleness wakes him, or trips his waking.

She stands, watches helpless and a little appalled, as he oars with his feet, picks at his dress, grunts in his nose, then turns his head, opens black eyes on ROSACOKE and throws a scream like a knife at her face.

ROSA looks in beginning panic to the open front door —still no MARY—so she forces herself to turn to the baby and struggles to calm his terror. Again she arranges his dress and blanket, then reaches behind his head to lift him; but he belches loudly and thick hot milk spews down his neck into her hand. ROSA jerks back her hand as if scalded, flinging the clots of milk on the floor, then wiping her fingers on MARY's bed.

The screaming continues—choked and full.

ROSA studies the baby, tries to smile to calm herself.

ROSACOKE
Baby, *I* ain't what you need.

She takes the first step to leave.

But the door is blocked by a large black figure—slowly the lamp reveals it as MARY.

ROSA points behind her to the howling child.

ROSACOKE
Come on, Mary, and help this child.

MARY

(Still, unsmiling) What you done to Mildred's baby?

ROSACOKE

Not a thing—but he's sick.

MARY

He ain't sick. He just passing time.

ROSACOKE

Well, I came in to bring him these clothes Mama sent, and he woke up.

MARY

(Still in the door, still unsmiling) And you picked him up when I done just fed him?

ROSACOKE

I was trying to stop his crying, Mary. Don't get mad.

By now the baby's crying is weaker. MARY enters, leans to the bag of clothes, touches the baby (with no special gentleness), leaves one hand on his bare stomach, looks to ROSA.

MARY

What you so scared of crying for? He come here crying and he be crying when I ain't here to hush him. *He* got his right to cry, Rosacoke, and why ain't you used to babies by now?

ROSACOKE

I will be soon. Milo's wife is due—overdue.

MARY

(Smiles at last as if roused from harsh sleep, moves from the baby to a rocking chair, slides it forward) Yes'm. Sit down, Miss Rosa. Thank you for them clothes.

ROSA sees the sky through the still-cracked door. It is nearly night.

#### ROSACOKE

It's nearly night, Mary. I got to get home. (Steps toward the door)

#### MARY

Yes'm, it is. You come by yourself?

#### ROSACOKE

(Looks round smiling as if for a ghostly companion) Just me and my thoughts. I'll come back soon and stay longer, Mary. (Takes another step, eager to leave)

#### MARY

They tell me Mr. Wesley got him a airplane.

#### ROSACOKE

Who is *they*, Mary?

#### MARY

Estelle was walking past the Aycock place when him and Miss Willie Duke landed in the pasture in a little airplane. He told Estelle the plane was his and he was heading back to Norfolk in the morning and to watch out for his dust in the sky.

#### ROSACOKE

That won't his plane. He just hitched a ride.

#### MARY

Yes'm. How is he coming on, Rosacoke?

#### ROSACOKE

Wesley?—Fine, I guess. I hadn't laid eyes on him since the funeral.

#### MARY

I didn't know that.

ROSACOKE

Well, it's God own truth. (Smiles with difficulty, meaning to leave; pushes the door completely open) Mary, what must I *do?*

MARY

(Pauses) Is he what you need? (ROSA nods) Then you got to hold him. (MARY joins ROSA at the door, points rightward at another thick woods) He's right in yonder behind them trees.

ROSA faces MARY another moment, takes the steps quickly and is almost at the opposite trees (where MARY pointed) before she turns.

ROSACOKE

Mary, excuse me—

MARY

Step along, Rosa, else night will catch you.

ROSACOKE enters the trees, running; vanishes at once.

ROSA runs toward us through a thick undergrowth of switches, briars—her face nearly dark but, in moments of open sky, light enough to show her panic. We precede her till she breaks into a clearing and stops to suck breath for a moment. Then slightly calmer, she smooths at her hair.

She has almost reached the end of the clearing. Only a transverse weeded gully lies between her and the thin trees beyond. She approaches the gully, prepares to jump it.

Up with a rush, brown wind, a great hawk flies.

ROSA drops back in fright and looks up to watch the hawk above her.

It circles the clearing, low, before leaving—its locked tan wings, black beak, black eyes above her on the sky. Then it flies on, the way she is headed.

She leaps the gully and follows the hawk, as faint harmonica music rises.

We follow closely behind her as she approaches the end of the woods. Harmonica music continues, louder but broken by breezes occasionally.

Then we enter ROSA's head; we see the lines of the BEAVERS' house beyond the last trees—clearer and clearer as ROSA nears it. The house sits back from the road at a slant in a white dirt clearing. It is low, one story with a porch across the whole front end and three concrete steps.

ROSA walks to the very edge of the clearing, staying only just hidden, and looks through the last light of dusk at the porch and the steps fifty yards away.

WESLEY stands at the top of the steps, leaning on a post on the right, facing the road but staring down at his youngest brother CLAUDE (age eleven) and playing his harmonica, both hands cupped round his mouth. (He wears dark trousers, a loose white shirt; and his hair is still light from the last summer sun.)

As ROSA takes her first clear look, his music pauses—hangs—for a moment, his hands still ready.

<div style="text-align:center">CLAUDE</div>

Don't stop.

So WESLEY's hands move and the music continues for another slow phrase—his hands being all that moves in our view: house, trees, CLAUDE, stonestill. Then the music begins a fall.

ROSA's dark face strains to hear, but the final phrase is lost in a breeze.

WESLEY's hands stop.

### CLAUDE
Is that all you know?

### WESLEY
No. Oh no. (Smiles) But it's all I'm *giving*. Got to save my strength.

WESLEY knocks out the spit from the harp on his palm. CLAUDE rises, silently enters the house; and WESLEY takes one step down as if to leave.

ROSACOKE breaks through her thin shield of trees and slowly crosses the clearing toward him, looking down as she comes, planning her words.

He pauses on the middle step (one foot on the bottom) and watches her come. When she is near him, he raises the harp and blows again his favorite phrase, keeping his hands across his face as the phrase ends and ROSA stops below him.

### ROSACOKE
I heard you playing almost to Mary's. (Points back through the woods) I've been to Mary's to see Mildred's baby—

WESLEY laughs gently—it whines through his harp.

### ROSACOKE
If you managed everything good as you manage a harp, wouldn't none of your friends ever be upset.

WESLEY lowers the harp, smiles as if to joke—but is not joking.

### WESLEY
Wesley's friends have to take Wesley—lock, stock and barrel—or leave him alone.

**ROSACOKE**

That doesn't make his friends' life easy, does it?

**WESLEY**

(Still smiling) Who did I ask to *be* my friend?

ROSA pauses, carefully weighing the truth; then faces him again, half-smiling.

**ROSACOKE**

You have spent your life—the last six years, at least—drawing people to you.

**WESLEY**

They don't have to come. I don't carry a gun.

**ROSACOKE**

(Pauses) That may well be. (Looks above to the sky—a night sky now; to the empty road; back to WESLEY) Can I use your phone? It's darker than I counted on.

**WESLEY**

I can carry you.

**ROSACOKE**

Can you? No, seriously, Wesley, my stomach's been bad; so I won't trust it to a motorcycle now.

**WESLEY**

You don't think I hauled my motorcycle here in a airplane, do you?

**ROSACOKE**

(Shakes her head 'No,' then smiles fully) Do me a favor—say "Rosacoke."

**WESLEY**

Why?

**ROSACOKE**

—A gift to me.

WESLEY

Rosacoke.

ROSACOKE

Thank you. That's my name. I bet you hadn't said it since late July.

WESLEY

(Smiling) I don't talk to trees and shrubs like some people if that's what you mean.

ROSACOKE

That's not what I mean. You are Wesley—is that still right?

WESLEY

Unless the Law has changed it and not notified *me*.

ROSACOKE

I was just checking. I know such a few facts about you and your doings that sometimes I wonder if I even know your name.

WESLEY

Yes ma'm. You can rest easy on that. It's Wesley all right, and is Wesley riding you home or ain't he?

ROSACOKE

If nobody else is wanting the car, I'd thank you —yes.

WESLEY

You'd be welcome.

He descends toward her, smiling, and walks to the car beside the house. She lingers behind him, so he turns midway.

WESLEY

It won't cost you nothing.

We see ROSA's face in the final moment of knowledge, choice. Then she goes to him and the car, unsmiling.

They ride through the dark, in silence, separate— WESLEY gripping both hands to the wheel; ROSA on her side watching the black woods, now and then turning to glimpse his face in the dashboard light. They pass many possible stopping places—little shafts of road sunk into the trees—but WESLEY shows no thought of stopping, though ROSA stares at each missed chance as if it were the last. Then they rush past Mount Moriah Church where Mildred was buried. It is on their left— windows dimly lit and the sound of singing heard for a moment. ROSA turns to see the church vanish, then back—a little closer to WESLEY.

ROSACOKE

We might as well be on the motorcycle for all the talking we have done.

WESLEY

What do you want to say?

ROSACOKE

Wesley, you are half of this trouble, at least, and you said you would talk.

WESLEY

I don't remember everything I say.

ROSACOKE

I sure to God do. You wrote me not more than two days ago, not mentioning a word about flying home today and then *flying* home and not moving one step to talk to me. What does that mean?

WESLEY

God A-mighty, Rosa. I don't mean *nothing. I* don't mean nothing. (Faces her) I live in the pres-

ent and say whatever crosses my mind when I'm
asked to speak. That's the risk people take, asking
me to—

They are rounding a thickly wooded curve and WESLEY
is stopped by a buck deer, broadside, leaping from their
right; then struck by their lights, heaving round in mid-
air and vanishing back the way it has come.

<div align="center">WESLEY</div>

(The deer still in sight) Sweet Jesus!

<div align="center">ROSACOKE</div>

Stop!

The deer gone, they sit a stunned moment—the only
noise the distant crashing of the buck's retreat.

<div align="center">WESLEY</div>

(Staring only at the road) First one I ever seen
try it.

<div align="center">ROSACOKE</div>

(Staring at WESLEY) Try what?

<div align="center">WESLEY</div>

Try to lead his does across a road to water.

<div align="center">ROSACOKE</div>

The spring where you found me?

<div align="center">WESLEY</div>

There's creeks all in there if you go far enough.
(He faces her for the first time, a neutral look—
not smiling, not harsh, quite undemanding)

<div align="center">ROSACOKE</div>

(Pauses) Wonder will he try to cross them again?

<div align="center">WESLEY</div>

If you ain't in a hurry, we can wait up yonder in
the tracks to the spring.

ROSACOKE

I can wait.

3. *Late night of the same November Saturday.*
*Rosacoke has returned from her meeting with*
*Wesley, having yielded finally, to find Milo's wife*
*Sissie in prolonged and complicated labor. She and*
*Baby Sister and Macey Gupton wait in the kitchen.*
*Mary Sutton is upstairs, assisting; and Mildred's*
*baby Sledge sleeps in a box by the stove.*

ROSACOKE stands at the kitchen sink, washing pans and
spoons from candy-making. In the center of the room,
beneath a naked dangling light, MACEY GUPTON sits at
the kitchen table, a plate before him that has held all
the fudge—now two pieces are left. BABY SISTER wan-
ders, apparently aimless; then fires a glance at ROSA's
back, a grin at MACEY; snatches one of the pieces of
fudge, gums it hastily and noisily. ROSACOKE turns in
tired annoyance.

ROSACOKE

Baby Sister, one sick woman is enough.

MACEY leans forward, takes the last piece himself,
speaks to ROSA above his chewing.

MACEY

Don't grudge her something harmless as fudge.
Four years ago Marise hadn't never wanted noth-
ing but candy—look at her now—(He gestures to
the air as though to MARISE, and ROSA and BABY
SISTER look as though to see her)—She got four
babies out of me quick as gunshots. . . .

Through the shut kitchen door, a long groan from

SISSIE. They suspend, listening; but before SISSIE ends, MACEY continues—

#### MACEY

Sounds like she's dying but she ain't. Of course, some women do it easier than that. (Points toward the just-ended groan) Marise has babies easy as puppies.

ROSA has finished her dishwashing now and to silence MACEY, speaks to BABY SISTER.

#### ROSACOKE

Baby Sister, look at what time it is. (They look to a clock on the mantelpiece—an old Baby Ben: it is 10:25)

#### BABY SISTER

OK, I've looked.

#### ROSACOKE

Then get on to bed. You got Sunday school tomorrow.

#### BABY SISTER

You are not the boss of me. I'm waiting for the baby.

ROSA flushes, waits to gather her reply but MACEY intervenes.

#### MACEY

Go to bed, honey. There'll be regular babies in this house now—

#### ROSACOKE

Macey. (Not harshly but pleading)

They are interrupted by the opening door. MARY SUTTON stands before them, a slip of paper in her hand. Then she walks to MACEY, hands it to him.

> MARY
>
> Doctor says will you go get this medicine please,
> Mr. Macey?

MACEY studies the slip. ROSA and BABY SISTER gather
closer. MACEY stands.

> MACEY
>
> (Smiles down at paper) I just hope the *druggist*
> can read it.

MACEY leaves. ROSA looks to MARY but MARY has walked
to a cardboard box on the floor by the stove and squats
by that. It is Mildred's baby, awake but silent.

So ROSA moves to BABY SISTER, whispers to her.

> ROSACOKE
>
> The baby's awake. Now go to bed.

BABY SISTER strains on her toes to see the baby, asks
ROSACOKE—

> BABY SISTER
>
> What's his name?

> ROSACOKE
>
> (Whispering even softer) Go on, Baby Sister.

BABY SISTER goes, quietly shuts the door. ROSACOKE walks
to where MARY squats by Mildred's baby, arranging his
clothes in a nest around him.

He is still awake but does not cry, only watches MARY,
then ROSACOKE.

At first ROSA dreads his black-eyed stare, afraid of an-
other scream from him; and she smiles down, hoping
to earn his trust.

He does not smile but holds out a hand toward her, and
she speaks.

ROSACOKE

Mary, what is his name?

MARY looks up to ROSA but does not stand.

MARY

I call him Sledge after Dr. Sledge that tried to save
Mildred but *I* don't know—I expect his name is
Ransom, but Sammy Ransom ain't mentioned
*feeding* him. (Stands, moves to the table, sits.
ROSA remains above the baby, who still watches
her) I ain't blaming Sammy though. Mildred
didn't know his name herself—at least, she never
told *me*.

ROSACOKE pulls herself from the baby, sits at the table
—MARY on her right.

ROSACOKE

*Mildred* didn't know. I met her in the road—oh,
last February. We hadn't seen each other since
summer; so we stood there, saying how cold it was
till it looked like we didn't have nothing else to
say. Then we said goodbye and Mildred moved off
to go her way, and her coat swung open and there
was this hard new belly riding on her, stuck in her
skirt like a coconut shell. I said 'Mildred, what is
that?' She said 'Nothing but a baby.' I said
'Whose baby?' and she said, 'Several have asked
me not to say.' Then I said, 'And you haven't
tried to throw it?' She said, 'What I want to throw
him for, Rosa?' I said 'Won't nobody marry you?'
She said, 'Some of them say they studying about
it. Ain't no hurry. Just so he come here having a
name.' Then I asked her why on earth she had
done it. She said she didn't know so I said 'Are
you *glad*?' She said, 'Rosacoke, *glad* ain't got noth-

ing to do with it. He coming here whether I glad or not.' (Pauses) She said goodbye and I stood and watched her out of sight—her thin wrists held to her sides, not swinging, and her fine hands clenched. When she was gone round the bend in the road, not looking back once, she was gone for good. I never saw her again—not alive, not her face.

MARY

Why you telling me that, Rosacoke? Mildred done what she had to do. Don't blame her *now*.

ROSACOKE

(Rousing from her memory) I'm not blaming, just remembering.

The baby whimpers as if to cry. MARY leans to see, then rises, finds his bottle (a nippled Coke bottle), sets it in a pan of water on the stove, then turns to ROSA.

MARY

Rosacoke, you got to live in the present.

ROSACOKE

I been trying to—but that don't stop me regretting Mildred, that she laid down in the dark somewhere and took this baby (Points) from some hot boy that didn't love her, that she didn't love no more than a snake.

MARY stands at the stove, stares silently at ROSA.

MARY

How old are you, Rosa? Mildred's age, ain't you? (ROSA nods) And you still thinking and talking about *love*, still waiting around for love to strike.

Time's running out on you, Rosacoke. Time's coming soon when you got to see that most people lie down and *die* without love, not the kind you talking about—two people bowing and scraping to themselves for forty years with grins on their mouths. (Moves to the baby, bends, takes him up) Of *course* Mildred didn't love nobody like that. But she knew what she needed and took it—and it killed her. That was *her* hard luck. You asked me this evening what to do with Mr. Wesley, and I said if he's what you need, then *hold* him—

Loud steps clatter down the stairs toward them. The door flies open, MILO stands in anguish.

MILO
Where the Hell is Macey?

ROSA looks to MARY.

MARY
Gone for the medicine; said he be right back.

MILO
(Again to ROSA, never glancing at MARY) We need it now. *Both* of them are dying. Rosa, come on with me. We'll have to get it. (ROSA looks to her hands, does not rise. MILO steps to the door) You owe me this much.

ROSACOKE faces him; studies the taut face that, hours before, had spewed the dirty song at her.

ROSACOKE
You ought to thought of that five hours ago when you sung me your song.

He pauses an unforgiving moment; then leaves, not shutting the door behind him.

ROSA sits frozen in her harsh refusal, untouched by the noise from SISSIE above or by MILO's retreating feet in the hall.

Then MARY speaks, looking down at the baby.

MARY

Who you going to have left, Rosacoke?

ROSA stands, never having met MARY's eyes, runs to the door, runs out. She snatches her coat from the rack, not stopping and struggles to put it on as she reaches the front door and opens it.

MILO's lighted car is backing in the yard to head for town. ROSA runs down the porch steps and toward him, waving as she goes; and once he has faced the car to the road, he stops and waits. ROSA opens the door on the passenger's side, leans and looks to MILO.

ROSACOKE

I beg your pardon.

MILO

Get in.

ROSA gathers her coat to climb in beside him, has one leg in when a loud rapping comes from behind and halts her. She withdraws, looks back, looks up. MAMA is standing at the upstairs center window, her knuckle still resting on the pane she has struck. When ROSA has turned, MAMA beckons to her.

ROSA nods, looks briefly to MILO.

ROSACOKE

Mama's calling us back.

MILO

See what she wants and hurry up.

ROSA rapidly walks to the house. MILO waits.

MAMA opens the front door as ROSA is still two steps away, and the look of her face stops ROSA in her tracks.

MAMA

It never breathed.

ROSACOKE

What was it?

MAMA

A boy.

ROSA turns and looks toward the waiting car.

The motor runs, the lights are on; but MILO stands by the rear bumper now, facing the house.

MAMA

There he is. God help me tell him.

MAMA opens the screen, steps onto the porch to go and tell MILO; but ROSA forestalls her.

ROSACOKE

You'll freeze. *I'll* go.

MAMA

And stick beside him whatever he does? Promise me that?

ROSACOKE

Yes'm, I will.

ROSA has reached the steps, unhurried, when MAMA speaks softly.

MAMA

Tell him Sissie is safe.

ROSA nods and goes on to MILO who waits, not advancing a step to meet her. She does not look up to take his stare till she stops six feet away from him.

ROSACOKE

It's over. Milo—he never even breathed.

MILO pauses a long moment but never breaks his stare.

MILO

*He?* Don't you know his name? He's had a name
since the day I made him.

ROSACOKE

Daddy's name?

MILO

(Nods) That was the trouble. (Long pause)—
That and the sorry mother he had. Sissie killed him
sure as if she cut him with a knife—to punish me.

ROSACOKE

Milo, that isn't so. I won't stand here and say I
love Sissie, but she worked nine months to make
that child and nobody works that long in hate.

MILO

I've worked every day of my life in hate.

ROSACOKE

(Still six feet away) Milo, take that back. You
don't mean that.

MILO breaks his stare, looks to the ground, shakes his
head 'No.'

So ROSA can finally go to him. He makes no move to
embrace or enfold her but stands, arms down, as she
circles his chest, lays her head against him, talks from
there, not meeting his eyes which look to the house.

ROSACOKE

I'll help you any way I can, any way you need.
(Pauses, no reply, notices the burning lights of the
car, the exhaust smoke) We could take a ride.

(Pauses, no reply) Or walk up the road. It's not that cold. When you were a boy, let you be worried, you'd walk for miles. Remember that? (No reply. She leans back from him to see his face. He looks to the house, the lighted upstairs hall window) Let's walk to Mr. Isaac's and back. That's what we need.

MILO stares on at the house a moment.

Then MAMA appears again in the upstairs hall window —stock-still now, not beckoning.

MILO walks past ROSA toward the house, stops beyond her.

<div align="center">MILO</div>

What I *need* to do and *got* to do are two different things. But thank you, Rosa.

For a long moment we watch ROSA's face—exhausted, abandoned; then we retreat from her toward the house. She comes toward the house and us.

She climbs the final flight of stairs, still in her coat— slowly, quietly, looking down—and we precede her down the upstairs hall till she pauses silently at SISSIE's door, half-open now so that ROSA can see the loose knot around SISSIE's bed—MAMA, MILO, DR. SLEDGE, MARY, even BABY SISTER in a flannel nightgown. No one has heard ROSA's approach, no one looks; so she walks on quietly to her own door, opens it, enters the dark empty room. From inside the room we see her enter, lighted only by moonlight through the unshaded window. She walks to the center of the room, still in her coat, reaches for the hanging light-string but drops her hand and begins to shiver—at first as though in reaction to cold. The shaking continues as she walks to the window, stands there, arms at her sides as if strapped. From out-

side the window we watch ROSA's face, shuddering violently now, as she presses her forehead to the cold pane.

*4. December—the Sunday afternoon before Christmas. Rosacoke's family have gone to church to practice the Christmas pageant, and she has gone to Mr. Isaac Alston's to deliver his annual gift of horehound candy. Wesley, whom she has not seen or communicated with since early November, has surprised her there; and she runs.*

We see ROSACOKE in profile, running—twenty yards downhill from the house toward the road, her breathing thrown up as animal grunts, her open coat blown back behind her, her throat open to the cold air. Then we see WESLEY's hand reaching toward her shoulder— only his hand and arm at first. They run four steps thus, separate. Then WESLEY's hand settles gently on her shoulder, and ROSACOKE slows immediately. She trots on another two steps from momentum, then stops, stands panting, slumped, looking only at the ground, hair fallen round her face. WESLEY waits a moment for her to face him. She does not; so again he touches her shoulder with a mild right hand—and leaves the hand there. Still she does not turn. WESLEY squeezes lightly once, twice. No more response than from a drowned child. He steps around her, stands before her (she being uphill now, is nearly his height), feels for her chin, rocks it toward him. Her mouth is open on her still harsh breath, her eyes are dry as sand; but they will not meet his. He finds no legible sign of her trouble.

<div align="center">WESLEY</div>

Please tell me what *hurts* you.

ROSACOKE

(Pauses, then draws her chin back down. Her voice is croupy) Nothing you can cure.

WESLEY

(Gently) You don't know that. *I* don't know that till you tell me your trouble.

ROSACOKE

If you don't know by now—

WESLEY

I don't know nothing about you, Rosa, and I've know you seven years. Six weeks ago you were so good to me, then turn yourself like a weapon against me; won't answer my letters, won't tell me nothing. (With both hands he takes her arms at the elbows, holds her firmly but kindly still) You don't have that right. Now come on with me. We got to go practice. Everybody's waiting. And Wesley is with you. (ROSA shakes her head 'No,' shuts her dry eyes which have not met his) Rosa, Willie has eloped. You got to take her part, or your Mama's show will fail.

ROSACOKE

(Eyes shut) Marise can do it.

WESLEY

You hadn't seen Marise lately, have you? (ROSA shakes her head again, but her eyes open now) Marise can't be in no *Christmas* pageant. She's swole up the size of that house with a baby.

WESLEY points to MR. ISAAC's house and ROSACOKE turns to follow his pointing.

SAMMY stands on the porch, looking toward them.

WESLEY waves to him.

###### WESLEY

It's all right, Sammy.

SAMMY waves, vanishes into the house.

###### ROSACOKE

(Slips from her throat; she is powerless to hold it)
No it ain't.

###### WESLEY

(Reaches for ROSA's clenched left hand, inserts his
thumb like a key. Her hand stays shut) What
ain't?

ROSA's hand opens round his thumb. She steps back
from him, her hands at her sides, twitching like nerves.
Her right hand jerks up to smooth her hair; then both
arms clamp down, rigid to her sides. She faces him
fully. Her voice is calm but immensely tired.

###### ROSACOKE

Marise Gupton ain't the only person working on a
baby.

###### WESLEY

(After searching her body with his still-calm eyes)
Who are you speaking of?

###### ROSACOKE

—Speaking of me.

They stand a long moment thus, four feet between
them. WESLEY looks slightly uphill toward the house
but sees only ROSA's exhausted face—drained of all hurt
now, numb to WESLEY for the first time in seven years,
her eyes on the empty road downhill. WESLEY is not
numb. His lips part to speak but wait open, while he
finds the slow and careful words to establish the only
truth he now needs.

WESLEY

Understand what I say—you don't know nobody
but me, do you, Rosa?

ROSACOKE

(Still looking slightly above and past him toward
the road) No.

WESLEY takes one long seamless breath, slowly releases
it, does not move toward her or try to touch but speaks
in a gentle whisper.

WESLEY

Well, come on then. We got to go practice.

He starts uphill to the right of ROSA—more wanders
than walks, still making no try to touch her. He has
gone ten yards before he knows he is walking alone. So
he stops, twists a foot in the hard white dirt, looks to
ROSACOKE—her left profile.

She hears his waiting, turns her head a little up to him.

WESLEY

Rosa?

He waits a moment, then continues to the car.

ROSACOKE turns and comes on behind him, slowly up
the hill, eyes to the ground, left arm straight down,
right hand gripped to the left elbow.

Five minutes later, ROSACOKE and WESLEY ride toward
the church, very much as they rode that November
night—not speaking, separate. ROSA is the still, passive
one now. She sits with her hands palm-up on knees that
have gapped apart to let her eyes bore through to the
floor. WESLEY's hands hang from the top of the wheel,
and his forehead presses almost to the glass. He does
not look to ROSACOKE yet. He is thinking, waiting till he

understands, knows what to say. They do not notice the land they pass—the trees and fields of their summer cycle-ride, their November night—and do not notice that they pass the church, slowly, and continue.

A few little boys, scuffling in the churchyard, stop and wave; one yells them back. They drive past MR. ISAAC's deepest woods now; and ahead on the right are the tracks to the spring—the path they took on their dark deer hunt.

WESLEY notices those and simultaneously knows words to say. He pulls to the side of the road beyond the tracks, kills the motor, looks to ROSA.

She assumes they are at the church and reaches for the door handle to descend, but WESLEY's voice is almost happy.

#### WESLEY
Rosa, how come you hadn't told me sooner?

#### ROSACOKE
(Realizes where they are, faces him bitterly) Take me to the church please.

#### WESLEY
We got to talk some.

#### ROSACOKE
I don't owe you two words—

#### WESLEY
—Wesley. Wesley. Say *Wesley*. It's my name.

#### ROSACOKE
Am I riding to Delight or have I got to go by foot?

He waits a long moment, meeting her eyes. Then he turns to the rear window.

WESLEY

You are on your way.

He backs into the tracks, turns the car toward the church and heads there again.

A few minutes later they approach Delight Church. The churchyard is empty of boys now—practice has started. WESLEY slows, drives past the building itself and turns into the entrance that swings them round by the ragged graves.

ROSA looks quickly to the MUSTIAN graves—her father's covered with fresh raw dirt, looking as new as the baby's grave where a few stark flowers lie rigid, frozen.

WESLEY stops his car away from the other cars, farther from the church; and while ROSACOKE still stares at the graves, he turns again to her.

WESLEY

Rosa, why hadn't you told me before now?

ROSACOKE

(Turned away) What good would that have done?

WESLEY

(Trying for a lighter tone) If I had had warning, I'd have spoke to Heywood Betts and we could have flew off with him and Willie to Daytona Beach for Christmas.

ROSACOKE

(Faces him) I have not been sleeping much. Don't joke with me. *Daytona Beach*—is that your idea of where to go to forget you're *grown*, and have been all the years I waited? You say I have turned like a weapon on you. *Weapons*, Wesley— I have laid down and got up and worked through

years with *you* here like a nail. (Pounds her own breast bone dully)

WESLEY has taken all that, full face—his left cheek, left eye twitching slightly. When she stops he hangs his hands on the top of the wheel, looks down a moment, begins very quietly as if to himself.

#### WESLEY

You ain't the only human made out of *skin*, Rosa. What you think all us others are, what you think I am?—asbestos? wood? (Looks up, faces her) I'm not; not now if I ever was. (He looks to her hands, laid again palm-up on her flanks; and he rings her left wrist with his own right fingers. They both study that knot of flesh through the rest) Listen. This much is clear—we will drive to South Carolina tonight when the pageant is over. That's where everybody goes. No wait for a license. Then we can head on to Myrtle Beach if it ain't too cold and get back here on Christmas Eve. OK?

#### ROSACOKE

(To her wrist and his hand) I'm not everybody. I am just the cause of this one baby. It's mine and I'm having it on my own.

#### WESLEY

Not a hundred percent yours. Not if what you said about knowing nobody but me is so.

#### ROSACOKE

It's so.

#### WESLEY

Then we got to leave here this evening. That's all.

#### ROSACOKE

It would break Mama's heart.

WESLEY

It'll break a lot louder if her first live grandbaby comes here lacking a name.

ROSACOKE

Hers isn't all that will break.

WESLEY

No, I guess not. I ain't exactly *glad* it happened this way myself, but it don't upset my plans too much. I have paid up all my debts. Every penny I make from here on is mine. We can live. Anyhow, we done this together and—

ROSACOKE opens her door, steps down, abandoning WESLEY in the midst of his offer. He sits a dazed moment, watching her walk slowly toward the graves; then he descends and follows her.

Once he has reached her, he walks two steps behind as she nears her father's grave, not looking back. Then, still walking, he tries again.

WESLEY

Rosa, I'm *here.* Do something about me.

ROSA walks another few feet, looks down at the graves of her father, MILO's baby.

ROSACOKE

(Looking down) Let me get this straight. You offer to drive me to South Carolina and marry me tonight in some poor justice of the peace's living room, then bring me home for Christmas with my family that will be struck dead by this second blow, then take me on to Norfolk to spend my life shut in rented rooms while you sell motorcycles to fools —me waiting out my baby sick as a dog—and pressing your shirts and staring out a window in

my spare time at concrete roads and people that look like they hate each other? (Faces him) That's what you are standing here, holding out to me, after all these years?

WESLEY

I never said I was anything but Wesley. All the rest, you made up and hung on me. That's one way of putting my offer; but if everybody looked at their chances like that, people would have gone out of style long since.

ROSACOKE studies him carefully now, steps back enough to see all of him—and finds she can see him without pain now; that as swiftly, mysteriously as it came years ago, it has now departed: his power over her. At last she can smile—and she does, gently, as she walks toward him, turns him with one hand and starts for the church, he walking beside her.

ROSACOKE

I have caused you a bad afternoon, I know; and if I have ruined your Christmas, I'm sorry. But I guess you have learned one thing you never would have learned on your own—that it's very lonely, donating things to people that they don't need or even want. (Smiles again and without irony) But you'll live; you'll be all right in a while. You have paid your debts; you don't have to bear no share of this load I brought on myself. I'm not saying I'm glad, Wesley, but I'm free. God knows I'm free.

Now they are at the side of the church. And WESLEY stops there. They face each other for what seems an end.

WESLEY struggles to find an answer, a wedge to split her resolve.

WESLEY

You are talking like the old Wesley now, Rosa-
coke.

ROSACOKE

I never knew there was but one Wesley.

WESLEY

Oh yes ma'm. There's Wesleys you never dreamt
of yet.

ROSACOKE opens her mouth to answer that, finds she has
no answer; then, lips still parted, she frowns in begin-
ning amazement—but is rescued, balked, by the sound
of the choir door opening (on the right side of the
church, toward the back). She looks toward the sound.

What emerges, takes the three steps slowly, looks at
first like a holly tree. Then it starts toward them and is
LANDON ALLGOOD, his arms full of holly.

When he is some ten yards away, WESLEY speaks to him
almost cheerfully.

WESLEY

Where are you taking all them greens?

LANDON

They is just some little Christmas greens for Mary,
Mr. Wesley. She decorating for Mildred's baby,
and it don't know holly from horses' harness.

WESLEY

How old is it, Landon?

LANDON

I don't know, sir. It won't walking last Tuesday
though.

ROSACOKE

His name is Sledge and he came in late July.

**WESLEY**

(To ROSA) That long ago?

ROSA nods in answer but quickly looks to LANDON.

**ROSACOKE**

I got to go practice, Landon, but here—let me give you this. (Begins to delve in her coat pockets)

**WESLEY**

What you hunting, Rosa?

ROSA does not answer but continues her search.

LANDON smiles to WESLEY and explains, whispering.

**LANDON**

Sometime she give me a dollar for my medicine I needs. (Abandons her search)

**ROSACOKE**

—But I haven't got it now. My purse is at home. Come by the house on Wednesday, Landon.

LANDON nods, smiling; bows as if to leave.

**WESLEY**

(Reaching for his own hip wallet) Wait. Here's your dollar.

**ROSACOKE**

(Firmly) *I'll* give it to him Wednesday.

**WESLEY**

(Half-smiling) Maybe you won't be here Wednesday.

**ROSACOKE**

Where am I going. (A fact, not a question)

But WESLEY, cheered by a chance to help, has produced two dollar bills from his wallet and stuffed them into LANDON's pocket (as LANDON's arms are full of holly).

WESLEY

That'll cure a heap of toothaches.

LANDON

Many-a-one. (Bows deeply on his holly) Thank
you, sir. Thank you, Miss Rosa. (Nods from ROSA
to the graves. ROSA follows his eyes there to her
father's grave) I been spreading new dirt on your
Daddy where he sinking.

ROSACOKE

I noticed you had. Thank you, Landon. (She
moves as if to head for the church steps)

LANDON

Yes'm. And Miss Rosa? (ROSA turns and waits for
him) I am mighty sorry for you.

ROSACOKE

(Carefully, a little fearfully) What do you mean?

LANDON

(Nods again toward the graves) Your baby that
died.

ROSACOKE

(Frowning deeply) It was Milo's boy. *Milo's* boy.

LANDON

(Unperturbed by his error) Yes'm. I wish you a
happy Christmas. (Bows to ROSA) And you, Mr.
Wesley—you deserve a good time.

WESLEY

I'm working on it.

LANDON moves away.

ROSA starts toward the church.

WESLEY follows her closely for three or four steps, then

stops her again with a hand on her shoulder. She faces him, patiently but distantly.

<div align="center">WESLEY</div>

You know I'm serious, don't you? (ROSA studies him a moment but looks down, unanswering) You got all evening to think it over. Tell me tonight.

ROSACOKE faces him but does not answer. Her look is a final search of WESLEY, not a sign of intent; and when she turns from him and walks to the church, she thinks she has left him for good.

WESLEY stands, watches ROSA leave him; and we retreat till we see them both—their backs seeming suddenly small, frail. As ROSA reaches the front-door steps, a distant out-of-tune piano creeps into the start of a tune and suddenly there is BABY SISTER's voice, high and pure singing—

<div align="center">BABY SISTER'S VOICE</div>

Joy to the world!
The Lord is come!

ROSA enters the church.

*5. Night of the same December Sunday. The pageant has just ended, and during it Rosacoke as Mary has resolved her answer to Wesley—"Yes." But she has not told him—only Frederick Gupton as the Baby Jesus.*

A quarter-hour later in the crowded churchyard, ROSA-COKE stands at the passenger window of the GUPTONS' truck.

MARISE is seated inside with FREDERICK, the window half-down.

ROSACOKE

He did fine, didn't he?

MARISE

He did real well.

ROSACOKE

I thought I'd scared him that one time though.

MARISE

(Talks to FREDERICK, asleep in her arms) Oh, I don't know. He may have had a bad dream. He dreams a lot.

MACEY walks up, followed by the three GIRLS all in their worn coats and knitted caps.

MACEY

Rosa, we made it through one more year.

ROSACOKE

Yes.

MACEY

Frederick near about threw in a monkey wrench when he started howling, but you got him calm; and anyhow, Jesus done a lot of crying. In *my* Bible, anyhow.

The GIRLS are loudly climbing into the truck bed, wrapping themselves in quilts for the ride.

ROSACOKE

(Turns to move away) Well, Merry Christmas all.

MACEY

Thank you, Rosa.

ROSA looks to MARISE but she is entirely concerned with FREDERICK.

MACEY

(Climbing into his seat) Tell Rosacoke 'Merry
Christmas,' Marise.

MARISE

(Looking up vaguely, finding ROSA's face) We'll
be thinking of you, Rosa.

MACEY cranks the truck and rolls away, leaving ROSA
alone in the dark churchyard, the other cars mostly
gone now, the few stragglers at a distance from her. She
looks around for a useful face.

She sees SAMMY RANSOM and MR. ISAAC in his arms,
heading for their truck.

Then suddenly there is WESLEY again, bareheaded now
in his suit and tie ten yards away, facing her, hands at
his sides, stock-still, waiting. For a moment they si-
lently, gravely look.

Then before they are forced to speak, MAMA speaks—
standing by the MUSTIAN car across the yard, MILO and
BABY SISTER waiting beside her.

MAMA

Rosacoke, are you coming with us?

ROSA looks to MAMA.

Then she looks to WESLEY.

WESLEY turns to MAMA.

WESLEY

I can carry her.

MAMA waves silently, turns to the car; and MILO and
BABY SISTER follow her.

WESLEY faces ROSACOKE, then moves toward his own
car, walks three steps, turns back to her.

**WESLEY**

I can carry you.

ROSACOKE nods and goes to him, and—hands separate, a foot apart—they go to his car.

# THE END

*1964–65, 1969*

# NEWS FOR THE MINESHAFT:

## AN AFTERWORD TO

## A GENEROUS MAN

I DON'T INTEND mystery or mischief in saying
that the meaning of *A Generous Man* is itself—its
physical shape, which is both the product of its mean-
ing and the container, limiter, protector; the shell of
the crab (though the crab can slough its shell and
grow). I say it in order to start with a minimal ac-
curacy; and I'd expand first by claiming that anyone
who has chosen to read it at all can discover its full
content in how-it-looks—not in what it says, least of
all in "what it says to you" (that bloodless scrap so
often flung by exhausted artists to the gaining wolves).
The famous little girl in Graham Wallas' *Art of
Thought,* warned to think out her meaning first, says,
"How can I know what I think till I see what I say?"
And Wallas says she has the makings of a poet. The
makings, granted—her crucial verb is *see*; but had she
been a poet, she would certainly have substituted *you*
for the first and third *I.* Tolstoy said it impersonally,
"This indeed is one of the significant facts about a
true work of art—that its content in its entirety can
be expressed only by itself." I labor what may seem a
thundering cliché because it is not honored in spirit—
as any American novelist will affirm who has skimmed
his potential two-hundred reviews or has had the hair-
raising experience of looking into the quarterly fiction
studies. In fact, I can think of only one contemporary

critic, since the death of Erich Auerbach, who has made it his steering principle (any critic who is not himself a novelist or poet)—H. D. F. Kitto, in *Greek Tragedy* and *Form and Meaning in Drama*—and he has quietly proceeded through Greek drama, producing startling illumination from a single assumption which, though he applies it only to drama, he holds valid for all other forms—"If the dramatist had something to say, and if he was a competent artist, the presumption is that he has said it, and that we, by looking at the form which he created, can find out what it is." *

The meaning therefore, for the audience or the artist himself, cannot be complete until the work is complete. This is not to say that the artist works automatically, unconsciously, without plan or continuous conscious control. It does say, though, that the plan for any work of the necessary length and complexity of a novel will (and must, for the sake of truthfulness and vivacity) undergo an elaborate and apparently uncontrollable bombardment of accident, accretion, whim—in addition to the more astonishing and satisfying discoveries of secret relations, the secret autonomous life of the story itself, its concealed fecundities (which will proceed in part from those accidents).

That process of continuous growth in the idea and shape of *A Generous Man* is, for me, most nearly recoverable now in the progressive titles which I find in the manuscript. The first page is dated 21 January 1964; the title is *A Mad Dog and a Boa Constrictor*. I kept no orderly notes for the story, as I had done—voluminously, a year in advance—for *A Long and*

* H. D. F. Kitto, *Form and Meaning in Drama* (Methuen, 1956), p. v.

*Happy Life*; but my memory is that the story surfaced as I lay in bed, insomniac, one night in January '64, still beached like many others by the backwash of John Kennedy's murder. What in fact had been beached was not so much me as the novel I had worked at for two years before, a story of waste and panic in which I had personal stakes, suddenly harmonious with recent events yet doomed by them, inaudible now as a clavichord note in a *Wozzeck* fortissimo. And what arrived that sleepless night—clicked up instantly formed in my head—was a story which seemed an antidote, a way back to work. The given was two tales, till then unrelated, which I had known for years—a runaway circus-snake and a mad dog whose rural owners set it free to rave (they could neither kill it nor watch it die slowly and would not pay a vet)—and my immediate grateful decision, seconds later, was that both tales were comic (the snake would be caught, the dog not actually mad); that both could be yoked into a single story by the Mustian family, the central family of *A Long and Happy Life* (1962) and of my second short story "A Chain of Love" (1955); and that the central figure now would be the elder Mustian son, Milo. The story, I thought, would be brief—eighty pages— and essentially a farce for my own good cheer. It would also, I thought, be easy work.

So within the next day or two I began, with very little more forethought than I've mentioned—the bones of a story, a set of characters ready-made and well-known for ten years. The title was as simple as the impulse seemed—*A Mad Dog and a Boa Constrictor*— and I rattled along through the early pages at, for me, a brisk clip (twenty-three pages in the first thirty days; a finished page a day is good speed). My initial aim was being fulfilled—for the first time in more than ten

years of writing, I was working with pleasure; without the reluctance, the neurotic obstacles which all craftsmen (Mozart and Handel excepted, apparently) strew between themselves and the desk (obstacles whose absence I have now come to fear, they being the surest danger signs that I'm nearing a center which shrinks from touch, the flesh puffing madly around the sore). I should have been apprehensive but I wasn't. In my gratitude to be at work at all, I was only delighted.

And the first eighty pages exhibit that delight, in their larger shape (the quick tumbling of scenes; scene hitched to scene more tightly than appears, by outrageous surprise); in a quality of action (the literal movement of characters through space) balletic and clear-lined, whose faith is that, in the young characters at least, gesture and movement is revelation, that they cannot *lie* so long as they move (a quality of course which is at the mercy of each reader's sight, his willingness to yield to coercion from me and make his own sights from the actions offered); in the archeology of character (the creation of pasts for characters whose futures I had long since fixed); the guying of as many as possible of the sacred solemnities of Southern fiction, my own included (from the bow to *Tom Sawyer* in the opening sentence on through the humble but noble dog, the pathetic idiot, the sanctity of blood and name—"We use the names they give us, that's all. They called me Milo so that's how I act"—the hunters who think they are chasing bear or boar but end with nothing more edible than Beauty and Truth in their gassy bags, the young stud watering some parched lady's life); most intensely, in the rhythm and rate of language, the conversion of mid-South farm-dialect into forms and meters which appear, I think, natural but are thoroughly made from the inside by pleasure

—a sentence in the meter of the *William Tell* Over-ture (so far undetected, page 4); * scenes as on pages 11–15, which have both a mirror-accuracy to this family's life and a striking resemblance, in form at least, to Rossini's scenes of comic confusion (the sextet in *L'Italiana in Algeri*) or the swirl of *ariette* in Verdi's *Falstaff*—three lines of passionate fun per man, which lay his life open to public view.

Yet there seems to me now, in those early pages, a high almost desperate pitch to the playfulness. Quite early, rifts begin to yawn in the farce and the buried strata are slowly revealed—though I did not know it, the theme was *loss*. My old abandoned impulse was asserting itself, humping up beneath the surface glaze —waste and destruction in their homeliest forms (the apparent loss of a dog to disease, remembered loss of a son-and-father to alcohol, the sudden separation by roaring adolescence of brother and sister, a drunk vet's drowning in loneliness, a woman's snake and chief means of support vanished, a middle-aged sheriff still panting to catch what he'd never had or earned—the love of his wife—and more). And the forms are progressive, dogs to men.

My working-title had changed by then (the end of part one). The manuscript does not show a date for the change, but it must have occurred between pages 48 and 67; for by page 67, I have twice used the phrase "clear day." The first time, without apparent intention of special weight for a common phrase—

Eyes still shut, his mouth burst open on the surge of his joy, the sudden manhood that stood in his groin, that firmed the bones of his face and wrists

* All page references are to the first American and British editions of *A Generous Man* (Atheneum, 1965; Chatto & Windus, 1966).

as the truck bore him on through this clear day among his family, his first known girl, toward his life to come, his life he would make for himself as he wished. (p. 48)—

but at its recurrence, twenty pages on, in Rosacoke's dream of Milo's new manhood, with a sense, for me at least, of gravity, freight—

She said, "You will die and ruin us, Milo." He said, not looking, "I am almost a man. I must fall to rise." He jumped and he rose and the last she saw—before she woke—was him rising not falling as he had foretold, above limbs and leaves into steady light, a single figure in clear day alone, no thought of when that day might end. (p. 67)

By then or within the next few pages (six months after the candid beginning), I had made the phrase my title—*Clear Day*, to which I added a protective description, *an escapade*. That remained my title, through the end—October '65—and the book was announced thus by Atheneum, though by early that fall, I had begun to face the need for a change. A musical play had been announced for New York, called *On a Clear Day You Can See Forever*. The papers were calling it *Clear Day*; and I know exactly the spot where I heard, on my car radio in the voice of Robert Goulet, its title-song—"On a Clear Day"— and admitted to myself that I was cornered and must change or risk confusion as "the book of the show."

Few readers understand the importance of titles and names to writers. It is difficult to discuss them at all without sounding precious or fraudulent; but surely what is involved is no stranger than the ancient and continuing magic of names—our names are organic to

us, handles to our lives, vulnerable heels; chosen for us before we were born and our surest survivors, in an age of records. We all spent solitary hours as children, saying our names aloud until they metamorphosed from familiarity through abstract sound to final mystery, essence—so with a novelist who has spent two years or longer with a carefully named set of characters and with a satisfying title on his manuscript. The prospect of change is the threat of loss—name is essence and can be lost. A changed name will be a diminished name. (I remember my confusion and revulsion when, as a child, I learned the true names of several famous film stars. The apparent ease with which they had shed them seemed then—and now—a frightening display of gleeful self-hatred. And one of the real crises of my career was the discovery, after years of use, that the male hero of *A Long and Happy Life* shared names with an elderly citizen of my town and that I might be required to change the name of a character I'd invented six years before—the man, approached, cheerfully gave permission for the use.)

Why had *Clear Day* insisted upon itself so early in the work and why at the end was I so reluctant to discard it? Habit—after eighteen months, I was used to the name. But also a weakness for its easy attractiveness of connotation. A clear day is a welcome experience. So is *calm sleep* or *steady love*. (So, supremely, is *a long and happy life*, though that bears a crippling sting in its tail.) And when I began to search for new titles, I at first turned up a series of approximations— *A Full Day, First Light, Morning Light, A Given Day, A Perfect Day, Fair Day*—and was near to settling on *Morning Light*, only to discover that H. M. Tomlinson had preempted the title. None of the others chimed. I was worried and since I was deep in revising the text, I

tried to discover the meanings which *Clear Day* had collected, for me and for the story. This is not to say that I had not known its meaning since at least page 80—sixteen months before—nor that the phrase, once chosen as title, had not exerted its own control, tunneling always only just out of sight, surfacing at moments of intensity as sign and reminder, almost warning—to the characters, to me, to the future reader—that this story was steered, not hauled or pushed; and steered by a steady vision of Milo, the boy at the center, the pitch of his youth.

But more than his youth—I saw, looking back. The pitch of his life.

A consecutive list of the chief passages, beyond the two already given, which contain the phrase *clear day* (with its related words—*morning, afternoon, night, day* or the adjective only) would reveal—I saw, with some surprise—the spine of the story, the linked control:

> Rooster said "What's the time?"
> "Maybe eleven twenty-five."
> "And you think it's morning?"
> "For half an hour—sure."
> Rooster said "What's your age?"
> "I told you—fifteen."
> "And you think that's young?"
> "Well, I've met one or two older people through the years."
> Rooster said it to the road. "It is eleven twenty-five, a clear broad morning that will be noon soon. You are fifteen, a man and the Lord has hung gifts on you like a *hatrack*. . . . Don't think it's morning when it's late afternoon." (pp. 85–86)

[Milo] did not hear (he was whirling on down), but blinded and weak, he did feel her gaze, accept her hopes and turn them in his mind to a momentary dream—Lois at last, clear in perfect nakedness, waiting on a porch as he moved towards her, answered her smile, extended his open hands to hers and heard her say, "I have been afraid, waiting in the dark. I have kept my promise. Why have you failed? You said you would come to me long before night." He answered, "Night? It is still clear day" but looking up, saw it was really night, that the light was from her, her readiness, so he said, "I am sorry. I was tending to duties but now I am here and look, I am ready." (pp. 160–161)

[Rooster] thumbed towards Milo. "He's had his day." (p. 211)

"But don't stop with taking," Mr. Favro said.
"I ain't," Milo said. "I been learning things— but I told you that. These past three nights, these two clear days. I been handing out stuff like the whole Red Cross, like loaves and fishes to people on the hills." (pp. 254–255)

So Rosa looked to Rooster—"Maybe this is the end?"
But Rooster looked to Milo, answered to him. "Could be I guess. What could *keep* it from being? You've had *your* day. Maybe I've had mine— maybe never will." (p. 256)

But Milo paused above her on arms as straight as what stood ready beneath to serve, looked at her eyes—only them, nothing lower—and said un-

smiling, "I have heard that the saddest thing on earth is to love somebody and they not love back."

"So have I," she said and by smiling fully, forced him to smile, then rocked the heel of her own tough hand in the pit of his neck (where nerves pierce the skull) and drew him forward, welcomed him down, and the rest was giving— pure gift for both, no thought of receipt though receipts poured in so long as they worked, as if fresh joy could flood your thighs, stream down through your legs, drown your heart, gorge throat and brain, offer (even threaten) a new clear life (so long as you moved) and yet roll on, roll past, leave you spared. (pp. 265–266)

But Rato turned, faced Milo, grinned. "Morning," he said.

"Morning," Milo said. Then they both looked up to the lifting sky—Lois followed their eyes— and found they were right. It was morning (clear, cloudless, the oldest gift), would be morning oh six hours yet. (p. 275)

The phrase had become, since its first uncalculated appearance, both a controlling and a fertilizing device. It had become—without, I am almost sure, conscious knowledge by me—the emblem of the fullness of the impulse. Whether it was an initial fullness or a gradually gathering one, I cannot say. It was certainly one which I neither anticipated nor understood when I began the story. And an emblem of more than its fullness—its truthfulness. Truth to the final seriousness, even grimness, of a story I had thought was farce and to the shape of a quickly changing character—the boy Milo's—as he reaches (in three days) the height

of his manhood, poises in clear broad day, descends
(descends, not falls).

I had seen what I had not quite seen before, in
the nearly two years since beginning the book (two
years which include a ten-month gap at the comma
in the penultimate line of page 172)—that the story
had made itself, and well (clearly, economically), in
response to its own impulse and needs. What must
go without saying is that it responded also to needs of
mine; to observation of life around me in those two
years; to personal bafflements, pleasures, and defeats;
family deaths. I do not mean to play hierophant in
barring the entrance to that one cave. It still contains
matters of the greatest force and urgency for my daily
life. I only confess my inability to talk sense—truthful
usable sense, anyhow—about a process so gradual, com-
plex and irrecoverable. Inability, and lack of curiosity.
The *story* exists, is the thing that matters—existed,
whole, as I searched it for a title. And the things which
I saw it saying most strongly of Milo's life were in
Rooster's voice. First, his early warning, "Don't think
it's morning when it's late afternoon"; then his grim
summation almost at the end, "You have had *your*
day."

So he had—Milo—and the sense is heavy at the
end (the final passage above is the end) that it was
his last day, that—in Donne's use of the same meta-
phor—"His first minute, after noon, is night." The
final light of the book is still morning, but morning
for only "six hours yet." A limited sentenced strip of
day is what is left him as he turns from his vision,
vague as it is, of a new clear life toward his home again,
his ravenous duties at his old—and future—mill, which
in nine years' time will have left him the charred and
raucous figure of *A Long and Happy Life*.

But, ended as it is, it had *been* day at least (three days in fact, Saturday to Monday). A number of witnesses realize that—the sheriff, his wife, Rosacoke, Lois, Selma. And what a day—the single moment when Milo stood ready to offer freely, with rushing plenitude, the virtues he had earned or had laid upon him; virtues called from him by the shape of the story, the demands of every event and meeting. It had been, I saw, his manhood, not his "coming to manhood" as might appear.

So my search for a title was colored now by my retrospective findings; and the list of prospects lengthened—*The End of Day, First Dark, The Midst of Day, A Generous Man.* That the last was best, I would still maintain—as the fullest flag for the whole—though I didn't see a notice of the book which actually considered the title, and only a few which accepted its clear offer of news. (How many readers accept and use the fairly indispensable help offered by such titles as *The Great Gatsby* and *Rabbit, Run?* An attempt to measure the degree of irony, if any, contained in that *Great* or the realization that the title of Updike's novel is an imperative, almost a plea, by author to hero, would carry a serious reader a good deal farther than he might otherwise go toward the core of the books. So, conversely, might an attempt to rename a supreme but misleadingly named book, like *Anna Karenina.* Maybe *Happy Families?* or Tolstoy's early title for it, *Two Marriages?*—either of them considerably more accurate and helpful than his final eloquent choice.)

I had called *Clear Day* an escapade, when I thought it was one. Perhaps I should have called *A Generous Man* a romance. If I had ended at what

might appear a possible point, on page 244, the end
of part two (with a further phrase to clarify that Milo
had fainted, not died), then I would have had a story
that answered the classical tests for prose romance—a
mode common from the first century to the present,
deriving apparently from the *Odyssey* and New Com-
edy, in which stylized characters capable of allegorical
expansion move through "strange adventures, separa-
tions, wanderings across seas and lands, rescues mira-
culously effected, dangers overcome and trials passed,
until the final triumph of reunion with loved rela-
tives." * But surely the minimal requirement for ro-
mance is a happy ending—Daphnis and Chloe married
and bedded; Prospero restored to his dukedom a wiser,
more merciful man; Ishmael alive in the wreck of the
*Pequod*, planning his book; Catherine and Heathcliff
joined in death on their rightful moors; the curse of
the Pyncheons laid.

Hawthorne's own definition of romance, in his
preface to *The House of the Seven Gables*, is disap-
pointingly exterior—

> When a writer calls his work a Romance, it need
> hardly be observed that he wishes to claim a cer-
> tain latitude, both as to its fashion and material,
> which he would not have felt himself entitled to
> assume, had he professed to be writing a Novel.
> The latter form of composition is presumed to aim
> at a very minute fidelity, not merely to the pos-
> sible, but to the probable and ordinary course of
> man's experience. The former—while, as a work
> of art, it must rigidly subject itself to laws, and
> while it sins unpardonably so far as it may swerve
> aside from the truth of the human heart—has

---

* Ernest Schanzer, introduction to Shakespeare's *Pericles*
(New American Library, 1965), p. xxxi.

fairly a right to present that truth under circumstances, to a great extent, of the writer's own choosing or creation.

But whatever a writer's reasons for choosing the form *romance* or, more probably, for producing one and then discovering he has done so, his basic strategy in prose romance will have been wish-fulfillment; or more exactly, the arousal and examination of a number of our oldest fears—that we are not the children of our parents, that lovers may be permanently parted, that nature is indifferent if not hostile—and then an at-least-partial allaying of those fears, a granting of our deepest needs: Here is your long-lost father / wife / daughter / beloved. All is well. The gods are not mocked.

All that could be said of *A Generous Man* at the end of part two. The dead have worked through their blood-relations—and beasts and extraordinary events—to right their wrongs; old debts are paid by a golden boy who never incurred them; relations are clarified through recognitions; forgiveness, comprehension, gratitude abound. They sometimes do in life—and to that extent the romance is "realistic." There is however a third part, thirty pages. Renunciations, further (and final) separations, a grim future seen, a grim present faced, its demands obeyed—and all that, not nailed on by a willfully sadistic author but inherent in the characters, their actions, the world.

So perhaps not *romance*, despite a passage in Northrop Frye's *Anatomy of Criticism* which tends my way (and the ways of Alain-Fournier, Kafka, Ralph Ellison)—

Certain elements of character are released in the romance which make it naturally a more revolutionary form than the novel. The novelist deals

with personality, with characters wearing their *personae* or social masks. He needs the framework of a stable society, and many of our best novelists have been conventional to the verge of fussiness. The romancer deals with individuality, with characters *in vacuo* idealized by revery, and, however conservative he may be, something nihilistic and untamable is likely to keep breaking out of his pages.

Yet *A Generous Man* is not a novel—its resemblance to Japanese Noh drama or to *The Magic Flute* is closer than to most twentieth-century fiction—and permitting it to appear as a novel only confirmed some readers in their suspicions that I had intended to write the previous history of the Mustian family in the realistic mode of *A Long and Happy Life* and had, early in the job, lost all control. A python capable of conceptual thought; a ghost who assists at a flat-tire change, then attempts a murder, then repents and leads the way to a lost fortune; a teenage palmist who foretells the plot of *A Long and Happy Life*; all accepted as apparently unexceptional by characters observed "realistically," recognizably the cast of an earlier sane novel—the man's lost hold.

Not this time. The form of the theme was new and different, and had taken hold. (The Milo of *A Generous Man* stands in roughly the same relation to Milo of *A Long and Happy Life* as Stephen Dedalus in *Ulysses* to Stephen in *Portrait of the Artist*.) The theme, I have said, was—for its own reasons and mine —*loss*. But loss in the midst of plenty or at the sudden end of plenty; loss-in-*time* too (three days' time)— *absence* before he had realized *presence*. The presence —of all Milo's resources and his use of them—had

been, as their counterparts are in any person, miraculous; that is, inexplicable in terms of our present knowledge of heredity, environment or training. The form of his story is therefore miraculous. Laws are suspended, laws of the European and American realistic novel and those physical laws which, in fiction or in life, are our most elegant walls against the large world—that terrible, perhaps even benevolent world which turns, huge, around and beneath our neater world which agrees to forbid it. The dead, incompletions, the past which is future. And *A Generous Man* proceeds under no law except its own—the demands of its meaning, demands of the large world to deal with ours. Demands which are met by the shape of the story; the resistance and yielding of character; finally, by language, the irreducible medium and servant and guide of the meaning.

There are, strangely, many readers who respond to the language of an elaborate work of fiction with considerable bluster and attempts at suppression. In fact, the long history of art and manners might be seen —and not entirely misleadingly—as an endless knock-up between the plain style and the elaborate. The good old days when men were men, could say what they meant in ten puffs of smoke and wore linsey-woolsey against all weather—Aeschylus vs. Euripides, Athens vs. Alexandria, Giotto vs. Bernini, Hemingway vs. Faulkner. Surely it might have been clear by now that, in serious verse and fiction, the language (in its atomic structure of syllable, meter, order) proceeds from the pressure of the entire given impulse as it shoulders upward through one man (his unconscious mind, his conscious, his training, his *character*) and will therefore bear the marks, even the scars, of its unique journey. When Shakespeare writes, in *Pericles,*

> *She speaks,*
> *My lord, that, may be, hath endured a grief*
> *Might equal yours, if both were justly weighed.*
> *Though wayward fortune did malign my state,*
> *My derivation was from ancestors*
> *Who stood equivalent with mighty kings:*
> *But time hath rooted out my parentage,*
> *And to the world and awkward casualties*
> *Bound me in servitude,*

and when Milton writes, in *Samson,*

> *Great Pomp, and Sacrifice, and Praises loud*
> *To Dagon, as their God who hath deliver'd*
> *Thee, Samson, bound and blind into thir hands,*
> *Them out of thine, who slew'st them many a slain,*

what is at issue is not clarity vs. murk, sincerity vs. artifice, but fidelity to an impulse, a willingness by the poet to display language which bears whole strips of his skin and entrails (because they are *his* entrails for good or bad, what he has to offer), and a refusal to contract with readers-on-horseback, racing by.

Or—another way—lines like

> *non sapei tu che qui è l'uom felice?*

or

> Before Abraham was, I am

simple as they sound, may express even more complicated realities than

> *But ah, but O thou terrible, why wouldst thou rude on*
> *me*
> *Thy wring-world right foot rock? lay a lionlimb against*
> *me? scan*
> *With darksome devouring eyes my bruisèd bones?*

But the clear terror was produced by Dante and Jesus, the turbid by Hopkins. You may have strong reasons for thinking that the first two achieved larger, worthier ends; but you cannot therefore dismiss Hopkins as obscure, mannered, self-intoxicated, any more than you can dismiss a turtle for failing to win the Kentucky Derby. *You* staged the race and entered the turtle against his will and his nature. Your duty—if you mean to read at all and not just clock winners—is to discover the exact race which Hopkins has entered, the goal he approaches, and only then to judge his performance over his own course.

That is not to claim that all language produced by all artists is equally acceptable and could not admit change. The implicit threat to plain-style is oversimplification; to the elaborate, fancification—both, forms of lying; the only error in art. And, more particularly, any process which is both so sudden and slow, and still so mysterious as inspiration is vulnerable to any number of accidents, from flu to madness, along the chain of transmission—accidents which will be almost impossible to hide. The weaknesses of Shakespeare's character are as clearly on show in every hundred lines (for all his track-covering) as Rimbaud's in all the *Saison en enfer* or mine in *A Generous Man*.

For the language of *A Generous Man*, so far as it differs from the "language really used by men" (what men? and when?—you? now?) in complexity, density and compression, is neither a style nor a manner as either is generally understood nor a series of calculated effects nor the appliqué of decoration (raising the rural tone a notch). It is the literally reflexive response of all my available faculties to the moment at hand—a boy's first drunk, a girl's nightmare, the boy's sudden possession by an unfinished past—and to my

vaguer sense of a total vision and structure, the story. The voice of the story is—with all faults of intonation and detail—the vision of the story.

This is not to say that I take no conscious care of language. It is the largest care I take (the other things, for better or worse, occurring beyond care); but—aside from obvious editings, omission of repetitions; the choice of a monosyllable here, a disyllable there, for sinew or speed—it is not a care directed toward elegance or memorability of diction. I never think, "This is a Price story and had better start sounding like one." What I think is roughly this (and it is really never a conscious thought)—my job is to make a language which is as faithful as my gift and craft permit to the complexity of knowledge and experience, the mystery and dignity of characters and objects, unearthed by this story; and finally, as clear and as quickly communicative as those prior fidelities will allow. (If you object that my argument rests on examples from verse and proves nothing for prose, which is traditionally the plainer medium, I'd want you to show me, on the hinges of the world, the law which says that prose cannot respond, like verse, to the full demands of its subject and the nature of its author.)

A *Generous Man*—read through now for the first time since passing proof three years ago—stands for me, at a possible distance, as a story told, an object made. Another three years might well bring it down around my ears (so they might the world); but now, though I don't claim perfection for it, I can say that I do not find a sentence I would cut or change. I think it is right, in the way it needs to be; and the question, I suppose, for a serious reader—who has somehow de-

cided to spend several hours of his life going through it and has got to the end—is then, *So what?* What was it doing? Did it do it well, in terms of its aim? Then, did it seem worth doing at all, with such care, in a world already choking on books (warehouses stuffed with Lord's Prayers on heads of pins)? You realize of course that it means to change your life? Has it made you begin? Would anything, anyone?

There are smaller questions which might follow those. How difficult is it for a reader not familiar with rural life in the American South to respond with serious attention to characters who speak and act in a dialect and manner which is simultaneously the manner—however coarsened—of a long and continuing tradition of comedy now most visible in Li'l Abner and the Beverly Hillbillies? Has "the South" been fouled beyond use, for now—and not merely by caricature but by its own follies—as a source of serious comedy? Aristophanes in Athens? (My faith is that existence is—or will prove to have been—comic and that a serious writer can use any matter which he knows and needs to know, in which he imagines a whole design.) Was it, on balance, an error to use the Mustian family in a work whose conventions are so nearly incompatible with earlier work in which they appear? (I hope I have answered that. Milo's early life —his quick manhood—was different in kind, not merely in degree, from the rest of his life. So is the youth of most men—in all times and countries known to me, at least. Teach for a few years if you doubt that. Watch a group of students be eighteen, then twenty-two. A *Generous Man* may have been my "college novel.") Was it an error to call the snake *Death* and send the symbol-hounds howling down dark trails that ended blankly?—not however before they had raced

past, or over, the sense of the book? (Maybe it was. Maybe I should change the name. I meant it first as a joke-in-character. What would you call a twenty-foot python that you showed for a living at county fairs?— what better than *Death?* Then other jokes followed— "Death is dead" etc.—and I let the name become one more nail in the coffin I was building for the great Southern hunt: what are you boys hunting? Death, what else? I trusted the wit of the audience.)

The final question, from reader to writer, might be, "There you stand with a smile on your face (or writhing at my feet). Explain and justify. Just what have you achieved that cheers (pains) you so?"

Today's answer might be, "The smile is of puzzlement, not satisfaction, and will not wipe off." Mr. Ramsay thinks in *To the Lighthouse,* "The very stone one kicks with one's boot will outlast Shakespeare." Quite possibly—though with the bomb on stock since Virginia Woolf's death, Shakespeare's chances are considerably improved. You could store him safely in an Arizona mineshaft; the stone's in trouble, though, like you and me. So the smile (if not the writhing) is apparently for that—that *A Generous Man* will clearly outlast me and everyone alive as I write this line (so will my cufflinks). What else will it outlast and what will it say to whoever lasts with it or oars through drowned space to find it in the rubble? Would it be enough?—a jawbone sufficient to remake the old ass, and plan a new?

1967

# PYLON

## THE POSTURE OF WORSHIP

MOST GOOD NOVELS, however they triumph over life in their orderly structure and clarity of language, will obviously complicate and enrich themselves on second readings—returning, as they move, to a truer imitation of human life; growing more mysterious as they are contemplated, mirrors which cloud from behind or whose depths deepen. (*Anna Karenina* —which seems at first like a broad river uncovering, washing, revealing all life—can come, on successive readings, to seem more mysterious than Kafka or the murkiest Dostoevsky. What can they offer which is stranger, more menacing, than this sentence from Anna's last monologue?—" 'No, I will not let you torture me,' she thought, addressing her threat not to him nor to herself but to that which forced her to suffer, and she walked along the platform, past the station buildings.")*

Some of Faulkner's strongest works move in that direction, from apparent lucidity toward opacity—*As I Lay Dying; Light in August; The Hamlet; Go Down, Moses*. But as many or more of them reverse the movement in that they clarify, simplify (sometimes oversimplify) on second reading. They are initially thickets, forbidding puzzles, which mount a great show of threat

---

* Leo Tolstoy, *Anna Karenina*, translated by Louise and Aylmer Maude (Oxford, 1933), II, p. 379.

or at least of indifference to solution—indeed, to mere reading—but which, if one makes a commitment of will, surrender their secrets with grateful and alarmingly loose-limbed ease (secrets which occasionally prove to have been no secrets at all).

*Absalom, Absalom!* is—its admirers insist—the most richly rewarding of Faulkner's bristling puzzles; and certainly *The Sound and the Fury* will not yield its staggering load to any straight-line reading (it demands to be read in all directions, at once). A *Fable* seems, on the testimony of its survivors, to be all puzzle; its final secret a puzzle—why was it done at all? But *Pylon*—though it is usually waved aside as Faulkner's second-worst novel (it is his eighth in order of composition) and though even its few defenders do not succeed in making its solution (*their* solutions, symbol-logged) seem grandly worth the effort—does yield curious and (for Faulkner) unique answers to a second reading. While not so complex as it looks, it is a more interesting book than it promises to be, and finally a surprising one—touching, oddly lovable, more needful of us than we of it.

Any tenth-grader can see, at first glance, what its weaknesses are—the willful havoc with grammar and spelling, the homemade artiness (the resort to Eliot and Shakespeare in chapter titles, the tired stream of unilluminating compounds and obstructive neologisms, which even in 1935 must have been old hat); the flirtation with objects and events which appear to be gathering emblematic functions but which finally are abandoned, unemblematic debris (the pylons themselves; the time of the novel—Mardi Gras, the entrance into Lent, time of mourning and repentance preceding rebirth; the airplanes as numinous receptacles of *eros* and *thanatos*); the coyness in refusing ever

to reveal the name of the chief character and the resulting confusion in passages involving several men, all referred to as *he*; the failure to distinguish by rhythm or diction between the interior monologues of the few characters who think at all—or between their thoughts and those of the narrator-author; and the placing cheek-by-jowl of a passage perfect in its precision with a long spin-off into bad prose-poetry (*bad* because unusable—viscid, obstructive, proceeding from no visible needs of character, plot or mood).

Why? The quickest answer would be the one given so often by Faulkner's early critics (most of the above weaknesses are common to all his work except *The Sound and the Fury*)—that Faulkner was a genius almost entirely dependent upon inspiration, afflatus, and therefore peculiarly lacking in the milder resources of joinery, stamina and taste which would have eased his way between seizures. That may finally be the truest answer (at least until someone learns to reproduce the phenomenon of artistic inspiration and production, at will, under laboratory conditions). Meanwhile, anyone seriously interested in discovering why *Pylon* is the book it is might begin by trying to establish what Faulkner thought he was making when he began the novel and what he believed he had made at the end.

In March 1957, a member of the English Club at the University of Virginia asked Faulkner, "do you regard *Pylon* as a serious novel, and what were you driving at in that novel?" Faulkner said,

> To me [the pilots] were a fantastic and bizarre phenomenon on the face of a contemporary scene, of our culture at a particular time. I wrote that book because I'd got in trouble with *Absalom,*

*Absalom!* and I had to get away from it for a while
so I thought a good way to get away from it was
to write another book, so I wrote *Pylon*. They
were ephemera and phenomena on the face of a
contemporary scene. That is, there was really no
place for them in the culture, in the economy, yet
they wouldn't last very long, which they didn't.
That time of those frantic little aeroplanes which
dashed around the country and people wanted just
enough money to live, to get to the next place to
race again. Something frenetic and in a way al-
most immoral about it. That they were outside the
range of God, not only of respectability, of love,
but of God too. That they had escaped the com-
pulsion of accepting a past and a future, that they
were—they had no past. They were as ephemeral
as the butterfly that's born this morning with no
stomach and will be gone tomorrow. It seemed to
me interesting enough to make a story about, but
that was just to get away from a book that wasn't
going too well, till I could get back at it.*

Notice that he does not directly answer the first
half of the question—"do you regard *Pylon* as a serious
novel?" He might be taken to imply both that he does
and doesn't. He expands on his *idea* of the barnstorm-
ing pilots of the early 1930s; but he ends with the pos-
sible hint that the book was—and remains for him—a
short dash away from the difficulties of *Absalom,
Absalom!* We could not in any case press close textual
analysis upon a remark which was impromptu and
courteous. What is clear enough is that the conscious
motive-to-work in *Pylon* was people—the sight of cer-

---

* Frederick L. Gwynn and Joseph L. Blotner, eds., *Faulkner
in the University* (Random House, 1965), p. 36.

tain people in action, at their work. It is clear from all Faulkner's remarks about his work assembled in *Faulkner in the University*, that his imagination was invariably triggered by pictures of people—knowledge of and curiosity about character, always arrived at through visual experience. He says of *The Sound and the Fury*, "It began with the picture of the little girl's muddy drawers, climbing that tree to look in the parlor window with her brothers that didn't have the courage to climb the tree waiting to see what she saw." And of "A Rose for Emily," "That came from a picture of the strand of hair on the pillow." In answer to a question about the theme of *Light in August*, "I was simply writing about people." And again, "the writer himself is too busy simply writing about people in conflict with themselves and one another and their background to wonder or even care whether he repeats himself or whether he uses symbols or not."

It is clear too, in his statement about *Pylon*, that the people whom Faulkner thought central to his impulse were the racing pilots and their retinue. He does not name them but he discusses only them. He does not refer at all to the non-pilots—the nameless reporter and Hagood, the editor. Faulkner had apparently seen a good deal of such people, though how intimately he had known them we cannot yet say. He had himself learned to fly in 1918 in the Canadian air force; and while he did not fly in the war, his interest in aviation remained strong enough for him to fly with barnstormers while he lived in New Orleans in 1925 and to purchase his own plane in 1933 with the profits of the first film of *Sanctuary*. He flew this plane to New Orleans for the dedication of Shushan Airport in February 1934 (the month in *Pylon* is February—the novel was published in March 1935); and he seems to have

continued flying until his brother Dean was killed in November 1935, while barnstorming in a plane Faulkner had given him. Barnstormers had been central to two of Faulkner's early short stories, "Honor" and "Death-Drag."

But *Pylon* is not about airmen—or about flying. On first reading, it appears to be. The title is *Pylon*, the posts round which air races are flown; the airmen seem at center-stage with their hard meager glamor—but that appearance is the cause of more than half our initial bafflement and irritation with the novel. Why do we spend almost no time actually in the air? Why are Shumann and Laverne and Holmes so vaguely seen, so physically impalpable? Why do they do so little (they are off-stage half the time), say so little? Why do they almost never think an audible thought? Why do we have no material for understanding them (that is, knowledge of their pasts) until the novel is thirty pages from the end?

Because we are not meant to "understand" them. The three of them are the literal center of the novel; but our geographical or spatial relation to them is the same as that of the nameless reporter—the relation of circumference to center. The subject of *Pylon* is that relationship—and a picture of it, at that (however murky), not an investigation.

For in a careful second reading of the novel—with eyes now trained for avoiding debris—one sees that, though the pilots may be the object for Faulkner's curiosity, even yearning, it is the reporter whom he inhabits and sends toward them in an effort to comprehend, an effort which becomes (for the reporter only?) a helpless offer of love and finally a balked isolated bitterness. The fact that the reporter does not begin the novel (Jiggs the mechanic has the first dozen pages, solo) and that he is at times intensely inhabited by

Faulkner (to the point of identification—the reporter's vision coinciding with the narrator's) and then without apparent reason flung beyond not only our comprehension but our sight—these are red herrings which are too successful in a first reading. But the bones of the novel can be made to appear—and most of them relate to the reporter. This, I think, is the anatomy of *Pylon*—a young man, age twenty-eight (born on April Fool's Day, the son of a multi-husbanded mother) who will remain nameless to us (the name by which the other characters know him is apparently a pseudonym), is a newspaper reporter and has been assigned by his impatient but paternal editor to cover an airshow held to celebrate the opening of a city airport in a thinly-disguised New Orleans during Mardi Gras. We first see the reporter through the eyes of Jiggs (the hot-eyed musclebound mechanic for a team of airmen) as

> something which had apparently crept from a doctor's cupboard and, in the snatched garments of an etherised patient in a charity ward, escaped into the living world. . . . better than six feet tall . . . about ninetyfive pounds, in a suit of no age or color . . . which ballooned light and impedimentless about a skeleton frame as though suit and wearer both hung from a flapping clothesline; a creature with the leashed, eager loosejointed air of a halfgrown highbred setter puppy.

And these are the terms in which the reporter is seen again and again throughout the novel by everyone, including the narrator—a scarecrow, a skeleton, Lazarus, an escaped ghost; in fact, a disembodied, unphysical being as contrasted with the cocked and "vicious" (as Faulkner so frequently calls it) physicality of the airmen.

It is only some thirty pages into the novel, when

the reporter has returned from the first day of the air show and is talking with Hagood his editor, that we see how his assignment to cover the show is becoming for him an assignment to cover three of the participants—Roger and Laverne Shumann and Jack Holmes. The growth of that involvement from curiosity to fascination to infatuation to abject devotion is complicated more by bad prose than by complexity in structure, and may be dissected. Hagood gives the first prod. He says that the reporter has a marked instinct for events but not for "the living breath of news. . . . just information" (*vision* perhaps as opposed to *comprehension*); and in a crucial passage, Hagood asks the reporter, "Can it be by some horrible mischance that without knowing it you listen and see in one language and then do what you call writing in another?"

The reporter will not accept the charge and rushes to say that he has given the editor only what he thought the paper required—bare news. Then he tells Hagood all that he has learned so far about the Shumann menage—that Roger is the pilot, Laverne an assistant mechanic, Jack the parachutist; that Laverne is technically married to Shumann but that she serves both men sexually and that none of them knows the paternity of the six-year-old child with them, though he has been named Jack Shumann through a roll of dice. Hagood urges the reporter "to write it." The reporter accepts enthusiastically. But at once Hagood says, "Go home . . . and write it. . . . And then set fire to the room"—present it, understand it, but burn it because, Hagood says, "I don't even care. Why should I find news in this woman's supposed bedhabits?"

The reporter is appalled, for two reasons. He has been lured now into revealing his own great ambition to be a writer (the classical ambition of young re-

porters), only to have it callously waved aside as useless; and he has suddenly seen the Shumann menage by Hagood's new scalding light, not as he'd seen them a moment before ("They ain't human") but, in their homelessness and poverty and outcast state, as forlorn and needful as himself, differing from himself perhaps only in their violent physical plenitude, their—as he thinks—rich sexuality, all of which has made them paradoxically defenseless in a world of the asexual, the condemning, the uncaring. He finds them derelict on the first night (the novel begins on a Thursday afternoon and continues through the following Monday morning), broke and unable to collect their share of the first day's prize money. He at first tries to help them find free lodging, then makes an impassioned call to his editor to explain the dilemma and to ask for help from the paper (what help is not clear). The editor, enraged, fires him; and the reporter takes them all, including Jiggs and the child, to his own room in the old quarter, moved by "the sheer solid weight of their patient and homeless passivity."

By now—a third of the way in—it is becoming apparent that the three are not interesting to the reporter (or to Faulkner, or us) as airmen—as a new phenomenon, new types demanding new modes of comprehension and judgment—but as what Faulkner might have called the present and temporary avatars of an archetype: the seductive rascal, the glamorous and lethal tramp. Alcibiades, Antony, knights-errant, goliards, Hell's Angels. Nor are the present instruments of their obsession—airplanes—essentially new. The great seducers have always possessed and displayed certain objects to which they were helplessly attached but which seemed, to the witnessing world, charged extensions of their superior vitality, bristling

monstrances of their fearful and enviable sexuality—
swords, shields, armor, champing steeds; lutes, tight
hose, laced codpieces; biplanes, leather clothing, gog-
gles, boots; motorcycles. What occurs too late to us,
their victims, is that these objects are never the
weapons or threats of the seducer but are his literal
attempts at defense and escape (escape from what?—
world? time? self? us? All, of course; always); thus our
relation to him is constant and predictable and is
partially described by Johannes de Silentio—

> as God created man and woman, so too He fash-
> ioned the hero and the poet, or orator. The poet
> cannot do what the other does; he can only ad-
> mire, love and rejoice in the hero. Yet he too is
> happy, and not less so, for the hero is as it were
> his better Nature, with which he is in love.*

The word *love* is accurate—for the poet, for Faulk-
ner perhaps, certainly for the reporter. What Johannes
does not say is that the love will end—is, anyhow, re-
fused. And the end occurs when love produces in us,
as it must, understanding—when adoration and con-
templation tell us that the Hero differs from us in
*degree*, not kind; that his body is rigid with fear, not
fullness; that all his strength is cocked only for flight
or revenge on us; that he is (to return to Faulkner's
discussion of *Pylon*) "outside the range . . . not only
of respectability, of love, but of God too." Why be-
yond the reach of God?

Because the Heroes are always incapable of love,
gift or receipt. And indeed they never deny this to us.

* Quoted as the epigraph in *Heroes and Orators* (McDowell,
Obolensky, 1958), a novel by Robert Phelps which would be of
interest to any reader of *Pylon*. Johannes de Silentio was Kierke-
gaard's pseudonym for *Fear and Trembling*.

The airmen announce it to the reporter from the start
—in their scorn, in Holmes' explicit jealousy, and, most
strongly, on the morning of the second day when
Laverne and the others rob the reporter of six dollars
as he lies blind-drunk in the alley beside his house. Yet
his knowledge of the theft only baits him deeper into
fascination and commitment. Now he must make them
confess the theft, must make *Laverne* confess (be-
cause by now his need is focused largely on her, though
never entirely)—"it seems I am bound to offer her the
chance to tell me that they stole . . . not the money.
It's not the money. It's not that." What is it then?—
their defiling his unsought generosity, his offered un-
needed love.

And he does achieve a moment of triumph. He
forces a moral act from them. After he has given them
the key to his room to use as they like, Laverne briefly
thanks him and confesses the theft; and a little later
(after Shumann's first crash, at almost the exact center
of the novel), he wrings from her another bleak word
of thanks and apology and—at last—rudimentary af-
fection.

"We're going on to your house," she said . . . .
"You have changed your plan about leaving town,
I imagine?"

"Yes," the reporter said. "I mean no. I'm go-
ing home with a guy on the paper to sleep. Dont
you bother about me." He looked at her, his face
gaunt, serene, peaceful. "Dont you worry. I'll be
o.k."

"Yes," she said. "About the money. That was
the truth. You can ask Roger and Jack."

"It's all right," he said. "I would believe you
even if I knew you had lied."

Now he is unleashed and his fantasy races hungrily ahead. He dares to tell Shumann (who has also betrayed the chance of warmth) of his desire for Laverne, a desire which he all but admits to be focused now upon the three of them, the old dream (dreamed most fully in the sonnets of Shakespeare) of the *ménage à trois*.

> Sometimes I think about how it's you and him and how maybe sometimes she dont even know the difference, one from another, and I would think how maybe if it was me too she wouldn't even know I was there at all.

(We recall his obscure and drunken remark of the previous night—"Did you tell him I was married? Did you tell him I got two husbands now?") Now he extends the dream—still aloud to Shumann—to the possibility of replacing Shumann in the event of Shumann's death in the faulty plane the reporter has found for them.

His infatuation is complete. He believes at last in his chance for love—participation, completed gestures, nodded receipts. Hagood (who has reinstated him in his job) says, "Why dont you let these people alone?" —"I can't," the reporter says, "Yes. . . . I tried." Even Shumann sees him now as "patron (even if no guardian) saint of all waifs, all the homeless the desperate and the starved."

One last moment of hope is allowed him. After he has managed to find a new plane for Shumann to fly in the final race, co-signed the note of purchase, made a dangerous first flight with Shumann to establish the plane's weight-distribution problem, he then persuades Colonel Feinman to waive qualification on the plane and can bear the news as a gift to Laverne—

"Yes. It was all right. Like I told you."

"They did it," she said, staring at him yet speaking as though in amazed soliloquy. "Yes. You fixed it."

"Yes. I knew that's all it would be. I wasn't worried. And dont you . . ."

This further triumph frees him, minutes later as he holds the Shumann child just before Shumann's fatal crash, to return to his first description of the three—"That's it . . . they aint human. It aint adultery; you can't anymore imagine two of them making love than you can two of them airplanes back in the corner of the hangar, coupled." The reporter has not known (and will never know) what we have possessed for some thirty pages now—Shumann's memory of Laverne's first attempt at a parachute jump, her ecstatic return from the wing to the cockpit to mount him in frenzy, then float to the ground, bare to all viewers—nor did the reporter witness, with us, the Shumanns' metallic preliminaries to copulation in the reporter's own bed.

But though his initial insight seems to him now confirmed in experience, his need remains firm and desperate. When Shumann crashes into the lake before their eyes and Laverne runs toward the seawall, the reporter follows (both are holding the child) "at his loose lightlyclattering gallop like a scarecrow in a gale, after the bright plain shape of love." Laverne instantly withdraws what little she has given—"she turned, still running and gave him a single pale cold terrible look, crying, 'God damn you to hell! Get away from me!'"

The next chapter (the next-to-last) is called "Lovesong of J. A. Prufrock." The lines from Eliot which

seem especially relevant (though not given by Faulk-
ner) are these—

> Would it have been worth while,
> To have bitten off the matter with a smile,
> To have squeezed the universe into a ball
> To roll it toward some overwhelming question,
> To say: "I am Lazarus, come from the dead,
> Come back to tell you all, I shall tell you all"—
> If one, settling a pillow by her head,
>> Should say: "That is not what I meant at all.
>> That is not it, at all."

For while the reporter seems, however dazedly, to
realize that his hope of involvement in these three
lives (perhaps in *life*) has died with Shumann, he is
still compelled to haunt Laverne, posted back again at
the circumference where he can only watch her as she
watches the grim attempts to snag Shumann's body
from the lake. His compulsion, which he states several
times, is to make Laverne understand—in fact, to step
forward as Prufrock cannot dare to do and speak his
love, to "tell you all." But she never looks or speaks to
him again and he does not dare. He is able to say to
Jiggs later that night, "I keep on trying to explain to
somebody that she didn't understand. Only she under-
stands exactly, dont she? He's out there in the lake and
I can't think of anything plainer than that." But the
plain acceptance of death is not an understanding of
love; and what has Laverne not understood?—the
mere fact of his infatuation, his abject loyalty? Or the
chance that he may have more than half-uncon-
sciously procured a faulty plane for Shumann in the
hope of assuming Shumann's place? What, after all,
would his love have consisted of? (No more, surely,
than he had offered in his confession to Shumann—

"I'd just be the name, my name, you see? the house and the beds and what we would need to eat . . . . I could anyway buy her the pants and the nightgowns and it would be my sheets on the bed and even my towels.") And what has the reporter understood of the motives and needs of Laverne, Roger, Jack? Nothing—for, again, he has imagined them different from himself only in degree, not in kind. His trust, his gamble, has been that their hectic lives were—like his own—in search of love, family, rest; solutions to a dilemma which he has assumed to be also his—loneliness, home-lessness. But they were not in search of love.

Why? No answer—either from them or the reporter or from Faulkner. After nine o'clock that final night, the reporter never sees Laverne again. He accepts from Jack Holmes the money to forward Shumann's body to his parents in Ohio; he works with Jiggs to conceal a gift of money in a toy for the child; but his truest response has been a question said only to himself—"How could it be?"

The last fifty pages shed no light, for him or us. The reporter hears from Jiggs of Shumann's Ohio boyhood, Laverne's Iowa orphanhood (both, in effect, obituaries which in their pathos and credibility, their late position in the novel, and their failure to *explain* the lives that ensued, closely parallel the glimpses of Jay Gatsby's early years which Nick Carraway receives from the father at Gatsby's funeral). He sits through an all-night blackjack game and vigil for the body with other reporters and hears their coarse unhelpful version ("It's because they have got to do it. . . . They can't help themselves")—hears it passively, offering no contradiction or justification. Then, with dawn, he sees the search abandoned, a wreath dropped into the lake in lieu of salvage; and having no knowl-

edge (which we have, in full) of Jack and Laverne's
trip to Myron, Ohio to abandon the child with Roger's
old parents (the child's predicament now paralleling
the reporter's own childhood—and Laverne's), he re-
turns to the paper and writes as his last visible act two
short passages. The first, resurrected from the trash by
a copyboy, is the reporter's attempt to make "literature"
(not *meaning* but *decoration*) from Shumann's
death—

> Thus two friends told him farewell. Two
> friends, yet two competitors too, whom he had met
> in fair contest and conquered in the lonely sky
> from which he fell, dropping a simple wreath to
> mark his Last Pylon.

The second attempt is for Hagood's desk—

> At midnight last night the search for the body
> of Roger Shumann . . . was finally abandoned by
> a three-place biplane of about eighty horsepower
> which managed to fly out over the water and re-
> turn without falling to pieces and dropping a
> wreath of flowers into the water approximately
> three quarters of a mile away from where Shu-
> mann's body is generally supposed to be since they
> were precision pilots and so did not miss the en-
> tire lake.

> Is this a final admission by the reporter that Ha-
> good was right?—that the reporter listens and sees in
> one language and writes in another? Or that he has
> not seen at all, but misseen, misapprehended, merely
> hoped? Or perhaps this ending (the whole book, in
> fact) makes those same self-condemning admissions
> for Faulkner himself?—that the years and energy

which he had spent among pilots and planes (seduced there by *something*) had yielded only turgid bafflement, ashes-in-the mouth? None of those questions can now be answered—the reporter is off for a thorough drunk; and we do not yet know (perhaps we never will) what actual relationships, if any, from Faulkner's own life lie beneath the story.

Yet this sphinx has its secret and keeps it closely, a secret whose answer even it does not know—not "Why are these airmen reckless and godless?" but "Why do the Orators (even this reporter) adore the Heroes (even these three, so tawdry and small)? What is the source of their need to love, on their knees thus, smiling?" And the fact of the secret, the fear of the secret—so clearly close to Faulkner, who all his life sought the company of Heroes (pilots, hunters, horsemen)—goes far to explain the cluttered and irrationally disarranged shape of the brief lean story which *Pylon* contains, barely bones enough for a lyric poem.

Perhaps *Pylon* is not a novel. Surely a good deal of irritation with its shape and language proceeds from our own—perhaps even Faulkner's—misconception of its form. It is called a novel, has the size of a novel. But east and west, the novel, as distinguished from the poem, has traditionally been an instrument of reason intended for discovery and comprehension and then, of necessity, forgiveness—in fact, the supremely Christian form, the new dispensation which rose to augment, if not supersede, older pagan forms (the psalm, epic, lyric, drama) which were hymns to mystery, human and divine. Faulkner's great books have other aims— or achieve other ends, whatever their aims. *The Sound and the Fury, As I Lay Dying, Light in August*—all end as examples of that older chthonic art, the icon which both portrays and worships the unseen god; and their

form and tone are shaped (often tortured, wrenched) by the posture of worship, of muffled awe at the sight of darkness. *Pylon* approaches a lesser darkness than those three great books—a private darkness, though real and hurtful, and a frightened, rapt and willful approach—but it makes all the same, if we struggle to watch, a moving obeisance.

1968

# A REASONABLE GUIDE
# THROUGH PERILOUS SEAS*

WILLIAM FAULKNER'S Nobel Prize was the rock that tripped a slide of journalistic and critical attention unequaled (for the span—fourteen years) in irrelevance, fantasy, sheer bad-mannered unhelpfulness. Even Shakespeare can barely have been so badly, uncomprehendingly, used. And to mention Shakespeare is to suggest possible reasons for the unique bulk and opacity of most Faulknerian criticism; for surely Faulkner more than any great artist except Shakespeare was silent to the world's curiosity and comment, scornful of seeking its fame, scornful of fame finally, belatedly, offered. Late in his life, for instance, he said that he wrote novels for years before it occurred to him that anyone might read them. And since an appetite for Fame (as end or means) has been one of the few constants in the declared motives of ancient and modern artists, despised Fame has taken a heavy toll of Faulkner for being of all great novelists the one least willing to prepare an audience, explain to an audience, clarify or dilute for an audience. Fielding, Dickens, Tolstoy, Stendhal, Twain—all were deeply conscious of writing for *someone* (one or millions); and they agonizingly adjusted their private visions, not to soothe

* *William Faulkner: The Yoknapatawpha Country* by Cleanth Brooks (Yale University Press, 1963).

or please but to be merely visible, audible, to that some-one. And Fame's toll is the volumes of nonsense, barnacled to the huge books *because* Faulkner would not explain, justify, adjust, not think of readers—who after all were hardly there for the first twenty-five years.

This indifference of Faulkner's was perhaps, like so much about him, peculiarly Southern, a form of fierce hauteur. Now another Southerner, Cleanth Brooks, has given us the first half of his study of Faulkner (a second volume is planned); and at once it is the most courteous, modest, sensible and helpful of existing guides. For a guide is most nearly what it is, a handbook for strangers. There are introductory chapters on Faulkner's province and people (full of the information that only a native could possess, information productive of calm understanding), a chapter on Faulkner as nature poet, separate chapters for each of the novels set in Yoknapatawpha County, eighty pages of notes which often and convincingly refute previous (sometimes hilarious) misreadings, genealogies and chronologies of fictional families, a full character-index with page numbers to the stories and novels, an index to Brooks himself, and Faulkner's own map of the county.

In many ways, then, the book one might have expected from Brooks as Southerner and distinguished teacher but curiously not the book expected of Brooks as New Critic, author of *The Well-Wrought Urn*, the relentless verbal inquisitor. Perhaps such fine combing will come in the second volume in which Brooks promises to

concentrate on Faulkner's development as an artist —his beginnings, the forging of his style, and the

working out of the special fictional techniques as-
sociated with his name. . . . to examine some of
the earlier drafts of his novels and to discuss his
process of revision with reference to style and
structure.

But, for now, Brooks has cast a broad loose net
and landed, not the inert mass of symbols, parallels,
archetypes which are the usual Faulknerian catch
(which Brooks himself denounces as "symbol-monger-
ing") but any number of separate attentions, insights
and understandings. His method—if not infallible,
surely the safest for dealing with an apparent genius—
is to assume from the start that Faulkner knew what he
meant, that the finished book is that meaning, that the
*form* is the meaning, and that the central question to
ask of form, characters, accidents is "Why are you
built as you are?" It is a method which now seems al-
most shockingly naive (In fact, I can think of only
one other living critic who employs it—H. D. F. Kitto,
whose studies of Greek drama are among the handful
of great illuminations of tragedy); but it leads Brooks
into fresh, relevant and—most valuable—unifying dis-
coveries, apparently modest perceptions around which
a whole work suddenly arranges its baffling elements.
For instance:
     —that in *Light in August* "Faulkner has given us a
kind of pastoral—that is, he has let us see our modern
and complex problems mirrored in a simpler and more
primitive world." (This is braced throughout with
numerous comparisons to Wordsworth.)
     —that the mode of *Light in August* "is that of
comedy. To say so in the light of some of the terrible
episodes may seem perverse. But Faulkner's comedy is
frequently a makeweight to the terrible. . . . Its func-

tion is to maintain sanity and human perspective in a
scene of brutality and horror."

—that "The only people in Faulkner who are 'in-
nocent' are adult males; and their innocence amounts
finally to a trust in rationality—an overweening con-
fidence that plans work out, that life is simpler than
it is."

Perhaps, to employ his own terms, it is the in-
nocence of Brooks' own method (however richly yield-
ing) which has restrained him from the kind of final
simple revelations of Faulkner which, say, Coleridge
and Bradley gave us of Shakespeare—revelations of the
*use*, the good, of reading Faulkner. The virtue of his
method is also its vice—its almost undoubting con-
fidence that all Faulkner's plans worked out, that to
have uncovered his intentions is to have confirmed his
achievement of those intentions and the worth of all
those intentions (even in *Sanctuary*, of which Brooks
thinks a good deal more highly than Faulkner did).
Such innocence leads him to argue for instance that
*Absalom, Absalom!* is "the greatest of Faulkner's nov-
els." He supports the claim with a stunning apparatus
of clarification, with elaborate ratiocinative tables for
the weighing of evidence in the separate accounts of
Sutpen's folly and fall; but he does not face Faulkner's
nearly total refusal to handle the story (and so many
other stories) in the way it begs to be handled, in the
way Faulkner worked most revealingly—scenically,
pictorially.

In short, Brooks finally makes common cause
with most other Faulknerian critics by dangerously
underestimating the extent to which Faulkner was not
so much the great undisciplined novelist of our time
as the most willful, *playful* great novelist since Fielding.
Faulkner himself often said that he wrote "for fun"

and that "Fun is to accomplish something which I thought that perhaps I couldn't." *

The imagined memory of that small beautiful head bowed alone in a room in Oxford, Mississippi, stroking down volume after volume—like the plays of Hamlet's players, "tragedy, comedy, history, pastoral, pastoral-comical, historical-pastoral, tragical-historical, tragical-comical-historical-pastoral, scene individable or poem unlimited"—because finally it *amused* him to do so, unchecked, unconcerned for the negligent present world or the solemn hierophants-to-be, unconcerned to be universal, to tell more than private truths about what he had seen and thought he knew (one has only to talk with any literate French- or Englishman to discover that half of Faulkner is as exotic to them as any Byzantine gold-enameled bird; by refusing to compare Faulkner's aims and achievements with those of other great novelists, Brooks has obscured this vital fact)—that image surely, nailed-up in our minds, would be the safest rudder through the perilous sea he poured us. Mr. Brooks' second volume may well clarify that image by examining the secret trails—manuscripts, drafts. But for now he has given us more than sufficient gifts for gratitude—the Baedeker of Faulkner guides, all that reason can give and money buy.

*1963*

---

* Faulkner in Gwynn and Blotner, *op. cit.*, p. 257.

# THE ONLOOKER, SMILING

## AN EARLY READING OF

## THE OPTIMIST'S DAUGHTER

On MARCH 15, 1969, *The New Yorker* published an issue half filled with a story by Eudora Welty called *The Optimist's Daughter*. The story is some thirty thousand words long, a hundred pages of a book —much the longest work published by Miss Welty in fourteen years, since her fourth collection of stories, *The Bride of the Innisfallen* in 1955. In those years, in fact, fewer than twenty pages of new fiction by her have appeared (two extraordinary pieces rising from the early civil rights movement, "Where is the Voice Coming From?" and "The Demonstrators"). Now there is this novella—and, close behind it, news of a long comic novel, more stories, a collection of essays.

A *return*, in our eyes at least (Miss Welty could well ask "From where?"); and some eyes (those that haven't raced off after the genius-of-the-week) have got a little jittery with time. Returns in the arts are notorious for danger—almost always stiff-jointed, throaty, short-winded, rattled by nerves and ghosts of the pressures which caused the absence. There have been rare and triumphant exceptions—among performers in recent memory, Flagstad and Horowitz, grander than ever. But who among creators? American arts are uniquely famous for silent but audibly breathing remains—novelists, poets, playwrights, composers. The game of naming them is easy and cruel, and the

diagnoses multiply. Yet I think back eighty years to Verdi's return with *Otello,* thirteen years after *Aïda* and the Requiem, for an ample precedent to Miss Welty's present achievement.

I have known the new story for less than a month and am straining backward to avoid instant apotheosis; but I don't feel suspended over any fool's precipice in saying this much—*The Optimist's Daughter* is Eudora Welty's strongest, richest work. For me, that is tantamount to saying that no one alive in America has yet shown stronger, richer, more useful fiction. All through my three readings, I've thought of Turgenev, Tolstoy, Chekhov—*First Love, The Cossacks, The Steppe*—and not as masters or originals but as peers for breadth and depth.

And an effortless power of *summary,* unity (of vision and means). For that is what I have felt most strongly in the story—that Miss Welty has now forged into one instrument strands (themes, stances, voices, genres) all present and mastered in various pieces of earlier work (many of them, invented there) but previously separate and rather rigidly compartmented. I'm thinking especially of "comedy" and "tragedy." In her early work—till 1955—she tended to separate them as firmly as a Greek dramatist. There is some tentative mingling in the larger works, *Delta Wedding* and the linked stories of *The Golden Apples;* but by far the greater number of the early stories divide cleanly—into rural comedy or farce, pathos or tragic lament, romance or lyric celebration, lethal satire. This is not to say that those stories over-select to the point of falsification (fear and hate lurk in much of the laughter, laughter in the pain) but that the selection of components-for-the-story which her eye quickly or slowly made and the subsequent intensity of scrutiny of those

components (place, character, gesture, speech) ex-
hibited a temporary single-mindedness as classical as
Horace's, Vermeer's.

But now in *The Optimist's Daughter* all changes.
If the early work is classic, this might be medieval—in
its fullness of vision, depth of field, range of ear. Jesus
*and* goblins, Macbeth *and* the porter. There is no sense
however of straining for wholeness, of a will to "ripe-
ness," no visible girding for a major attempt. The rich-
ness and new unity of the story—its quality of sum-
mary—is the natural image produced by *this action* as
it passes before Miss Welty's (literal) vision—look at
a room from the perfect point, you can see it all. She
has found the point, the place to stand to see this story
—and we discover at the end that she's seen far more
than that. Or perhaps the point drew her—helpless,
willing—toward it, her natural pole?

For it is in this story that she sustains most in-
tensely or has the fullest results extracted from her by
the stance and line-of-sight which, since her first story,
have been native to her—that of the onlooker (and the
onlooker's avatars—the wanderer, the outsider, the
traveling salesman, the solitary artist, the bachelor or
spinster, the childless bride). Robert Penn Warren in
his essay "Love and Separateness in Eudora Welty"
defined the stance and theme as it formed her early
stories—

> We can observe that the nature of the isola-
> tion may be different from case to case, but the
> fact of isolation, whatever its nature, provides the
> basic situation of Miss Welty's fiction. The drama
> which develops from this basic situation is of
> either of two kinds: first, the attempt of the iso-
> lated person to escape into the world; or second,

the discovery by the isolated person, or by the reader, of the nature of the predicament.

And a catalogue of her strongest early work and its characters is a list of onlookers, from R. J. Bowman in "Death of a Traveling Salesman" (her first story) and Tom Harris in "The Hitch-Hikers" (both lonely bachelors yearning for the richness which they think they glimpse in the lives of others—mutual love, willful vulnerability), to the young girl (a would-be painter) in "A Memory" and Audubon in "A Still Moment" (the artist who must hole-up from life, even kill it, to begin his effort at description and comprehension), to the frightening and hilarious spinsters of "Why I Live at the P.O." and *The Ponder Heart* or the more silent but equally excluded Virgie Rainey of *The Golden Apples*, to the recently orphaned Laura who visits her Fairchild cousins in *Delta Wedding* as they plunge and surface gladly in their bath of proximity, dependence, love.

You might say—thousands have—that the onlooker (as outsider) is the central character of modern fiction, certainly of Southern fiction for all its obsession with family, and that Miss Welty's early stories then are hardly news, her theme and vision hardly unique, hardly "necessary," just lovely over-stock. Dead-wrong, you'd be.

In the first place, her early onlookers are almost never freaks as they have so famously been in much Southern, and now Jewish, fiction and drama. (Flannery O'Connor, when questioned on the prevalence of freaks in Southern fiction, is reported to have said, "It's because Southerners know a freak when they see one.") They have mostly been "mainstream" men and women —in appearance, speech and action at least. Their vi-

sions and experiences have been far more nearly diurnal—experiences comprehensible at least to most men—than those of the characters of her two strong contemporaries, Carson McCullers and Flannery O'Connor, whose outsiders (often physical and psychic freaks) seem wrung, wrenched, from life by a famished special vision.

In the second place, the conclusions of Miss Welty's early onlookers, their deductions from looking—however individual and shaped by character, however muted in summary and statement—are unique. Their cry (with few exceptions, her salesman the most eloquent) is not the all-but-universal "O, lost! Make me a *member*" but something like this—"I am here alone, they are there together; I see them clearly. I do not know why and I am not happy but I *do* see, and clearly. I may even understand—why I'm here, they there. Do I need or want to join them?" Such a response—and it is, in Miss Welty, always a response to vision, literal eye-sight; she has the keenest eyesight in American letters—is as strange as it is unique. Are we—onlookers to the onlookers—moved to sympathy, acceptance, consolation? Are we chilled or appalled and, if so, do we retreat into the common position?—"These people and their views are maimed, self-serving, alone because they deserve to be. Why don't they have the grace to writhe?" For our peace of mind (the satisfied reader's), there is disturbingly little writhing, only an occasional moment of solemn panic—

"She's goin' to have a baby," said Sonny, popping a bite into his mouth.

Bowman could not speak. He was shocked with knowing what was really in this house. A marriage, a fruitful marriage. That simple thing.

Anyone could have had that.

Somehow he felt unable to be indignant or protest, although some sort of joke had certainly been played upon him. There was nothing remote or mysterious here—only something private. The only secret was the ancient communication between two people. But the memory of the woman's waiting silently by the cold hearth, of the man's stubborn journey a mile away to get fire, and how they finally brought out their food and drink and filled the room proudly with all they had to show, was suddenly too clear and too enormous within him for response.

Or a thrust through the screen, like Lorenzo Dow's in "A Still Moment"—

He could understand God's giving Separateness first and then giving Love to follow and heal in its wonder; but God had reversed this, and given Love first and then Separateness, as though it did not matter to Him which came first. Perhaps it was that God never counted the moments of Time. . . . did He even know of it? How to explain Time and Separateness back to God, Who had never thought of them, Who could let the whole world come to grief in a scattering moment?

But such moments are always followed by calm—Bowman's muffled death or Dow's ride onward, beneath the new moon.

Yet in those early stories the last note is almost invariably rising, a question; the final look in the onlooker's eyes is of puzzlement—"Anyone could have had that. Should I have tried?" Not in *The Optimist's Daughter* however. The end clarifies. Mystery dis-

solves before patient watching—the unbroken stare of Laurel McKelva Hand, the woman at its center. The story is told in third person, but it is essentially seen and told by Laurel herself. At the end, we have not watched a scene or heard a word more than Laurel; there is not even a comment on Laurel which she, in her native modesty, could not have made aloud. That kind of secret first-person technique is at least as old as Julius Caesar and has had heavy work in modern fiction, where it has so often pretended to serve Caesar's own apparent aim (judicial modesty, "distancing") while in fact becoming chiefly a bullet-proof shield for tender egos, an excuse for not confronting personal failure (Joyce's *Portrait* is the grand example), a technical act of mercy. But Laurel Hand is finally merciless—to her dead parents, friends, enemies, herself; worst, to us.

This is what I understand to be the story—the action and Laurel's vision of the action.

Laurel Hand has come on sudden notice (and intuition of crisis) from Chicago, where she works as a fabric designer, to a New Orleans clinic where her father Judge McKelva, age seventy-one, is being examined for eye trouble. (The central metaphor begins at once—vision, the forms of blindness; the story is as troubled by eyes as *King Lear*; and our first exposure to Laurel's sensibility suggests youth and quivering attentiveness.) In a clinic she has time to notice this—

Dr. Courtland folded his big country hands with the fingers that had always looked, to Laurel, as if their simple touch on the crystal of a watch would convey through their skin exactly what time it was.

Laurel's father is accompanied by his new wife Fay;
and at the diagnosis of detached retina, Fay's colors
unfurl—hard, vulgar, self-absorbed, envious of Laurel
and, in Laurel's eyes, beneath the McKelva's and
Laurel's dead mother. The doctor advises immediate
surgery, over Fay's protests that nothing is wrong. The
judge declares himself "an optimist," agrees to eye-
repair; the surgery goes well, and Laurel and Fay take a
room in New Orleans to spell one another at the
Judge's bedside—their important duty, to keep him
still, absolutely motionless with both eyes bandaged
through days of recovery. Friction grows between the
two women but with no real discharge. Fay shows her-
self a kind of pet, baby-doll—her idea of nursing con-
sisting of descriptions of her new shoes or earrings, her
petulance at missing Mardi Gras whose time approaches
loudly through the city. Laurel watches quietly, read-
ing Dickens to her father, oppressed by his age and
docility—

> He opened his mouth and swallowed what she
> offered him with the obedience of an old man—
> obedience! She felt ashamed to let him act out the
> part in front of her.

Three weeks pass, the doctor claims encouragement,
but the Judge's deepening silence and submission begin
to unnerve Fay and to baffle Laurel. (It is only now—
nearly fifteen pages in—that we learn Laurel's age. She
is older than Fay and perhaps Fay is forty. We are, I
think, surprised. We had felt her to be younger—I'd
have said twenty-four and only now do I notice that
she bears a married name; yet no husband has been
mentioned and will not be till just before the midpoint
of the story. There is no air of caprice or trick about
these crucial withholdings, only quiet announcement

—"Now's the time for this.") Then on the last night of
Carnival, Laurel in her rooming house senses trouble
and returns to the hospital by cab through packed,
raucous streets. (Inevitably, a great deal of heavy holy
weather will be made over Miss Welty's choice of
Carnival season for this opening section and the eve
of Ash Wednesday for the first climax. So far as I can
see, she herself makes almost nothing of it—the revelry
is barely mentioned and then only as a ludicrously in-
appropriate backdrop to death. Even less is made of
the city itself, almost no appeal to its famous at-
mosphere—it is simply the place where a man from the
deep South finds the best doctors.) At the hospital,
Laurel finds her foreknowledge confirmed. Fay's pa-
tience has collapsed. She shakes the silent Judge, shouts
"enough is enough"; and Laurel enters to watch her
father die—

> He made what seemed to her a response at
> last, yet a mysterious response. His whole pillow-
> less head went dusky, as if he laid it under the
> surface of dark pouring water and held it there.

While Laurel and Fay await the doctor's confirma-
tion in the hospital lobby, they watch and listen to a
Mississippi country family come to oversee their own
father's death—the Dalzells, family of the Judge's de-
ranged roommate. (Their sizable appearance is not, as
might first seem, a chance for Miss Welty to ease
tension and pass necessary clock-time with one of her
miraculously observed country groups. Funny and
touching as they are—

> "If they don't give your dad no water by next
> time round, tell you what, we'll go in there all to-
> gether and pour it down him," promised the old

mother. "If he's going to die, I don't want him to
die wanting water."

—the Dalzells make a serious contribution toward de-
veloping a major concern of the story. They are, for all
their coarse jostling proximity, a *family* of finer feeling
and natural grace than whatever is constituted here by
Fay and Laurel; and they will soon return to mind, in
sweet comparison with Fay's Texas kin who swarm for
the funeral.) At final news of the Judge's death, Fay
lunges again into hateful hysterics; but Laurel tightens
—no tears, few words. Only in the ride through revelers
toward the hotel does Laurel begin to see, with a new
and steelier vision, meanings hung round people, which
she does not yet speak—

> Laurel heard a band playing, and another
> band moving in on top of it. She heard the crowd
> noise, the unmistakable sound of hundreds, of
> hundreds of thousands, of people *blundering*.

Part II opens with the train ride home to Mount
Salus, Mississippi. (Laurel's view from the train of a
single swamp beechtree still keeping dead leaves be-
gins to prepare us for her coming strangeness, her as
yet unexpected accessibility to ghosts.) Mount Salus is
a small lowland town and is now home only to the
dead Judge—Fay will inherit Laurel's childhood home
but is Texan forever; Laurel will return to Chicago
soon. But two groups of her friends survive in the
town—her dead parents' contemporaries and her own
schoolmates—and they rally to her, ambivalent hurt-
ful allies, as Fay's kin—the Chisoms—arrive for the
funeral. Led by Fay's mother, they cram the Judge's
house like a troupe of dwarfs from a Goya etching,
scraping rawly together in a dense loveless, shamingly

vital, hilarious parody of blood-love and loyalty—
"Nothing like kin. Yes, me and my brood believes in
clustering just as close as we can get." It is they—
Fay's mother—who at last extract from Laurel what
we have not yet known, that Laurel is a widow:

> "Six weeks after she married him. . . . The
> war. Body never recovered."
> "*You* was *cheated*," Mrs. Chisom pronounced.
> . . . "So you ain't got father, mother, brother,
> sister, husband, chick nor child." Mrs. Chisom
> dropped Laurel's finger to poke her in the side as
> if to shame her. "Not a soul to call on, that's you."

So the Chisoms stand at once—or pullulate—in Lau-
rel's sight, as a vision of the family and of love itself
as horror, hurtful, willfully vulnerable, parasitic. Yet
one of them—Wendell, age seven, viewing the corpse
—also provides her with a still point for temporary
sanity, for "understanding" Fay and her father's love
for Fay—

> He was like a young, undriven, unfalsifying,
> unvindictive Fay. His face was transparent—he
> was beautiful. So Fay might have appeared to her
> aging father, with his slipping eyesight.

That emergency perception and the cushioning care of
friends prop Laurel through Fay's last hysterical kiss
of the corpse and on through the burial. —Propped
but stunned, and open on all sides—especially the eyes
—for gathering menace to her saving distance. Above
the graveyard, she sees a flight of starlings—

> black wings moved and thudded in perfect unison,
> and a flock of migrant starlings flew up as they
> might have from a plowed field, still shaped like

the grounds of the cemetery, like its map, and wrinkled in the air.

And afterwards, at the house again, she numbly accepts more insults from Fay and waits out the slow departure of the Chisoms—taking Fay with them for a rest in Texas.

Part III is the longest of the four parts, both the story's journey through the underworld and the messenger of what the story learns there. It has four clear divisions. In the first, Laurel entertains four elderly ladies, friends of her parents, who raise a question so far unasked (among the signs of mastery in the story, one of the surest is the patience, the undefended gravity with which Miss Welty answers—or asks—all the reader's questions in her own time, not his; and finally makes him admit her justice). The question is, why did Judge McKelva marry Fay?—"What happened to his judgment?" One of the ladies flatly states that Laurel's to blame; she should never have married but stayed home and tended her widowed father. Laurel makes no defense, barely speaks at all till the same lady weakens and begins "forgiving" Fay—

"Although I guess when people don't *have* anything. . . . Live so *poorly*—"

"That hasn't a thing to do with it," Laurel said.

This new ruthlessness (a specific defeat of her own attempt to forgive Fay through the child Wendell) calms in the following scene—Laurel alone in her father's library. Here, because of a photograph, she thinks for the only time in our presence of her own marriage— "Her marriage had been of magical ease, of *ease*—of brevity and conclusion, and all belonging to Chicago

and not here." But in the third scene—Laurel's con-
temporaries, her bridesmaids, at drinks—she bristles
again, this time to defend her parents against affection-
ate joking—"Since when have you all thought my
father and mother were just figures to make a good
story?" Her friends retreat, claim "We weren't laugh-
ing at them. They weren't funny." (Laurel accepts the
clarification; only at the end, if faced with "They
weren't funny," might she offer correction, huge am-
plification.) The fourth scene is longest, strangest, the
crisis—from which Laurel, the story, all Miss Welty's
earlier onlookers and surely most readers emerge
shaken, cleared, altered. On her last night in Mount
Salus before returning to Chicago and before Fay's re-
turn, Laurel comes home from dinner with friends to
find a bird flying loose indoors, a chimney sweep. She
is seized at once by an old fear of birds (we are not re-
minded till the following morning that a bird in the
house means bad luck ahead), and in panic shuts her-
self into her parents' bedroom—now Fay's—against its
flight. Here, alone and silent except for sounds of wind
and rain, among her parents' relics, she endures her
vision—of their life, hers, the world's. Her initial step
is to calm herself, to examine the sources of her recent
angers, her present terror—

> What am I in danger of, she wondered, her
> heart pounding. Am I not safe from *myself?*
> Even if you have kept silent for the sake of
> the dead, you cannot rest in your silence, as the
> dead rest. She listened to the wind, the rain, the
> blundering, frantic bird, and wanted to cry out, as
> the nurse cried out to her, "Abuse! Abuse!"

What she first defines as the "facts" are these—that
her helpless father had been assailed and killed by his

own senseless self-absorbed young wife and that she
(his only child) was powerless to save him but can now
at least protect his memory. Protect—and flush her
own bitterness—by exacting justice from Fay, extract-
ing from Fay an admission of her guilt. Yet Laurel
knows at once that Fay, challenged, would only be
baffled, sealed in genuine blind innocence. Balked in
advance then by invincible ignorance, is Laurel to be
paralyzed in permanent bitterness? She can be, she
thinks, released and consoled by at last telling someone
—the facts, the names. But tell who? Her own mother,
long since dead. To tell her mother though—should
that ever be possible—would be an abuse more terrible
than Fay's. Laurel can only go on telling herself and
thereby through her perpetual judging become a new
culprit, another more knowing Fay. That is—and can
go on being—"the horror." At that moment, desperate
with rage and forced silence, she makes the only physi-
cal movement open (the bird still has her trapped in
the room). She retreats into an adjoining small room.
It had been her own nursery, where she'd slept near her
parents; then the sewing room; now a closet where Fay
has hidden Laurel's mother's desk. Here, memory be-
gins—a long monologue (yet always in third person)
which bears Laurel back through her parents' lives, her
life with them. (The structure and method of these
fifteen pages at first seem loose, old-fashioned. No at-
tempt is made through syntax or ellipsis to mimic the
voice or speed of Laurel's mind, to convince us that we
literally overhear her thoughts. Yet the process of mem-
ory proceeds with such ferocious emotional logic to an
end so far beyond Laurel's imagined needs or desires—
Laurel's and ours—that we are at last convinced, as
shaken as she.) The memories begin warmly—here are
things they touched, relics of their love, a family desk,

a small stone boat carved with her father's initials, his letters to her mother (which Laurel will not read, even now), a photograph of them in full unthreatened youth. In the flood of affection, Laurel begins to move from her old stance of onlooker to a conviction of having shared her parents' lives, been a corner of their love. She continues backward through memories of summers in the West Virginia mountains with her mother's family. (Both her parents' families were originally Virginian; and it would be possible—therefore someone will do it—to construct a kind of snob-machine with these genealogies: Virginians are finer than Mississippians are finer than Texans. The story says no such thing; only "This is what happened"— Miss Welty's own mother was from West Virginia, her father from Ohio.) Those summers, recalled, seem made of two strands—her mother's laughing immersion in family love and her own childish bafflement: tell me how much and why they love you, your mother and brothers. This early bafflement is focused for Laurel in her first sight of her grandmother's pigeons. Without claiming a mechanical connection which Miss Welty clearly does not intend, it is worth noting that this sight is the beginning (so far as we know) of Laurel's present personal distance, her stunned passivity in the face of the Chisoms feeding on one another—

> Laurel had kept the pigeons under eye in their pigeon house and had already seen a pair of them sticking their beaks down each other's throats, gagging each other, eating out of each other's craws, swallowing down all over again what had been swallowed before: They were taking turns.
> . . . They convinced her that they could not escape each other and could not be escaped from.

So when the pigeons flew down, she tried to position herself behind her grandmother's stiff dark skirt, but her grandmother said again, "They're just hungry, like we are."

It was a knowledge and revulsion which her mother had seemed to lack—until her long final illness at least. The terms of that illness are not fully explained—Laurel's mother went blind, lay in bed for years, growing slowly more reckless and condemnatory, more keensighted in her observation of husband and daughter as they hovered beside her helpless. As the illness had extended through five years (just after Laurel's widowhood) and as Laurel now recalls it, her mother had at last endured the awful knowledge in its simple killing progression—that we feed on others till they fail us, through their understandable inability to spare us pain and death but, worse, through the exhaustion of loyalty, courage, memory. In the pit of her illness, Laurel's mother had said to the Judge standing by her—

"Why did I marry a coward?". . . Later still, she began to say—and her voice never weakened, never harshened; it was her spirit speaking in the wrong words—"All you do is hurt me. I wish I might know what it is I've done. Why is it necessary to punish me like this and not tell me why?"

Then she had sunk silent toward her death, with only one last message to Laurel—"You could have saved your mother's life. But you stood by and wouldn't intervene. I despair for you." In the teeth of such judgment, Laurel's father—the optimist—had married Fay; had chosen to submit again to need, and been killed for his weakness. What had been betrayed—what her mother like a drugged prophetess had seen and con-

demned before the event—was not his first love but his first wife's *knowledge*, the dignity and achievement of her unanswerable vision. Fay's the answer to nothing. Then can love be? —Answer to what? Death and your own final lack of attention doom you to disloyalty. You're killed for your cowardice. With that news, the scene ends. Laurel sleeps.

> A flood of feeling descended on Laurel. She let the papers slide from her hand and put her head down on the open lid of the desk and wept in grief for love and for the dead.

—Grief surely *that* love had not saved but harrowed her parents, a love she had not shared and now can never.

Part IV is a quick hard, but by no means perfunctory, coda. Laurel wakes in early light, having slept at her mother's desk. Now unafraid, she leaves her parents' room, sees the exhausted bird perched on a curtain. Mr. Deedy, the blundering handyman, calls by to peddle spring chores. Laurel asks him in to catch the bird. He declares it bad luck and scares it around from room to room but only succeeds in making a nosey tour of the house. Then Missouri, the maid, arrives and she and Laurel gingerly arrange the bird's escape in the only passage of the story where the touch seems to me to press a little heavily, uneasily—

> "It's a perfectly clear way out. Why won't it just fly free of its own accord?"
>
> "They just ain't got no sense like we have. . . . All birds got to fly, even them no-count dirty ones."

Laurel burns her mother's papers, saving only the snapshots and the carved stone boat. She calls herself a

thief—the house and contents are Fay's now—but she justifies herself:

> It was one of her ways to live—storing up to re-member, putting aside to forget, then to find again—hiding and finding. Laurel thought it a modest game that people could play by them-selves, and, of course, when that's too easy, against themselves. It was a game for the bereaved, and there wasn't much end to it.

Her calm seems complete, her departure foregone and unprotested; but in a final look through kitchen cup-boards, she finds her mother's breadboard—its worn polished surface inexplicably gouged, scored and grimy. Her numb peace vanishes, her rejection of revenge. She knows that, in some way, this is Fay's work, Fay's ulti-mate murder of Laurel's mother, the house itself, that she has "conspired with silence" and must finally shout both "Abuse!" and "Love!" And indeed Fay arrives at this moment, her return from Texas timed for Laurel's departure (the bridesmaids by now are waiting at the curb to drive Laurel to Jackson). Laurel challenges Fay with the ruined breadboard—

> "It's just an old board, isn't it?" cried Fay.
> "She made the best bread in Mount Salus!"
> "All right! Who cares? She's not making it now."
> "Oh, my mother could see exactly what you were going to do!"

Laurel has judged at last, in rage, and in rage has dis-covered the order of experience, the mysterious justice of time and understanding, her mother's final accurate desperation—

Her mother had suffered every symptom of having been betrayed, and it was not until she had died, had been dead long enough to lie in danger of being forgotten and the protests of memory came due, that Fay had ever tripped in. It was not until then, perhaps, that her father himself had ever dreamed of a Fay. For Fay was Becky's own dread. . . . Suppose every time her father went on a business trip . . . there had been a Fay.

So memory itself is no longer safe, no "game for the bereaved." The past is never safe because it is never *past*, not while a single mind remembers. Laurel requires revenge. She accuses Fay of desecrating the house, but in vain—as she'd known the night before, Fay does not understand and will not ever, least of all from Laurel (she had used the board for cracking nuts). Fay can only resort to calling Laurel "crazy," to hurtful revelation, an anecdote of Laurel's mother's last wildness—throwing a bedside bell at a visitor. Laurel raises the breadboard to threaten Fay. Fay has the courage of her ignorance, stands and scornfully reminds Laurel that her friends are waiting outside—"You're supposed to be leaving." Then Fay goes on to claim she'd intended reconciliation, had returned in time for that—"we all need to make some allowance for the cranks." Laurel abandons the weapon, one more piece of Fay's inheritance, and hurries to leave, escorted away by her own bridesmaids.

I have summarized at such length because it's my experience, both as writer and teacher, that even a trained reader (especially trained readers) cannot be relied on to follow the action, the linked narrative, of

any long story, especially of a story whose action is interior. (Ask ten trained readers what happens in *Heart of Darkness*—not what are the symbols or controlling metaphors but, simply, who does what to whom and why? Who knows what at the end? Then you'll see some darkness.) Also because to summarize *The Optimist's Daughter* is to demonstrate how perfectly the meaning inheres in the form and radiates from it. Nothing is applied from outside or wrenched; the natural speed of the radiation—action into meaning—is never accelerated (with the possible exception of the trapped bird's escape); and no voice cries "Help!" at its lethal rays—lethal to illusion, temporary need.

But the length of a summary has left me little space to discuss important details—to mention only two: first, the language (which in its stripped iron efficiency, its avoidance of simile and metaphor, bears almost no resemblance to the slow dissolving impressionism, relativism, of the stories in *The Bride of the Innisfallen*; that was a language for describing what things are *not*, for intensifying mystery; this is a language for stating facts) and, second, the story's apparent lack of concern with Mississippi's major news at the time of the action—the civil rights revolution. Its apparent absence is as complete as that of the Napoleonic wars from Jane Austen. And for the same reason, surely—it is not what this story is about. When Judge McKelva's old law partner says of him at the funeral, "Fairest, most impartial, sweetest man in the whole Mississippi Bar," no irony seems intended or can honestly be extracted. (I've stressed *apparent* absence because any story which so ruthlessly examines blindness is "about" all the forms of blindness; and if any reader is unprepared to accept the fact that in all societies at all times good and evil coexist in all men and can, un-

der certain conditions of immense complexity, be compartmentalized, quarantined from one another within the same heart, then this story's not for him. So much the worse for him—neither will most art be.)

What I cannot skimp is my prior suggestion that the puzzlement or contented suspension of onlookers in Miss Welty's earlier fiction vanishes in *The Optimist's Daughter*, that the end clarifies. The stance of the onlooker—forced on him and/or chosen—is confirmed as the human stance which can hope for understanding, simple survival. The aims of participation are union, consolation, continuance—doomed. Laurel (who might well be the adult of the girl in "A Memory" or even of Laura in *Delta Wedding*) might so easily have left us with a last word fierce as her mother's. She might have said, "Show me a victor, an *actor* even." Or worse, she might have laughed.

For there is at the end, each time I've reached it, a complicated sense of joy. Simple exhilaration in the courage and skill of the artist, quite separate from the tragic burden of the action. Joy that a piece of credible life has been displayed to us fully and, in the act, fully explained (I take Laurel's understanding to be also the author's and ours; there can be no second meaning, no resort to attempts to discredit Laurel's vision). And then perhaps most troubling and most appeasing, the sense that Laurel's final emotion is joy, that she is now an "optimist" of a sort her father never knew (if not as she drives away from her home, then tomorrow, back at work)—that the onlooker's gifts, the "crank's," have proved at last the strongest of human endowments (vision, distance, stamina—the courage of all three); that had there been any ear to listen, Laurel would almost surely have laughed, abandoning her weapon (as Milton's God laughs at the ignorance and ruin of Sa-

tan, only God has hearers—the Son and His angels).
For Laurel has been both victim and judge—who goes
beyond both into pure creation (only she has discov-
ered the pattern of their lives—her parents', Fay's, the
Chisoms', her friends', her own) and then comprehen-
sion, which is always comic. All patterns are comic—
snow crystal or galaxy in Andromeda or family history
—because the universe is patterned, therefore ordered
and ruled, therefore incapable of ultimate tragedy (in-
terim tragedy is comprised in the order but cannot be
the end; and if it should be—universal pain—then that
too is comic, by definition, to its only onlooker). God's
vision is comic, Alpha and Omega.

*1969*

## POSTSCRIPT

IN THE fall of 1971 Miss Welty revised the story on
which this essay was based; and the new version was
published in the spring of 1972, still as *The Optimist's
Daughter* though longer by a third. Despite the addi-
tions and changes, it is much the same story—so nearly
so that I have not rewritten the essay. It was the result,
glad but considered, of renewed contact with Miss
Welty's work after some fourteen years of silence; and
to revise now would be to compromise that shock of
pleasure. In any case, the story described above—both
what happens and what is meant—seems to me intact
in the new version and virtually identical with it. Miss
Welty has said, "I hope it's simply more what it was
meant to be."

Yet the addition of ten thousand words to a previous thirty thousand—and the consequent adjustments of pace, texture, emphasis—provide the opportunity to watch a powerful hand at work, refining, defining (occasionally over-defining perhaps), inventing credible irrefutable life in spaces which no reader can have noticed as blank. Since such a detailed comparison would require a long essay of its own, I'll point only to the two sets of additions which seem most substantial.

Laurel's stepmother Fay Chisom McKelva has acquired, early in the story, a refusal to admit to Laurel the existence of a living family (the numerous Chisoms who materialize crucially at Judge McKelva's funeral) —a refusal which lends human credibility to the nearly monstrous Fay and eventually casts new light on the story's love-and-horror of kin, duty, company. Laurel herself has acquired memories of and reflections upon her own long-distant love, marriage and widowhood; and those thoughts are now triggered in her by a new scene as powerful as any in the first version. At the end of her night's vigil in the room of her dead parents, among the debris of their love, her dead husband appears—

Now, by her own hands, the past had been raised up, and *he* looked at her, Phil himself—here waiting, all the time, Lazarus. He looked at her out of eyes wild with the craving for his unlived life, with mouth open like a funnel's.

What would have been their end, then? Suppose their marriage had ended like her father and mother's? Or like her mother's father and mother's? Like—

"Laurel! Laurel! Laurel!" Phil's voice cried.

She wept for what happened to life.

"I wanted it!" Phil cried. His voice rose with the wind in the night and went around the house and around the house. It became a roar. "I wanted it!"

Strong as that is, my initial reaction to it—and especially to the dream and morning reflections which it evokes from Laurel—was that it diluted the true harshness of Laurel's own widowhood. (In the first version her marriage and its brief happiness was mentioned, but hardly more; and Laurel indulges in no memories of it. The reader was allowed to deduce, from Laurel's own present and her natural forgetfulness, the harsh justice of her pure condemnation of Fay and the swarming Chisoms, her own friends, even her father.) But after several readings, the additions seem to me clearly aimed at keener definition of Laurel's belated discovery, growth and endurance; and while (as with the additions to Fay) they were not strictly required, why should they be omitted, once they have occurred to a writer in a form as rich as this?—

As far as Laurel had ever known, there had not happened a single blunder in their short life together. But the guilt of outliving those you love is justly to be borne, she thought. Outliving is something we do to them. The fantasies of dying could be no stranger than the fantasies of living. Surviving is perhaps the strangest fantasy of them all.

What Miss Welty has done seems to me to stand as an instructive parallel to the practice of those ancient tragedians who told, and retold several times, a single story vital not only to their own individual continuance as men and artists but also to the health of the state.

She described once an initially tragic, ultimately comic action of apparent personal urgency; and now, for her own reasons, she has described it again with slightly altered eyes (a changed name or two, occasionally variant reports of the ways in which characters proceed from one event and its burdens to the next). My own conviction that the story is the masterpiece till now of her short fiction and that it has not only use for readers but urgent news, the force and mutability of universal myth, is strengthened by the new version (as is my pleasure in its challenge to a tenet of post-Flaubertian fiction—the vision of a single perfect telling of a given story). Any serious reader who will read both *The New Yorker* version of March 15, 1969 and the Random House version of 1972 will be rewarded with that news and—in its two forms—with the chance for intimate encounter with the feeling, thought and procedure, the astonishing power for both summary and continuous growth of a writer as sizable as any in modern letters and certainly as deep.

# FRIGHTENING GIFT*

Eudora Welty's new novel (her first in sixteen years) is a frightening gift—because it hands us, after so long a wait, an offering of such plenitude and serene mastery as to reveal with panicking suddenness how thin a diet we survive on—little dry knots of fashion, self-laceration; windy flights from "plot and character" into bone-crushingly dull (and ancient and easy) "experiment" and, throughout, a growing and maiming attachment to the modern city as the only scene for fiction. Reading it, one is reminded that liberated prisoners of war in 1945 often succumbed to shock on receiving full rations.

Not that *Losing Battles* has gone unheralded. Miss Welty's admirers have heard of its growth for well over ten years; and any of them who backslid into doubt (would it ever appear and, if so, would it be one more arthritic mastodon of the sort that generally lumbers out in response to long waits?) were firmly rescued last year by a new long story, *The Optimist's Daughter*, her strongest work till then.

But here it is, full and finished—more than twice the length of *Delta Wedding*. As that (her first novel, 1946) was secreted around a wedding (and the final section of *The Golden Apples*, 1949, around a funeral)

* *Losing Battles* by Eudora Welty (Random House, 1970).

so *Losing Battles* grows from and eventually around a family reunion in northeast Mississippi in the mid-1930s, Depression-time. The family are the children—at least five generations—of Elvira Vaughn; and the occasion of their gathering is Elvira's ninetieth birthday and the simultaneous end of a prison term by her great-grandson Jack Renfro—nineteen, a golden boy and the family's one hope in the face of destitution, a lovable hope but clearly doomed.

Hope for what and why doomed? First, for the continuation and perpetuation of Elvira's line, of the chance for reunion, the chance for love, dependence, personal hate (as opposed to urban anonymous hate); then for rescue, the raising of a crop, simple salvation from the welfare rolls. And doomed because we have already seen or heard Jack lose every battle he has entered, except the struggle to retain sweetness, patience, self-confidence, green hope—but who and what will Jack be in, say, 1945? Defeated like his kin—but embittered? dried? hating? Those are responses which most of them have escaped. How? Miss Welty shows —through obsession with blood-ties, the duties of family regardless of "love."

Doomed also because Jack (before his sentence for "aggravated battery") has married his schoolteacher Gloria, who has borne him a daughter in his eighteen-month absence. Gloria is an orphan, a foundling whose paternity becomes a matter of deepening mystery as the novel proceeds; and though she may or may not be Jack's cousin (and thus a blood-member of the reunion), she urges Jack from the moment of his return to take her and their child and leave the ganging family, "afloat in night, and nowhere, with only each other."

Gloria's vision is simple and touching ("If we could stay this way always—build us a little two-room house, where nobody in the world could find us"); and

her persistence has been such as to suggest that she may eventually succeed in separating Jack from his family (and hers?) or, if not that, then in poisoning the well of affection by her objecting presence. Yet even if they were to go now into isolation, against Jack's will and nature, and love only one another, they would carry their own doom, palpable as their baby. All Elvira's descendants, except Jack's mother, have left—but to return, with their own loud families, their own lives submerged in dozens of others, diluted, finally lost. Lost for lack of sense—the knowledge of how to flourish, even survive, alone. (Jack's grandparents fled years ago—abandoning home, Elvira, children—only to drown in the nearest river.)

But so are all the novel's solitaries lost—the spinsters and bachelors descending into viciousness (Miss Lexie, a hateful but hilarious practical nurse to invalids) or guilty madness (Uncle Nathan, an uncaught murderer) or the grander balked but lucid rage of Miss Julia Mortimer, the schoolteacher who fought vainly for years to show her pupils (most of the reunion) some of the forms of freedom.

It is Miss Julia's rage and death which, though only reported (with appalling, again comic, power), radiate from the center of the novel with unstoppable power, the unanswerable truth to which the reunion and the human family itself are attempts at defiant answers—that solitude is, first and last, man's condition, his home, his loyal companion who will always turn lethal when its claims are ignored. As of course they must be ignored, if recognizable human life is to proceed. But should it proceed?

As beautiful, as rich in pleasure and laughter, as this novel shows the natural world to be and many of the lives in that world, it is urgent to see that *Losing Battles* finally raises such questions (they have always

been the central questions of Miss Welty's work) in forms as complex and massive as in any earlier novel in English. I am not indulging in literary-couturier's hyperbole in saying that Miss Welty's new novel is comparable, for depth and breadth and stamina, not with other American novels but with larger things—*The Tempest, The Winter's Tale, War and Peace.* And —lest the above suggest a tragedy—like them, it is comic (more, it is funny—perhaps the funniest novel since *Huckleberry Finn*). Its faith is clearly that the world is ordered, that life—even a Renfro's—unfolds to messages contained in its seed and that any man's efforts to misread the commands, even decipher them, must only end in laughter. And if only God laughs— well then, only He was watching.

But Eudora Welty has seen at least the seed and the codes packed in it, and has shown us what she sees. No one writing sees more. And no one else's writing— the actual surface of the language, the bones of the novel—says more fully and clearly, yet with more justice to the multiplicity of experience and vision, what is seen and known, what in fact is partly discovered for her and for us *by* the language this story has produced in her mouth, a language almost entirely devoted to human speech and supported on literally thousands of metaphors and similes. Everything is and is not what it seems; is itself but slides as we watch and listen, into some other thing (now its brother, now its enemy), a metamorphosis which grips not only objects (trees, houses, dishes) but people and their actions, all created beings, good itself and evil, and comes to rest in only one mind, the maker's.

1970

# THE WINGS OF THE DOVE
## A SINGLE COMBAT

Tolstoy, in the blind lucidity of his age and conversion, consigned all his own fiction to the category of bad art, exempting only two short stories, "God Sees the Truth But Waits" and "A Prisoner of the Caucasus." No sane reader has ever believed him (five years before his own death, drowned in *Finnegans Wake*, Joyce wrote of one of Tolstoy's late fables, "In my opinion *How Much Land Does a Man Need* is the greatest story that the literature of the world knows"); * but a large share of the agony of Tolstoy's old age boils steadily through him from that conviction—*Most of my work is worthless, even wicked*. Pain on that scale commands at least respect. And we might have considered more carefully his awful self-mutilations; grappled with his aesthetic, not merely dismissed it as puritan crankery.

Henry James has not been believed either—not by his admirers; his detractors are hungry for any concession—when in his preface to *The Wings of the Dove*, written nearly ten years after the novel, he calls it a failure. Not in so many words of course—

Yet one's plan, alas, is one thing and one's result another; so that I am perhaps nearer the point in

* Stuart Gilbert, ed., *Letters of James Joyce* (Viking, 1957), p. 364.

saying that this last strikes me at present as most characterised by the happy features that *were*, under my first and most blest illusion, to have contributed to it. I meet them all, as I renew acquaintance, I mourn for them all as I remount the stream, the absent values, the palpable voids, the missing links, the mocking shadows, that reflect, taken together, the early bloom of one's good faith.

And notice that he does not concede a failure of conception or vision, only of execution. All his examples of failure (all of them just; almost all of them ignored by those who think *The Wings of the Dove* his masterpiece) are essentially failures of technical economy—this or that character is skimped, this part is disproportioned to that and (worst, he implies) the latter half of the novel is "false and deformed . . . . bristles with 'dodges.' "

Well, a declaration—I admire James more than many, less than some; but I believe him about this novel. He was no masochist, professed no fake humility; years after finishing *The Wings of the Dove*, he saw that it failed. I believe he was right.

But failed to do what?—and how? How might he have succeeded? My own strong feeling is that his sense of failure is intuitive, muffled, not understood, and that his list of mere technical errors, while accurate, is no more than a screen, one more screen erected between himself and his subject. And the screen, as so often, is built of near-chatter. In fact, his own diagnosis of the major technical error seems to me the reverse of true —the first half is the distended, time-serving half; only in the second does he begin to edge toward the buried subject, to accept the force of the magnet of his interest, his helpless obsession (the second half suffers from

omissions, starvations).

What did he conceive his subject to be? In the preface he defines what he calls his *motive* or *idea*—

> a young person conscious of a great capacity for life, but early stricken and doomed, condemned to die under short respite, while also enamoured of the world; aware moreover of the condemnation and passionately desiring to "put in" before extinction as many of the finer vibrations as possible, and so achieve, however briefly and brokenly, the sense of having lived.

Then he summarizes—a little tidily and unconvincingly, as always—the metamorphosis of that given into his final plan, his pattern:

> My young woman would *herself* be the opposition —to the catastrophe announced by the associated Fates, powers conspiring to a sinister end and, with their command of means, finally achieving it, yet in such straits really to *stifle* the sacred spark that, obviously, a creature so animated, an adversary so subtle, couldn't but be felt worthy, under whatever weaknesses, of the foreground and the limelight.

He never, in the preface, mentions a fact which he freely owned in letters and implied in his memoirs and which has since become one of the most famous facts of his life—the relation of *The Wings of the Dove* to the death of his beloved cousin Minny Temple at twenty-four of consumption. It is possible to trace through his letters, notebooks and scenarios his lifelong intention to memorialize Minny in a novel; but for all Leon Edel's cautious and credible suggestion that James felt relief and therefore permanent guilt at

Minny's death—now he would not have to marry her, only love her—nothing is explained. *The Wings of the Dove* intends, secretly if not consciously, to be a good deal more than an elegy to Minny Temple, more than a lovely pavan on the death of a beautiful girl, a princess who yearned to live. (James had said of Minny, "Death, at the last, was dreadful to her; she would have given anything to live"; and perhaps more revealingly to his brother William, "I can't put away the thought that just as I am beginning life, she has ended it.") *

The book itself—the finished book—yearns. And it is that sense of yearning—in James; in the material itself, plot and character—to be the last word on something other than poor Minny Temple (or Milly Theale) which raises the richest questions about it and hints at least at their answers. *The Wings of the Dove* struggles—against James himself—to be the full, perhaps final, statement on James' central lifelong obsession—betrayal, treachery. Graham Greene was among the first, and is still the most eloquent, to have tracked the theme. In 1936 he suggested, "It is possible that through Wilky and Bob we can trace the source of James's main fantasy, the idea of treachery which was always attached to his sense of evil." † (Wilky and Bob were the two James brothers who served in the Civil War; and Green suggests that Henry's own mysterious avoidance of service may be the seed of his fantasy—there two persons are betrayed by one.) And again in 1947, Green returns to the theme, with no theory now of its genesis—

* Leon Edel, *Henry James: The Untried Years* (Lippincott, 1953), pp. 332, 326.

† Graham Greene, "Henry James: The Private Universe," *Collected Essays* (Viking, 1969), p. 35.

what deeply interested him, what was indeed his ruling passion, was the idea of treachery, the 'Judas complex'. . . . We shall never know what it was at the very start of life that so deeply impressed on the young James's mind this sense of treachery; but when we remember how patiently and faithfully throughout his life he drew the portrait of one young woman who died, one wonders whether it was just simply a death that opened his eyes to the inherent disappointment of existence, the betrayal of hope. The eyes once open, the material need never fail him. He could sit there, an ageing honoured man in Lamb House, Rye, and hear the footsteps of the traitors and their victims going endlessly by on the pavement.*

Granting the passion, I would suggest that the treacheries in James' fiction do not generally take a one-to-one form (Judas vs. Christ or, say, Henry vs. Minny Temple or Constance Woolson) or the form of one-betraying-two (as in Henry vs. Wilky and Bob). No, doesn't the theme burn most intensely, writhe most painfully, when there is a *gang-up* (secret at first but later revealed—because intended to be revealed; therefore hurtful, even lethal)?—two against one. The tutor and the pupil against his parents, Miles and Flora (and the ghosts) against the governess, Kate and Densher against Milly, Amerigo and Charlotte against Maggie (and her father). In fact, if betrayal is at the center of *The Wings of the Dove*, isn't Kate after all the most terribly betrayed? Milly merely triumphs.

And in all those examples, the treachery is—in some degree—sexual. Some character is always brought to an agonized moment which might be spoken thus—

* Graham Greene, *"The Portrait of a Lady,"* op. cit., p. 60.

*Those others there—those two in shadow—are having*
*together the thing I require, which they refuse me. But*
*look, they are moving into light to show me!* James'
recognition of the degree of sexuality involved ranges
from apparent and embarrassing blindness in "The
Pupil" (1892) through the teasing, near-coyness of *The*
*Turn of the Screw* (1898) to the veiled, subaqueous yet
brutal thrusting of *The Golden Bowl* (1904). Yet it is a
continuously growing recognition, an almost straight-
line journey toward fullness and daring until, in *The*
*Golden Bowl*, he manages a treatment of adult sexual
hunger, fulfillment, damage and regret as complete as
any in western fiction before, say, Lawrence. Only
Tolstoy in *Anna Karenina* and perhaps Stendhal (cer-
tainly not Flaubert or Hardy, who badly needed to be)
were as successful in working round the restrictions of
censorship, public and personal. The triumph of all
three—including James in *The Golden Bowl*—is that
they supply for us, but entirely by implication and in-
direction, all that we require to know about the sexual
needs, behavior (the actual techniques) of their pro-
tagonists. Their methods are similar—their lovers are,
first of all, beautiful (therefore desirable to the reader),
relatively "healthy" in relation to their sexuality (there-
fore readily followable, as opposed to Bovary or Tess or
the women of Dickens); and great technical care is
taken to impress upon us, early and throughout, their
visible physical presence, their animal odor, so that
when the necessary veils descend, we can by simple ex-
tension penetrate them and watch. It is entirely rele-
vant to see that a reader of *The Golden Bowl* can take
this paragraph (preliminary to the first adultery of
Amerigo and Charlotte) and extend it through the
next half-hour of unrecorded action. Not only can but
must, for a full reading of the joy, offense and pain
James intended—

"It's sacred," she breathed back to him. They vowed it, gave it out and took it in, drawn, by their intensity, more closely together. Then of a sudden, through this tightened circle, as at the issue of a narrow strait into the sea beyond, everything broke up, broke down, gave way, melted and mingled. Their lips sought their lips, their pressure their response and their response their pressure; with a violence that had sighed itself the next moment to the longest and deepest of stillnesses they passionately sealed their pledge.

But that is later than *The Wings of the Dove*—though since it is by only two years, we can safely assume one of two reasons to explain James' far greater reticence in the earlier novel on the crucial matter of Merton Densher's passion for Kate, the hold over him of which she is conscious and which she manipulates coldly—either James considered a fuller treatment of their union and decided against it for some technical reason, relevant to the novel only, or he feared it. Since the suppression results in a serious thinness in his fabric, I assume that—in this story, with these characters —he feared their sexuality, this particular set of acts. Imagine what an extraordinary flood of light (not necessarily lethal or even corrosive) might have been shed upon Densher's bondage to Kate and upon Kate as an even more complex and powerful (and frightened) tiger than she now appears—if James had only chosen, or been able, to *see* and dramatize for us, the hour of their first intercourse in Venice. Or of how Densher would have been complicated if James could have occupied all of his head, dramatized the daily workings, ravages, of his hunger—a little coarsened, no doubt, but so much more credibly humanized and comprehensible in his subservience to Kate, in his otherwise

unexplained inability to do a stroke of work in the novel (he talks of wishing to write) and in his growing, unwilling entanglement with Milly, a dying body.

It is impossible to guess now—even if we possessed the concluding volume of Edel's biography—at the reasons, in 1902, for James' flight from the sexuality which stands so centrally in *The Wings of the Dove* (it would not be untrue of the *story* to say that it is a murder story, as lurid in its own way as that of Sir Thomas Overbury, in which the motive and fuel is sexual lust). I've mentioned Graham Greene's early suggestion that James' obsession with treachery may have sprung from his conviction of having malingered his own way out of the Civil War while permitting two of his brothers to go and be psychically (at least) destroyed; we still read occasionally claims of his impotence, his mysterious early accident (though Edel has convincingly laid those to rest: he injured his back); and there are increasing suggestions (especially in Edel's fourth volume and in surviving second-hand oral tradition) that James accepted only very late in life the fact of his own homosexuality (therefore, treachery to all women, above all his mother—for among the paradoxes of the thoughtful homosexual is a realization that should the Oedipal dream be granted, father removed and mother led bedward smiling, he would alas fail her; he would no longer want her); but it would be ignorant and falsely reductive to accept any or all these as explanations for a permanent personal demon of such strength as this one that rode James into his work. (My own tentative observation would be that, however strong the obsession, James is capable of "identifying" now with the betrayer, now with the victim. In *The Wings of the Dove*, for instance, he inhabits, almost entirely, Densher and Kate; but in *The Golden Bowl*, he in-

habits Milly—we never "understand" the feelings of Charlotte or Amerigo. And I might, in justice, record the casual and quasi-disastrous question of a friend of mine—"Aren't all novels secreted round a betrayal?")

No, but what is important is to recognize that something has apparently forbidden James to tell his given story in *The Wings of the Dove*—to tell it in the only way it could have been told and in the way he seems to have intended to tell it—dramatically, scenically. I've read a number of the eloquent defenses of the novel which claim that it is precisely that—entirely dramatic (see Percy Lubbock's in *The Craft of Fiction* for the most ingenious case); but a quick glance through the pages will show what a majority of burdened readers know—that for any one page treated scenically, with the hieratic intensity which is entirely James' own and one of the most impressive gifts acquired in his later years (though subject, often, to deflating guffaws—*Come, ladies, this is only a tennis match; the world is unmoved by your little game!*), there will be a number of those gray unparagraphed pages which, whether they intend to inhabit a character's head or (in pursuit of James' blessed economy) to summarize a sequence of ungiven scenes, remain so often inert and obscuring—the monologue of an artist who has locked himself out of his subject and, to pass the time till he dares re-enter, must lurk on the stoop (but must never cease talking, dictating this day's stint). He recognized the error himself. He writes in the preface,

> I haven't the heart now, I confess, to adduce the detail of so many lapsed importances; the explanation of most of which, after all, I take to have been in the crudity of a truth beating full upon me

through these reconsiderations, the odd inveteracy
with which picture, at almost every turn, is jealous
of drama, and drama (though on the whole with a
greater patience, I think) suspicious of picture.

Given my own understanding of James' under-
standing of his subject and characters then, what might
have been his way of writing the novel? First, I should
state what I take to be his story. Kate Croy, a beautiful
young woman made desperate by an uncertain and im-
poverished childhood, has simultaneously come to live
with her wealthy, vulgar and imperious Aunt Maud
and fallen in love with a handsome and almost equally
poor young journalist, Merton Densher. In the teeth of
Aunt Maud's intentions of a better match, the lovers
pledge a permanent but secret troth as Densher pre-
pares to depart for America, on his paper's business.
There he meets, casually and with no great interest,
Milly Theale, a young New Yorker, orphaned and the
heiress to immense wealth, who is about to depart for
Europe with an older companion, the widowed short-
story writer Susan Stringham whose heart Milly has
won. (There are hints that Milly is seriously ill.) While
Densher continues his American tour, the ladies sail to
Italy, cross the continent slowly (with further omens
of Milly's condition) and arrive in London—where
Milly becomes the immediate toast of Aunt Maud's
tacky circle (Aunt Maud is an old schoolmate of
Susan's). As quickly, Milly and Kate become intimates
(neither knowing of the other's acquaintance with
Densher). But soon Milly, accompanied by Kate, is
consulting Sir Luke Strett, a famous physician. He is
at once fascinated by her—her person, her case, her

solitude and freedom (there is some suggestion that he may be infatuated with Milly)—but though he soon tells Susan of the gravity of Milly's condition (we are never told the disease but, despite Kate's denial, consumption seems implied), he never prescribes more to Milly than that she *live*, seek happiness. It is a prescription which she seriously attempts to take. But now Aunt Maud has learned of Milly's meeting with Densher and asks Milly to discover if Densher has returned to England and is again seeing Kate. (Aunt Maud intends Kate for Lord Mark, a member of her circle, who has however begun to eye Milly.) Milly has no sooner said that she believes Densher still absent when—on the morning of Sir Luke's talk with Susan—she surprises Densher and Kate in the National Gallery. Fascinated, Milly still does not fathom the extent of the relation (she assumes that Densher loves Kate but is unreciprocated); and soon Kate is proposing that Densher capitalize on Milly's clear infatuation with him to permit them—Kate and Densher—to meet more openly. Further, Kate knows that Milly is ill and offers Densher the excuse that he can console Milly. So intense by now is Densher's sexual fascination with Kate that he cannot refuse; and he calls on Milly, who —attempting to follow Sir Luke's advice—complicatedly welcomes him, as the occasion for "living." She has assumed, without asking, that Sir Luke has told Susan of the gravity of her illness. She knows, at least, that he has ordered her to leave London for three months. She goes to Venice, takes a palazzo and—attended by Susan, Kate, Aunt Maud, Lord Mark (who soon departs, refused by Milly), Densher and a staff—accepts the role of princess urged on her by all. She knows by now that she is "very badly ill." It is there, at last, in his rented rooms (where he has hoped to

write but cannot) that Densher persuades Kate to bed
with him—only after Kate, now certain of Milly's ap-
proaching death, has forced him to promise to marry
Milly, for her money and their freedom. Densher does
permit Milly to believe that he loves her, remains in
Venice (unable to work) because of that love; but he
has not brought himself actually to propose ("It was
on the cards for him that he might kill her") when he
finds himself, after six weeks, without explanation, no
longer received by Milly. Immediately thereafter, he
discovers Lord Mark (balked of both Kate and Milly)
in the Piazza and realizes that he—freshly returned to
Venice—is somehow the cause of Densher's exclusion
from Milly. After three solitary days, he is visited by
Susan, who tells him that Milly is worse, has not so
much as mentioned his name in three days—and then
that Lord Mark has informed Milly of Densher's secret
engagement to Kate. Susan asks him to deny it, true or
not, to save Milly's life. Densher responds only with a
baffled "Oh!," and they await the arrival of the ur-
gently summoned Sir Luke. After more days of silence,
Sir Luke, departing, conveys to Densher a message
from Milly that he call on her and that Milly is "bet-
ter." That visit is not directly communicated to us. We
see Densher next in London, where he has waited two
weeks before contacting Kate. Kate at once informs
him that Milly is dying, that Sir Luke has rushed again
to Venice. Densher explains the reason for Milly's
haste—Lord Mark's revelation. Kate accepts, ambigu-
ously, a share of the guilt for Milly's knowledge but
asks why Densher could not have denied the story. He
replies that he could not; that in any case it would not
have helped Milly now, sick as she is. He even adds,
ominously, that had he made the denial, he would also
have made it true—broken their engagement. Only

then do we get from Densher any hint of the final in-
terview with Milly—and then only that she merely,
and pleasantly and without signs of disease, asked him
not to stay in Venice any longer. Kate's satisfied vision
is that Milly is dying in peace, with the knowledge "of
having *been* loved"; that therefore her own deceit and
Densher's is blessed. But Milly's wings hover too closely
over Densher now. He feels his relation to her to be
beautiful, sacred, and that he is now "forgiven, dedi-
cated, blessed"; and though he feels both able and com-
pelled to marry Kate at once, she refuses—her plan is
incomplete; Milly still lives. But Milly dies at Christ-
mas and Densher, knowing that, receives a letter from
her, which he cannot bring himself to open. He car-
ries it to Kate, who announces without opening it, that
she knows the contents—Milly has made him rich.
Then she burns the letter. Two months later, her guess
is confirmed—Densher learns from New York of a large
bequest to him. But in a final meeting with Kate, in
his rooms, Densher refuses to accept it—Kate may
have it if she likes and go her way. Or, without it—as
they were—he will marry her "in an hour." The un-
acceptability—impossibility—of either choice expels
Kate from the rooms, and his life, forever.

That is, I think, a summary of the action which
would be acceptable to the finished novel's warmest
admirer, give or take a detail. Now again I suggest that
the story is untold—or is *only* told (recited at us) in a
number of places and, in several crucial places, not told
at all. A glance back through the summary suggests a
number of baffling omissions, figures hastily sketched
and demanding fuller work—what is the full nature of
Sir Luke's interest in Milly (he appears to be unmar-
ried)? What is the background of Densher's agonizing
case of sexual rut?—is he virgin before Kate? How ex-

actly does Kate act in their one embrace? What is its meaning to her? Was she a virgin? What is the meaning to Densher of his work? Is he a *good* writer? Why do we have no samples? What is the source of his income when he is idle? What is the full nature of Lord Mark and his interest in Milly, Kate and Densher (there is a hint of his homosexuality)? How does he learn of the betrothal? What is the full atmospheric, sensory role of Venice in the action (there is extraordinarily little detailed scene-painting)? Doesn't a great deal of Densher's moral evolution in Venice (his solitary thinking) need to be scenic?—thought can be scenic. Why may we not see fully the final interview between Milly and Densher? Why are we given nothing of the thoughts and actions—the awful sights—of Milly's last days and death? (In the preface, James says, "Heaven forbid that we should know more"—I'd think Heaven required it.) Isn't a great deal of the famous difficulty of the late prose produced not so much by the convolutions of the method, the complexities of the subject, but simply by haste in composition and the fact that the novel was dictated to a typist, not written by hand? And to name only two of the other matters which are hinted, then abandoned, their effects forbidden—what is the background of Kate's passionate hatred of illness ("I'm a brute about illness. I hate it.")? What of the undertones of lesbian love in almost all the numerous female relations?

If you grant that even a small number of those questions are valid, then you must return me to the postponed question—what other fictional method might James have employed? —Only, I suspect, that method which he is often credited with developing or at least perfecting but which comes to an earlier and richer growth in writers who offended his passion for

form and economy—Tolstoy, Dostoevsky. It might be called the Dramatic-Cerebral or the Thinking Dramatic—that is, a method whose faith is in the dignity and visual comprehensibility of objects (people, rocks, buildings) and whose conviction is that if all the objects relevant to a given action can be clearly and truly shown (literally pictured in language), heard (through dialogue) and overheard (through a conventionalized rendering of the relevant thoughts of characters), then the given story, so long as it concerns essentially sane men and women in a recognizably organized society, will be told, so far as it is possible to tell. *Anna Karenina, The Brothers Karamazov.*

This is not to beat James with other men's sticks, even geniuses'. It is only to say that—faced with the action, characters, themes, the secret impulses and pressures of *The Wings of the Dove* and James' own admission of failure—I can imagine no alternative. If he could have forced himself to face every turn of his story as *scene*, to trust in the rendering of action and speech (and ruthlessly to reduce his own hovering authorial presence, a presence he had deplored in "The Art of Fiction"), to do the full work of imagining and conventionalizing the individual thoughts of characters (notice that, so often, such thoughts as he renders *sound* only like—James), to say "Heaven forbid!" to no necessary horror—then we'd feel his purpose, his pattern would be wrought. We would have learned it, not been told. (It is this almost ceaseless *telling* which combines with his abandonment of all but a few explicit visual effects—Milly's clothes—to make him seem, in the late novels, like one of the great blind poets—Milton, Joyce.) Wouldn't this, you say, produce a novel far longer than the existing novel? Yes, thousands of pages—Tolstoy again, Proust, Dostoev-

sky, Samuel Richardson: no expendable page; no whole
scene, at least. But surely it would not result in a novel
which diminishes, not intensifies, the complexity of ex-
perience. For, by so steadily diminishing the literal
visibility of his figures in *The Wings of the Dove*, James
has diminished our interest in them either as "human
beings" or as ciphers in his game. He has also (and by
no means incidentally) diminished their own threat to
him, their creator. The late method so often risks earn-
ing the description which James himself applied to
puppet shows—"What an economy of means—and
what an economy of ends!" It can be meager, even
easy.

But is this more than an exercise in futility? Was
such an alternative conceivably open to James in 1902?
I have glanced at his scorn of an entirely scenic method,
as practiced by the great Russians. Here is a full state-
ment, from a letter to Hugh Walpole, written in 1912—

> Don't let any one persuade you—there are plenty
> of ignorant and fatuous duffers to try to do it—
> that strenuous selection and comparison are not
> the very essence of art, and that Form is [not]
> substance to that degree that there is absolutely no
> substance without it. Form alone *takes,* and holds
> and preserves, substance—saves it from the welter
> of helpless verbiage that we swim in as in a sea of
> tasteless tepid pudding, and that makes one
> ashamed of an art capable of such degradations.
> Tolstoi and D.[ostoevsky] are fluid puddings,
> though not tasteless, because the amount of their
> own minds and souls in solution in the broth gives
> it savour and flavour, thanks to the strong, rank
> quality of their genius and their experience. But
> there are all sorts of things to be said of them, and

in particular that we see how great a vice is their lack of composition, their defiance of economy and architecture, directly they are emulated and imitated; *then*, as subjects of emulation, models, they quite give themselves away. There is nothing so deplorable as a work of art with a *leak* in its interest; and there is no such leak of interest as through commonness of form. Its opposite, the *found* (because the sought-for) form is the absolute citadel and tabernacle of interest.*

So it would be difficult enough to imagine James choosing a method (or returning to it; he'd employed it earlier, extensively) which seemed to him now so unshapen and wasteful. (And yet—even granting James a temperamental aversion to the Russians, couldn't he have seen that their method, scorning charges of its inimitability, was a bow for Odysseus, an instrument usable only by precisely what James claimed to be—an artist, the high-priest of the sanctity of appearances, the visible world?) And there were other pressures directing him forcefully elsewhere—the increasing importance of sexuality in his late work (or his increasing consciousness of its importance; it had always been there, though often embarrassingly ignored) clearly drove him, technically and personally, toward the methods of indirection; then, urgently (but not really discussibly), language was now arriving in his mouth (for unrecoverable reasons—he had had *his* life) in more and more complex, writhing and opaque forms (and the mouth was the page, as we've seen—a fact which suggests that the best hope of reading the late novels is *aloud*, to say them back to him); there was

* Percy Lubbock, ed., *The Letters of Henry James* (Scribner's, 1921), II, pp. 237–238.

the matter of habit and the necessity of speed (he had always worked rapidly—several books a year in many years—and the prospect of a five or ten year effort may have been literally unthinkable to him; he lived by writing, he needed cash, which the late books hardly made); finally—and I'd guess most powerfully—there was the matter of his subject, the past of his theme, its potential for killing raids on his psyche.

That returns me to my earlier suggestion that this particular subject (for whatever reasons—his relations with Minny Temple, with his brothers, his parents, whoever) was one which James, at this time, was prevented from treating fully—not by the literary conventions and repressions of his time (he circumvented them brilliantly, and shockingly, earlier and later) but by personal fears. James' last completed novels—*The Wings of the Dove* and *The Golden Bowl*—cast a strong backward light on all his previous work and show him to stand, not where he wanted us to think he stood (with Turgenev and Flaubert, lucid and aware) but with Kafka—as lurid and mad in his own quite private way, as desperate in his efforts at comprehension and self-healing and often as helpless. Not in *The Golden Bowl*—that triumphs, but triumphs in turning on the threats, staring them all into basilisk stone; the method works, both reveals and heals, though both operations are monstrous—but certainly here in *The Wings of the Dove*. He knew it, of course, long before us.

Then—so what? Should the novel not exist? Should James never have attempted it or, at least, never published it? Should it not be read? On the contrary, strongly. I'd call it his second most interesting novel (first, *The Golden Bowl*) and the richest source of all for a study of the workings of his final manner,

its relation to his life as both enemy and shield. There is a whole category of deeply flawed works by masters which, literally through their rifts, permit us to see more deeply toward their centers of origin than do any number of sealed perfections—the last *Pietàs* of Michelangelo, Shakespeare's *Tempest*, Milton's *Samson*, Beethoven's *Fidelio*, Tolstoy's *Resurrection*, *The Wings of the Dove*.

Without yielding any of the foregoing, I can still understand, and all but agree with, F. O. Matthiessen's assessment of it—

> In a more restricted but very relevant sense one may also look for the essential design, not through the successive stages of an artist's whole development, but in his masterpiece, in that single work where his characteristic emotional vibration seems deepest and where we may have the sense, therefore, that we have come to 'the very soul.'
>
> Such a book in James' canon is *The Wings of the Dove*.\*

It is most of that. And it has real splendors, scenes as powerful as any in all his work, as any west of Moscow—the last gathering at Milly's palazzo with Kate like a bronze python coiled loosely round the room but waiting, ready and competent; the destruction of Milly's unopened letter, an act so large in its forward and backward revelation as to surpass any ordinary notion of "symbol" and become pure action, any novelist's greatest dream, where a single hand moving from here to here lays open whole lives; the final meeting of Densher and Kate where their stored-up acts march inward to meet them with the crushing tread of an ending

* F. O. Matthiessen, *Henry James: The Major Phase* (Oxford, 1944), pp. 42–43.

Bach fugue; the many scenes in which two characters stand alone in a room, cubes of air between them, and say to one another, not what any imaginable "human being" might have said but the awful monosyllables of what they *mean* to say, a secret language of hate and longing which was how James had come to hear the language of men, as strange to him now, as unresonant, as Martians.

It isn't, though, "his masterpiece." He made that clear himself; no one would have known better (his own candidate seems to have been *The Ambassadors*). Too often it is best described by a passage from itself—

> an impenetrable ring fence, within which there reigned a kind of expensive vagueness made up of smiles and silences and beautiful fictions and priceless arrangements, all strained to breaking.

But I don't know another work of his—of any great novelist, for that matter—which demonstrates more intensely, movingly, maddeningly, frighteningly and rewardingly the dilemma of an artist whose subject has seized *him* and will not relent, will neither free him nor permit his success, will inflict awful wounds for every infidelity—every flinch or flicker—yet will maim him at last for his helpless devotion. Again, I think of Kafka, his spiritual brother—

> You do not need to leave your room. Remain sitting at your table and listen. Do not even listen, simply wait. Do not even wait, be quite still and solitary. The world will freely offer itself to you to be unmasked, it has no choice, it will roll in ecstasy at your feet.*

* Franz Kafka, *The Great Wall of China* (Schocken, 1946), p. 307.

That contains, in full terror, the dilemma of James in *The Wings of the Dove*. His subject came—his old loyal subject, the world he knew, rolled grinning on his floor. If he—being himself, having weathered his life—was forced to rise, move farther away and (far from being silent) was compelled to talk at its uninvited ecstasies, I can still see courage in his being there at all, his struggle to watch. The novelists of my own generation—most of whom ignore him, an irrelevant spinster—might learn from the sight, the uneven combat, invaluable lessons in stamina and courage. So might Hemingway, say—whose own combat, set down beside James', seems often conducted under lights, before cheering fans. So might any reader. Courage is honored in proportion to the threat, to the victory won.

1969

# DODO, PHOENIX OR
# TOUGH OLD COCK?

Whither the Southern novel? Anyone who has lived and tried to write fiction within the bounds of the old Confederacy in the last ten years has heard that question, and been asked to answer it, only slightly less often than "Whither race?" No one imagines that the first question is more urgent than the second—though even in the deepest South there are sane men who suspect the two questions to be intimately and secretly related, perhaps symbiotic—and few serious novelists have the time or need to answer such idle, hilariously unanswerable questions as the first, knowing, like artists in any art, that *the novel* has never existed, only *novels*, and that Southern novels will proceed, if at all, not by anyone's diagram or battle-plan—there are whole careers, whole magazines devoted to making nothing else—but as they always have: by miracle. By the unpredictable, so far unmanageable but apparently not accidental births of babies who will in their teens and twenties—because of the specific weight of their experience upon certain cerebral and coronary tendencies (genetic? or even more directly God-given?)—begin to produce long works of narrative prose fiction. Any plans or diagnoses which advance beyond that bedrock, however sane and studious the planner, are no more than sibylline mutterings-amongst-the-offal (or self-justifications, screwings-up of courage or face: *whither me?* or *whence my silence?*).

So—my own answer (or a sketch for this week's answer), my own justification, quick calisthenics as I poise at the brink of a sixth book of fiction (Southern: by a Southerner; set in the South and about the South, among other places). But first a little brush-clearing to state at least an intelligent question. I've suggested that there never was a Southern novel (though there are already sober-looking guides to The Novel in North Carolina or Mississippi or Georgia). I'll go further—there was never a flood of good novels out of the South, though there was and still is a thick torrent of prose fiction, no better than most—and my question will be something like this: will strong fiction (attentive, passionately perceived, freshly and honestly built, useful beyond the Mason-Dixon) continue to trickle out of a geographical region defined as the old Confederacy, a country larger than France? If so, will it come from natives and long-term inhabitants or, indiscriminately, from writers who, in an increasingly mobile population, happen to pause there?

First answer: why wouldn't it?

—Two strong reasons maybe: (1) that the old South is used-up, worked-out, as a vein for novelists and (2) that the new South will prove unworkable, not a vein at all but a Medusa.

To consider the question of exhaustion—and for a change, from the point of view of a novelist, not a reader or a literary journalist: I've never heard a Southern novelist, good or bad, speak more than momentarily about the South-as-exhausted-vein. (I've spoken of it momentarily myself, usually after a bout of reading journalists on the subject, journalists who assume that because *they* are exhausted, with a quantity of reading which they have after all volunteered to do, therefore the South is—or the midwest or urban Jewry or, tomorrow, the black ghetto.) But I do hear the lament from

everyone but writers—"Oh, you're a Southern novelist. How brave!" (and, *aside,* "How sad! how touching!"). But then how brave to have been a painter in fifteenth-century Rome, a composer in nineteenth-century Vienna.

For surely what is exhausted is the *reader* of Southern fiction of the past forty years, not the South or its novelists. And exhausted by what?—as always, by quantity not quality. The publicists of any renaissance—especially among an oppressed people (ex-Confederates, Jews)—can hardly be blamed for their early delirium; but any publicity is doomed to sate an audience very quickly—and in our case, to sate it with what amounted to a serious inaccuracy: that the South swarmed with genius. It didn't, though considering its size, the length and range of its history, the South can come honorably out of a cool examination of its fiction in the past forty years. In fact, its record as a country can stand with the simultaneous record of any other country—with France, Britain, Germany, the rest of America. For since 1930 the South (as literal cradle and crucible) has contained the careers of three novelists of world stature—William Faulkner, Robert Penn Warren, Eudora Welty—and of two masters of the short story—Katherine Anne Porter, Flannery O'Connor. Three women, two men—four of them from or concerned with the deep South, one from Texas.

Unquestionably there have been in the same period other distinguished Southern novelists and story-writers, not to speak of poets and dramatists; and in another ten years the list may well bear another two or three names (there are strong visible candidates). But I think my point is clear. Insofar as there is any sense of exhaustion with the South-as-literature, that exhaustion is felt only by readers (and by professional readers, at

that) who have forced themselves to consume large quantities of the fiction—first-rate or fifth—emerging from so peculiar, so high and gamy a culture as that of the old South.

The situation is radically different for young Southerners who think of themselves as novelists and are beginning their work now. If they have read widely in the fiction of their region (by no means a certainty; I hadn't until I had written two books of my own), they may indeed feel that certain objects and themes have been handled so frequently and obsessively, well and badly, as to be dangerously worn, the comic-Southern stereotypes—odorous ladies with memories of the War in mansions by swamps hung with moss and moccasins where dead blacks are dumped for misdemeanors. And yet, and yet—most Southerners my age (b. 1933) and thousands born in 1971 have had or will have early, intense and formative encounters with a number of living originals of the types. And more—bellied sheriffs, beloved and loving retainers, revival preachers, claustrophobic families, tottering rhetorical childhoods drowned in lonely backwaters fed by books (not Southern) and dreams of escape.

If these Southerners have had their very educations as writers determined in part by realities which now arouse conditioned boredom in a small over-read audience, what are they to seize as their themes and subjects when their experience requires, compels the order of fabulation? —Their experience, of course; the matter on which they can speak with authority, their lives, their literal visions, the mysterious inventions and combinations which their imaginations extract from, force into, that experience. For any serious novelist who is sane enough to ignore book-journalism will know, as cornerstone of his work, that if the compulsion to write fiction

continues in any one organism, then the exhaustion of a portion of a given decade's journalists with a given subject or region is precisely meaningless since it is produced by the unavoidable plethora of lesser work summoned by a local genius' call and promoted by the hucksters of a free economy, work whose memory and force will survive (twenty years hence) only in the author's family and in graduate English departments. The man who can and must merely proceeds, trusting the heat of his own vision to vaporize accretions, dissolve patinas, reveal the thing itself. In any case, time—if time continues—will winnow the products. Whoever wrote for less than time?

And no one maintains that the past forty years have seen no changes in the old South—its look, sound, smell, the charge in air and objects. Enormous changes, apparently, though most of them so recent (since 1945) as to be beyond measurement or tests for permanence, influence, direction. Industrialization, urbanization, integration, uglification. Yet however great their threat to all that has been meant by "South"—and the first two would seem the great threats, as they did to the Agrarians in 1930—the fact remains that vast stretches of the old South remain untouched by the twentieth century. *Survive* is perhaps more accurate, but *surviving* as opposed to *flourishing* has always been the supreme Southern specialty, black and white.

When Eudora Welty's *Losing Battles* was published in 1970, several of the more serious reviewers (I saw a handful of the old "What?-more-hillbillies?" groans; my own two earliest novels got a fair amount of hillbillying when in fact they dealt with characters who live two hundred miles east of the nearest hill and are as distinct from hillfolk as from Brooklyn cabbies) suggested that, strong as it was, this was clearly the last

Southern novel, since the South that had fueled Faulkner and Miss Welty was gone and good-riddance.

Nonsense. The old South—the Confederacy, still spiritually intact, with the difference only that the slaves were called servants—continued in alarming good-health into the late 1950s and throughout the whole huge region, Mississippi to Virginia, country and town. And today I can leave my house, midway between Duke University and Chapel Hill, walk five hundred yards and be in houses and among people, white and black, who could today conduct mutually intelligible, agreeing dialogues with their resurrected great-grand-parents and who, for all that, do not see themselves as isolated islands of the past but as typical of the world around them. I can drive sixty miles to the house where I was born, in a town of two hundred; visit my aunts (whose mother—my grandmother whom I clearly remember—was kissed by General Lee in 1870), submerge with them gladly in days of memory—the sacred hilarious appalling past reeled through us again in the sacred forms (each word as rigid in its place and function as a phrase of the Mass, as productive of promise, release, joy). And not only I—my niece, age three, already listens closely to the same ceremonies; and though she is a visitor, how can I guess what strata are slowly, immovably depositing in her? Or the millions of children who live, not visit, in the rural/small-town South and turn from television to the oral tradition many times each day, who are fighting again this afternoon in hundreds of public schools the final lost battles of the Civil War, a gray line of six-year-olds in the van? If such encounters do not, in fifteen years or so prove to have been intense, mysterious, scarring enough to produce their own novelists (whose work will feed at the same dugs as Faulkner's or Warren's or Welty's), then

claim that Southern fiction is dead. For whatever new subjects, new forms of life the new South is offering (and to me they seem either developments of the old or copies of standard American types), the old South will go on offering its life as subject for another fifty years at least—the working life of those who are children in it now. Not *offering* but *imposing,* and those apprentice novelists upon whom it imposes itself must invent new tools for seeing and controlling its intent on their lives or smother in silence—or turn to the fiction of game and puzzle which is presently cranking-up in younger regions already gone to desert.

But these children, like their parents, are also experiencing various kinds of new South—almost half of them are chiefly if not exclusively experiencing an urban South (North Carolina plans to have a 51% urban population by 1980); and while neither Atlanta nor New Orleans yet vies seriously with New York, Chicago, Los Angeles as irreclaimable disaster-sites, they are trying hard and cheerfully, and, given time, may well succeed. Birmingham is nearly as difficult to breathe in as Gary; and dozens of smaller cities—green and clean ten years ago: Raleigh, Richmond, Charleston, Savannah —are imploring not so much their own ruin as their mortal trivialization, drowning in a sea of carwashes, burgerstands, pennanted gas pumps. So the next question is, as I said at the start—will the new South prove unrelated to the old, a petrifying gorgon quite literally?

Unanswerable of course, and in any case not a peculiarly Southern question—though a look at simultaneous American fiction of other regions gives serious pause. Insofar as the twentieth-century novel in this country has consisted of the South and the Jews (with the odd midwesterner), it has been the product of two profoundly similar cultures—God-and-family centered,

oppressed and oppressing (the old ghetto Jew being his own Negro), gifted with unashamed feeling and eloquence, supported by ancient traditions of sorrow and the promise of justice, a comic vision of ultimate triumph. But with one large difference—the classical Southern novel is rural; the Jewish, urban. I can think of no exception (maybe Malamud's *A New Life?* Roth's *When She Was Good?*). And while the moral resources of Judaism have irrigated the work of Malamud, Bellow and Roth, a great many other specifically Jewish novels have suffered the predictable pressures of their scenes—frayed nerves, self-absorption (through urban isolation), ghetto smugness, *noise*.

Surely, in fact, the great dilemma of an American Jewish novelist now is not, again, exhaustion (the unimaginableness of certain repetitions after *Portnoy*, say) but the far more daunting fact that the modern novel, from its eighteenth-century origins till 1922 (*Ulysses*), was a bilocal form—city and country. It is difficult to think of any great European novelist before Joyce whose every novel is not intricately strung between the mutually nourishing poles of city and country—Fielding, Stendhal, George Eliot, Tolstoy, James, Proust, Lawrence, Mann. Dickens and Dostoevsky (the supreme urban novelists, the first and richest students of city-nerves) send their plots and people for frequent and indispensable visits to the country; and I'm not the only man who thinks that *Wuthering Heights*, entirely rural, is the greatest single novel of a nineteenth-century England already locked in the mania of urbanization, nor the only one to notice that not one of the classic American novels through Hemingway and Faulkner is exclusively, even largely, urban in setting.

Why this oscillation?—a simple reflection of earlier life when populations were mostly rural and writers

could afford villas, cottages, *dachas* for clearing-the-head, flushing-the-pipes? The remnants of nineteenth-century nature worship? All that and a good deal more. Chiefly this—such a range of geographical movement has, until the past ten years, been the novelist's technical strategy for expressing what was an early and strengthening perception of the occidental novel: that the European and American city of stone, asphalt, traffic, harassed parks cannot provide an *anima* of imagery sufficiently rich or varied to support long fictions concerned with emotions other than hate, rage, anxiety. Why?

Wordsworth knew, in 1800, the preface to *Lyrical Ballads* (and the fact that he speaks of conditions for poetry seems to me no objection)—"Humble and rustic life was generally chosen . . . because in that condition the passions of men are incorporated with the beautiful and permanent forms of nature." *Permanent.* You might argue that a city is a form of nature (even that, as recently as ten years ago, a few of them were beautiful forms); and I'd join you in affirming that the suggestiveness-to-art of a Rome or an Athens is largely a function of its longevity, its *apparent* permanence, the long scale it offers for the measurement of our brevity; but even the most resigned city-dweller would not contend that permanence is a feature of any American city —oh, a few square blocks of Charleston, Savannah, a few other "heritage-squares" in chloroform. The deepest principle of American cities as opposed to European or Oriental is precisely their impermanence, mutability (and surely one explanation of the present state of horror of our cities is that our premise has always been, "It's awful; never mind; we'll get it right next time"). Now, add to that basically economic impermanence a new and perfectly feasible threat—nuclear destruction

—and anyone can see that, for the first time in history, a city the size of greater New York is literally easier to destroy, to vaporize in every stone, than any one man within the city. Given five minutes' warning, the man can take shelter; the city cannot. Neither can the country of course; but the threat of destruction against, say, the Appalachians or any given rock, field or tree has thus far seemed less credible than that against clustered buildings. (The current revival of fear for the environment, overdue as it is, is essentially a fear for man—man may succeed in destroying himself, the tuna, the plankton; but does anyone seriously suppose that nature— the earth—would not survive us? The earth has been hell and desert several times before.)

So rocks and trees condemn our folly and our virtue, chasten our fret as buildings never can—scratch a farmer and find the tragic sense of life—yet they still can console us because they will submit to the pathetic fallacy, will absorb all our emotions, not simply our destructive emotions. Or—if consolation is impossible or irrelevant—illumination, clarification; because they offer us the only objects of meditation in the presence of which the literally human qualities of man can be distanced, comprehended, calmed, controlled. That is not merely the experience of Wordsworth and all the novelists of the world till 1922 but of Aeschylus, Jesus, Oedipus at Colonus, King Lear.

Will Southern novelists then—undaunted by their native horrors, unintimidated by general misapprehension—be finally silenced by urban din? or galvanized into nerves and jitters? or forced into cave art (the scared cottage-industries mentioned above)? Maybe. Why not? Maybe I've answered that already. Literally because many more than half of the people of the South still live in close proximity with a nature that beauti-

fully, grandly asserts its permanence. If that nature—
its organic killable members—is killed, as it may be,
then its memory may well survive in a few of the hu-
man survivors and work for generations (the Garden of
Eden has lingered nicely—as dream, implied condem-
nation, blueprint). And if, in twenty or fifty years,
Southerners all huddle like the rest of the nation in
cities of dreadful night, there will still be what there
has always been (often all there has been for the South,
always all there has been for the novelist)—the past, as
dream, condemnation, cause of the present. The past
which, for all the stunning raids upon it, all the muffled
hobbling obeisance to it, refuses to die or yield for more
than the space of one novel in one man's life but
grows, proliferates in each new life and demands early
treatment, desperate remedy. Perhaps, indeed, as read-
ers we *have* had the Civil War, the lavendered ladies,
preachers and sheriffs, bare-souled adolescents; but as
the stuff of life in a huge and long-inhabited country,
they have no more been plumbed than the Marianas
Trench. And other central traumas and figures are un-
touched—the great Depression (my father's Civil
War), the manless years from 1941–45 when many of
us grew up in the midst of a war three thousand miles
away yet hooked into our hearts, the black-rights strug-
gle of the 50s and 60s, the present agonies of school
and housing integration, another war; thousands of
others unknown to me; and Southern blacks (having
given us our best poetry) have only begun to write their
pasts, their visions of self and of us, into novels that
may yet tell us, and in time, so much we need to know.
And what Jeremiahs we could make among the ruins.
Our credentials are impeccable—the only people in the
nation who have claimed from the start that graceless
man, even *homo Americanus*, was damned and doomed,

would botch all jobs, and that we in the South were the damnedest of all.

So—given an imaginably livable world and the survival of memory—the next fifty years seem as safe as years get for anyone born in the South whose life here demands control in the form of what we have agreed in the past two centuries to call fiction. Beyond that—well into the twenty-first century—even I won't peer. First, children must be born with the genes, the senses (though maybe all that will prove manageable). Then the world must remain an observable world, one that human eyes and ears can bear to study, can conceive reasons for wishing to portray, a world that will hold pose long enough. If these conditions vanish, so probably will the novel. Forms with longer lives and achievements as grand are dead as pterodactyls—epic, pastoral, dramatic tragedy. And not only the American Southern novel—all fiction, everywhere. Not to speak of organisms far more gravely threatened, of far greater weight in the life of the race.

And yet, and yet. If the race survives in some recognizable form, if language is employed to communicate emotion and acquired experience, if men spend large tracts of time in one place (however man-ruined or man-made) and if one of those places remains the ground we now call the South, it is all but inconceivable that one man at least (white, black, red, yellow; whatever new mixtures) won't be compelled to retire to private space and, helpless to do otherwise, invent some means of saying what he knows, having had his life. The novel, for instance. A Southern novel.

1971

# FOR ERNEST HEMINGWAY

IF I HAD BEEN conscious of caring enough, as late as the spring of 1970, to check the state of my own feelings about the work of Hemingway (nine years after his death and at least five since I'd read more of him than an occasional story for teaching purposes), I'd probably have come up with a reading close to the postmortem consensus—that once one has abandoned illusions of his being a novelist and has set aside, as thoroughly as any spectator can, the decades of increasingly public descent into artistic senility (dosing those memories with the sad and sterile revelations of Carlos Baker's biography), then one can honor him as "a minor romantic poet" * who wrote a lovely early novel, *The Sun Also Rises*, and a handful of early stories of the north woods, the first war, postwar Americans in Europe which are likely to remain readable and, despite their truculent preciosity, leanly but steadily rewarding. But I don't remember caring enough to come up with even that grudging an estimate.

Why?—partly a participation in the understandable, if unlikable, international sigh of relief at the flattening of one more Sitting Bull, especially one who had made strenuous attempts to publicize his own worst nature; partly an attenuation of my lines to the

* Patrick Cruttwell, "Fiction Chronicle," *The Hudson Review*, XXIV (Spring 1971), p. 180.

work itself; partly a response to the discovery that, in my first three years of teaching, A *Farewell to Arms* had dissolved with alarming ease, under the corrosive of prolonged scrutiny, into its soft components (narcissism and blindness) when a superficially softer looking book like *The Great Gatsby* proved diamond; but mostly the two common responses to any family death: forgetfulness and ingratitude.

Then two reminding signals. In the summer of '70, I visited Key West and wandered with a friend one morning down Whitehead to the Hemingway house, tall, square and iron-galleried with high airy rooms on ample grounds thick with tropic green, still privately owned (though not by his heirs) and casually open, once you've paid your dollar, for the sort of slow unattended poking-around all but universally forbidden in other American Shrines. His bed, his tile bath, his war souvenirs (all distinctly small-town Southern, human-sized; middle-class careless well-to-do—the surroundings of, say, a taciturn literate doctor and his tanned leggy wife just gone for two weeks with their kin in Charleston or to Asheville, cool and golfy; and you inexplicably permitted to hang spectral in their momentarily cast shell). But more—the large room over the yard-house in which Hemingway wrote a good part of his work between 1931 and 1939 (six books) at a small round table, dark brown and unsteady; the small swimming pool beneath, prowled by the dozens of deformed multi-toed cats descended from a Hemingway pair of the thirties. Green shade, hustling surly old Key West silent behind walls, a rising scent of sadness— that Eden survived, not destroyed at all but here and reachable, though not by its intended inhabitants who are barred by the simple choices of their lives and, now, by death (Hemingway lost the house in 1939 at his sec-

ond divorce). The rising sense that I am surrounded, accompanied by more than my friend—

> *I am moved by fancies that are curled*
> *Around these images, and cling:*
> *The notion of some infinitely gentle*
> *Infinitely suffering thing.*

The center of my strong and unexpected response began to clarify when I discovered, at home, that I had recalled Eliot's first adjective as *delicate*—"some infinitely delicate / Infinitely suffering thing." What thing?

In October, the second signal. *Islands in the Stream* was published and received, with one or two enthusiastic notices, a few sane ones (Irving Howe, John Aldridge) and a number of tantrums of the beat-it-to-death, scatter-the-ashes sort. In fact, the kinds of notices calculated to rush serious readers to a bookstore (such response being a fairly sure sign that a book is alive and scary, capable of harm); and no doubt I'd have read the book eventually, but a combination of my fresh memories of Key West and a natural surge of sympathy after such a press sent me out to buy it, a ten-dollar vote of—what? *Thanks*, I suddenly knew, to Hemingway.

For what? For being a strong force in both my own early awareness of a need to write and my early sense of how to write. Maybe the strongest. A fact I'd handily forgot but was firmly returned to now, by *Islands in the Stream*.

A long novel—466 pages—it threatens for nearly half its length to be his best. And the first of its three parts—"Bimini," two hundred pages—is his finest sustained fiction, itself an independent novella. Finest, I think, for a number of reasons that will be self-evident to anyone who can bury his conditioned responses to

the Hemingway of post-1940, but chiefly because in it Hemingway deals for the first time substantially, masterfully and to crushing effect with the only one of the four possible human relations which he had previously avoided—parental devotion, filial return. (The other three relations—with God, with the earth, with a female or male lover or friend—he had worked from the start, failing almost always with the first, puzzlingly often with the third, succeeding as richly as anyone with the second.)

It would violate the apparent loosehandedness of those two hundred pages to pick in them for exhibits. Hemingway, unlike Faulkner, is always badly served by spot-quotation, as anyone will know who turns from critical discussions of him (with their repertoire of a dozen Great Paragraphs) back to the works themselves. Faulkner, so often short-winded, can be flattered by brief citation, shown at the stunning moment of triumph. But Hemingway's power, despite his continued fame for "style," is always built upon *breath*, long breath, even in the shortest piece—upon a sustained legato of quiet pleading which acts on a willing reader in almost exactly the same way as the opening phrase of Handel's *Care selve* or *Ombra mai fù*. What the words are ostensibly saying in both Hemingway and Handel is less true, less complete, than the slow arc of their total movement throughout their length. Therefore any excerpt is likely to emphasize momentary weakness—artificiality of pose, frailty of emotion—which may well dissolve in the context of their intended whole. The words of *Ombra mai fù* translate literally as "Never was the shade of my dear and lovable vegetable so soothing"; and any three lines from, say, the beautifully built trout-fishing pages of *The Sun Also Rises* are likely to read as equally simple-minded, dangerously vapid—

He was a good trout, and I banged his head against the timber so that he quivered out straight, and then slipped him into my bag.

So may this from part I of *Islands in the Stream*—

The boys slept on cots on the screened porch and it is much less lonely sleeping when you can hear children breathing when you wake in the night.

But in the last novel, the love among Thomas Hudson, a good marine painter, and his three sons is created—compelled in the reader—by a slow lateral and spiral movement of episodes (lateral and spiral because no episode reaches a clear climax or peaks the others in revelation). All the episodes are built not on "style" or charged moments, though there are lovely moments, or on the ground-bass hum of a cerebral dynamo like Conrad's or Mann's but on simple *threat* —potentially serious physical or psychic damage avoided: the middle son's encounter with a shark while spearfishing, the same boy's six-hour battle to bloody near-collapse with a giant marlin who escapes at the last moment (the only passage outside *The Old Man and the Sea* where I'm seduced into brief comprehension of his love of hunting), the boys' joint participation in a funny but sinister practical joke at a local bar (they convincingly pretend to be juvenile alcoholics, to the alarm of tourists). Threats which delay their action for the short interim of the visit with their father but prove at the end of the section to have been dire warnings or prophecies (warnings imply a chance of escape) —the two younger boys are killed with their mother in a car wreck, shortly after their return to France. Only when we—and Thomas Hudson—are possessed of that

news can the helix of episodes deliver, decode, its ap-
palling message, to us and to him. The lovely-seeming
lazy days were white with the effort to speak their
knowledge. *Avoid dependence, contingency.* The rest
of the novel (a little more than half) tries to face those
injunctions (restated in further calamities) and seems
to me to fail, for reasons I'll guess at later; but the first
part stands, firm and independent, simultaneously a
populated accurate picture and an elaborate unanswer-
able statement about that picture. Or scenes with
music.

For in that first two hundred pages, the junction of
love and threat, encountered for the first time in Hem-
ingway within a family of blood-kin, exact from him a
prose which, despite my claims of its unexcerptibility, is
as patient and attentive to the forms of life which pass
before it (shark, marlin, men) and as richly elliptical as
any he wrote, requiring our rendezvous with him in the
job—and all that as late as the early 1950s, just after
the debacle of *Across the River and Into the Trees.*
Take these lines of the son David after his ordeal with
the marlin—

"Thank you very much, Mr. Davis, for what
you said when I first lost him," David said with
his eyes still shut.

Thomas Hudson never knew what it was that
Roger had said to him.

Or this between Hudson and young Tom, his eldest—

"Can you remember Christmas there?"
"No. Just you and snow and our dog Schnautz
and my nurse. She was beautiful. And I remember
mother on skis and how beautiful she was. I can
remember seeing you and mother coming down

skiing through an orchard. I don't know where it
was. But I can remember the Jardin du Luxem-
bourg well. I can remember afternoons with the
boats on the lake by the fountain in the big garden
with trees."

(That last sentence, incidentally, reestablishes Hem-
ingway's mastery of one of the most treacherous but
potentially revealing components of narrative—the
preposition, a genuine cadenza of prepositions set natu-
rally in the mouth of a boy, not for exhibit but as a
function of a vision based as profoundly as Cézanne's
on the *stance* of objects in relation to one another: a
child, late light, boats on water near shore, flowers,
shade.)

Such prose, recognizable yet renewed within the
old forms by the fertility of its new impetus—family
love—is only the first indication, coming as late as it
does, of how terribly Hemingway maimed himself as an
artist by generally banishing such passionate tenderness
and emotional reciprocity from the previous thirty
years of his work (it is clear enough from *A Moveable
Feast*, the Baker biography, and private anecdotes from
some of his more credible friends that such responses
and returns were an important component of his daily
life). The remaining 260 pages suggest—in their at-
tempt to chart Hudson's strategies for dealing with ex-
ternal and internal calamity, his final almost glad ac-
ceptance of solitude and bareness—an even more mel-
ancholy possibility: that the years of avoiding perma-
nent emotional relations in his work left him at the
end unable to define his profoundest subject, prevented
his even seeing that after the initial energy of his north-
woods-and-war youth had spent itself (by 1933), he be-
gan to fail as artist and man not because of exhaustion

of limited resource but because he could not or would not proceed from that first worked vein on into a richer, maybe endless vein, darker, heavier, more inaccessible but of proportionately greater value to him and his readers; a vein that might have fueled him through a long yielding life with his truest subject (because his truest need).

Wasn't his lifelong subject *saintliness?* Wasn't it generally as secret from him (a lapsing but never quite lost Christian) as from his readers? And doesn't that refusal, or inability, to identify and then attempt understanding of his central concern constitute the forced end of his work—and our failure as his readers, collusive in blindness? Hasn't the enormous and repetitive critical literature devoted to dissecting his obsession with codes and rituals, which may permit brief happiness in a meaningless world, discovered only a small (and unrealistic, intellectually jejune) portion of his long search? But doesn't he discover at last—and tell us in *Islands in the Stream*—that his search was not for survival and the techniques of survival but for goodness, thus victory?

What kind of goodness? Granted that a depressing amount of the work till 1940 (till *For Whom the Bell Tolls*) is so obsessed with codes of behavior as to come perilously close to comprising another of those deadest of all ducks—etiquettes: Castiglione, Elyot, Post (and anyone reared in middle-class America in the past forty years has known at least one Youth, generally aging, who was using Hemingway thus—a use which his own public person and need for disciples persistently encouraged). Yet beneath the thirty years of posturing, his serious readers detected, and honored, great pain and the groping for unspecific, often brutal anodynes— pain whose precise nature and origin he did not begin

to face until the last pages of *For Whom the Bell Tolls*
and which, though he can diagnose in *Islands in the
Stream,* he could not adequately dramatize: the polar
agonies of love, need, contingency and of solitude, hate,
freedom.

What seems to me strange and sad now is that few
of his admirers and none of his abusers appear to have
sighted what surfaces so often in his last three novels
and in *A Moveable Feast*—the signs that the old quest
for manly skills (of necessity, temporary skills) became
a quest for virtue. The quest for skills was clearly re-
lated to *danger*—danger of damage to the self by Nada,
Chance, or Frederic Henry's "They": "They threw you
in and told you the rules and the first time they caught
you off base they killed you." But the quest of Col.
Cantwell in *Across the River* (which metamorphoses
from obsession with narcotic rituals for living well to
the study of how to die), the unconscious quest of San-
tiago in *The Old Man and the Sea* (too heavily and
obscurely underscored by crucifixion imagery), the
clear fact that the subject of *A Moveable Feast* is Hem-
ingway's own early failure as a man (husband, father,
friend), and the fully altered quest of Thomas Hudson
in *Islands in the Stream* (from good father and com-
rade in life to good solitary animal in death)—all are
related not so much to danger as to mystery. No
longer the easy late-Victorian "They" or the sopho-
more's Nada (both no more adequate responses to hu-
man experience than the tub-thumping of Henley's
"Invictus") but something that might approximately
be described as God, Order, the Source of Vaguely
Discernible Law. The attempt not so much to "under-
stand" apparent Order and Law as to detect its outlines
(as by Braille in darkness), to strain to hear and obey
some of its demands.

What demands did he hear?—most clearly, I think, the demand to survive the end of pleasure (and to end bad, useless pleasures). That is obviously a demand most often heard by the aged or middle-aged, droning through the deaths of friends, lovers, family, their own fading faculties. But Hemingway's characters from the first have heard it, and early in their lives—Nick Adams faced on all sides with disintegrated hopes, Jake Barnes deprived of genitals, Frederic Henry of Catherine and their son, the Italian major of his family in "In Another Country," Marie Morgan of her Harry, and on and on. Those early characters generally face deprivation with a common answer—activity. And it is surprising how often the activity is artistic. Nick Adams becomes a writer after the war (the author of his own stories); Jake Barnes is a journalist with ambitions (and, not at all incidentally, a good Catholic); Frederic Henry, without love, becomes the man who dictates to us *A Farewell to Arms*; Robert Jordan hopes to return, once the Spanish Civil War is over, to his university teaching in Missoula, Montana and to write a good book. But, whatever its nature, activity remains their aim and their only hope of survival intact—activity as waiting tactic (waiting for the end, total death), as gyrostabilizer, narcotic. In the last novels, however—most explicitly in *Islands in the Stream*—deprivation is met by *duty*, what the last heroes see as the performance of duty (there are earlier heroes with notions of duty—Nick, Jake—but their duty is more nearly chivalry, a selfconsciously graceful *noblesse oblige*).

The duty is not to survive or to grace the lives of their waiting-companions but to do their work—lonely fishing, lonely soldiering, lonely painting and submarine-hunting. For whom? Not for family (wives, sons) or lovers (there are none; Cantwell knows his teenage

contessa is a moment's dream). Well, for one's human
witnesses then. Why? Cantwell goes on apparently, and
a little incredibly, because any form of stop would di-
minish the vitality of his men, his friend the headwaiter,
his girl—their grip upon the rims of their own abysses.
Santiago endures his ordeal largely for the boy Manolin,
that he not be ashamed of his aging friend and with-
draw love and care. Thomas Hudson asks himself in a
crucial passage in part III (when he has, disastrously
for his soul, stopped painting after the deaths of his
three sons and gone to chasing Nazi subs off Cuba)—

> Well, it keeps your mind off things. What
> things? There aren't any things any more. Oh yes,
> there are. There is this ship and the people on her
> and the sea and the bastards you are hunting.
> Afterwards you will see your animals and go into
> town and get drunk as you can and your ashes
> dragged and then get ready to go out and do it
> again.

Hudson deals a few lines later with the fact that his
present work is literally murder, that he does it "Be-
cause we are all murderers"; and he never really faces
up to the tragedy of having permitted family sorrow to
derail his true work—his rudder, his *use* to God and
men as maker of ordered reflection—but those few lines,
which out of context sound like a dozen Stoic mono-
logues in the earlier work, actually bring Hudson nearer
than any other Hemingway hero toward an explicit
statement of that yearning for goodness which I sus-
pect in all the work, from the very start—the generally
suppressed intimation that *happiness* for all the young
sufferers, or at least *rest*, would lie at the pole opposite
their present position, the pole of pure solitude, detach-
ment from the love of other created beings (in the

words of John of the Cross), and only then in work for
the two remaining witnesses: one's self and the in-
human universe. "There is this ship and the people on
her and the sea and the bastards you are hunting"—
brothers, the Mother, enemies: all the categories of
created things. Hudson, and Hemingway, halt one step
short of defining the traditional goal of virtue—the
heart of God. And two pages before the end, when
Hudson has taken fatal wounds from a wrecked sub-
crew, he struggles to stay alive by thinking—

> Think about the war and when you will paint
> again. . . . You can paint the sea better than any-
> one now if you will do it and not get mixed up in
> other things. Hang on good now to how you truly
> want to do it. You must hold hard to life to do it.
> But life is a cheap thing beside a man's work. The
> only thing is that you need it. Hold it tight. Now
> is the true time you make your play. Make it now
> without hope of anything. You always coagulated
> well and you can make one more real play. We are
> not the lumpenproletariat. We are the best and
> we do it for free.

But again, do it for whom? Most of Hudson's
prewar pictures have been described as intended for this
or that person—he paints for his middle son the lost
giant marlin, Caribbean waterspouts for his bartender,
a portrait of his loved-and-lost first wife (which he later
gives her). Intended then as gifts, *from* love and *for*
love, like most gifts. But now, in death, the reverbera-
tions threaten to deepen—Thomas Hudson's paintings
(and by intimation, the clenched dignity of Nick
Adams and Jake Barnes, Robert Jordan's inconsistent
but passionate hunger for justice, Cantwell's tidy death,
Santiago's mad endurance—most of Hemingway's

work) seem intended to enhance, even to create if necessary the love of creation in its witnesses and thereby to confirm an approach by the worker toward goodness, literal virtue, the manly performance of the will of God. *Saintliness,* I've called it (*goodness* if you'd rather, though *saintliness* suggests at least the fierce need, its desperation)—a saint being, by one definition, a life which shows God lovable.

Any God is seldom mentioned (never seriously by Hudson, though Jake Barnes is a quiet Catholic, Santiago a rainyday one—and though Hemingway himself nursed an intense if sporadic relation with the Church, from his mid-twenties on, saying in 1955, "I like to think I am [a Catholic] insofar as I can be" and in 1958 that he "believed in belief").* Isn't that the most damaging lack of all, in the life and the work?—from the beginning but most desperate toward the end, as the body and its satellites dissolved in age and the abuse of decades? I mean the simple fact that neither Hemingway nor any of his heroes (except maybe Santiago and, long before, the young priest from the Abruzzi who lingers in the mind, with Count Greffi, as one of the two polar heroes of *A Farewell to Arms*) could make the leap from an enduring love of creatures to a usable love of a Creator, a leap which (barring prevenient grace, some personal experience of the supernal) would have been the wildest, most dangerous act of all. Maybe, though, the *saving* one—leap into a still, or stiller, harbor from which (with the strengths of his life's vision about him, none canceled or denied but their natural arcs now permitted completion) he could have made further and final works, good for him and us. That he didn't (not necessarily *couldn't*, though

* Carlos Baker, *Ernest Hemingway, A Life Story* (Scribner's, 1969), pp. 530, 543.

of modern novelists maybe only Tolstoy, Dostoevsky and Bernanos have given us sustained great work from such a choice) has become the single most famous fact of his life—its end: blind, baffled.

But he wrote a good deal, not one of the Monster Oeuvres yet much more than one might guess who followed the news reports of his leisure; and there remain apparently hundreds of pages of unpublished manuscript. What does it come to?—what does it tell us; do to us, for us, against us?

I've mentioned the low present standing of his stock, among critics and reviewers and older readers. Young people don't seem to read him. My university students—the youngest of whom were nine when he died—seem to have no special relations with him. What seemed to us cool grace seems to many of them huffery-puffery. But then, as is famous, a depressing majority of students have special relations with only the fayest available books. (Will Hemingway prove to be the last Classic Author upon whom a generation modeled its lives?—for *classic* read *good*.) Even his two earliest, most enthusiastic and most careful academic critics have lately beat sad retreat. Carlos Baker's long love visibly disintegrates as he tallies each breath of the sixty-two years; and Philip Young nears the end of the revised edition of his influential "trauma" study (which caused Hemingway such pain) with this—

> Hemingway wrote two very good early novels, several very good stories and a few great ones . . . and an excellent if quite small book of reminiscence. That's all it takes. This is such stuff as immortalities are made on.

The hope is that the good books will survive a depression inevitable after so many years of inflation

(Eliot is presently suffering as badly; Faulkner, after decades of neglect, has swollen and will probably assuage until we see him again as a very deep but narrow trench, not the Great Meteor Crater he now seems to many)—and that we may even, as Young wagers gingerly, come to see some of the repugnant late work in the light of Hemingway's own puzzling claim that in it he had gone beyond mathematics into the calculus (differential calculus is defined, for instance, as "the branch of higher mathematics that deals with the relations of differentials to the constant on which they depend"—isn't his constant clarifying now, whatever his reluctance to search it out, his failures to dramatize its demands?).

But since no reader can wait for the verdict of years, what can one feel now? What do I feel?—an American novelist, age thirty-eight (the age at which Hemingway published his eighth book, *To Have and Have Not*; his collected stories appeared a year later), whose work would appear to have slim relations, in matter or manner, with the work of Hemingway and whose life might well have had his scorn? (he was healthily inconsistent with his scorn).

I have to return to my intense responses of a year ago—to the powerful presence of a profoundly attractive and needy man still residing in the Key West house and to the reception of his final novel. I've hinted that these responses were in the nature of neglected long-due debts, payment offered too late to be of any likely use to the lender. All the same—what debts?

To go back some years short of the start—in the summer of 1961, I was twenty-eight years old and had been writing seriously for six years. I had completed a novel but had only published stories, and those in England. Still, the novel was in proof at Atheneum—A

*Long and Happy Life*—and was scheduled for publication in the fall. I had taken a year's leave from teaching and was heading to England for steady writing—and to be out of reach on publication day. On my way in mid-July I stopped in New York and met my publishers. They had asked me to list the names of literary people who might be interested enough in my book to help it; and I had listed the writers who had previously been helpful. But as we speculated that July (no one on the list had then replied)—and as we brushed over the death of Hemingway ten days before—Michael Bessie startled me by saying that he had seen Hemingway in April, had given him a copy of the proofs of *A Long and Happy Life* and had (on the basis of past kindnesses Hemingway had done for young writers) half-hoped for a comment. None had come. But I boarded my ship with three feelings. One was a response to Bessie's reply to my asking "How did you feel about Hemingway when you saw him?" —"That he was a wounded animal who should be allowed to go off and die as he chose." The second was my own obvious curiosity—had Hemingway read my novel? what had he thought? was there a sentence about it, somewhere, in his hand or had he, as seemed likely, been far beyond reading and responding? The third was more than a little self-protective and was an index to the degree to which I'd suppressed my debts to Hemingway—what had possessed Bessie in thinking that Hemingway might conceivably have liked my novel, the story of a twenty-year old North Carolina farm girl with elaborate emotional hesitations and scruples? My feelings, close on a death as they were, were so near to baffled revulsion that I can only attribute them to two sources. First, the success of Hemingway's public relations in the 40s and 50s. He had managed to displace the un-

assailable core of the work itself from my memory and replace it with the coarse useless icon of Self which he planted, or permitted, in dozens of issues of *Life* and *Look*, gossip-columns, *Photoplay*—an icon which the apparent sclerosis of the later work had till then, for me at least, not made human. Second, emotions of which I was unconscious—filial envy, the need of most young writers to believe in their own utter newness, the suppression of my own early bonds with Hemingway. In short, and awfully, I had come close to accepting his last verdict on himself—forgetting that he laid the death-sentence on his life, not the work.

Yet, a month later, I received a statement which Stephen Spender had written, knowing nothing of the recent distant pass with Hemingway. It said, in part that I was a "kinetic" writer of a kind that recalled certain pages of Hemingway, and Joyce. I was pleased of course, especially by Joyce's name ("The Dead" having long seemed to me about as great as narrative prose gets —certain pages of the Bible excepted); but again I was surprised by the presence of Hemingway. Spender had known my work since 1957. He was the first editor to publish a story of mine, in *Encounter*; and in his own *World Within World*, he had written briefly but with great freshness of his own acquaintance with Hemingway in Spain during the Civil War (one of the first memoirs to counter the received image of Loud Fist). So I might well have paused in my elation to think out whatever resemblance Spender saw. But I was deep in a second book—and in the heady impetus toward publication of the first—and a sober rereading of Hemingway (or a reading; I'd read by no means half his work) was low on my list of priorities.

It should have been high; for if I had attempted to trace and understand Hemingway's help in my own

work, I'd have been much better equipped for dealing with (in my own head at least) a comment that greeted A *Long and Happy Life* from almost all quarters, even the most sympathetic—that it sprang from the side of Faulkner. It didn't; but in my resentment at being looped into the long and crowded cow-chain that stretched behind a writer for whom I felt admiration but no attraction, I expended a fair amount of energy in denials and in the offering of alternate masters—the Bible, Milton, Tolstoy, Eudora Welty. If I had been able to follow the lead offered by Bessie and Spender, I could have offered a still more accurate, more revealing name.

So it was ten years before my morning in the house in Key West and my admiration for *Islands in the Stream* reminded me that, for me as a high-school student in Raleigh in the early fifties and as an undergraduate at Duke, the most visible model of Novelist was Hemingway (*artist* of any sort, except maybe Picasso, with whom Hemingway shared many external attributes but whose central faculty—continuous intellectual imagination, a mind like a frightening infallible engine endowed with the power of growth—he lacked). For how many writers born in the twenties and thirties can Hemingway not have been a breathing Mount Rushmore?—though his presence and pressure seem to have taken a far heavier toll on the older generation, who not only read Hemingway but took him to war as well. Not only most visible but, oddly, most universally *certified*. Even our public-school teachers admired him, when they had been so clearly pained by Faulkner's Nobel—the author of *Sanctuary* and other sex-books. In fact, when I reconstruct the chronology of my introduction to Hemingway, I discover that I must have encountered the work first, at a distant remove, in

movies of the forties—*The Short Happy Life of Francis Macomber, For Whom the Bell Tolls*. It was apparently not until the tenth or eleventh grade—age fifteen or sixteen—that I read any of him. As the first thing, I remember "Old Man at the Bridge" in a textbook. And then, for an "oral book-report" in the eleventh grade, A *Farewell to Arms*. (I remember standing on my feet before forty healthy adolescents—it was only 1949— and saying that Hemingway had shown me that illicit love could be pure and worth having. I don't remember remarking that, like water, it could also kill you—or your Juliet—but I must have acquired, subliminally at least, the welcome news that it made Frederic Henry, a would-be-architect, into a highly skilled novelist.)

It was not till my freshman year in college, however, that the effect began to show (in high school, like everyone else, I'd been a poet). My first serious pieces of prose narrative have a kind of grave faith in the eyes, the gaze of the narrator at the moving objects who are his study—a narrowed gaze, through lashes that screen eighty percent of "detail" from the language and the helpless reader, which seems now surely helped onward, if not grounded in, early Hemingway. Here, for example, is the end of the first "theme" I remember writing in freshman English, a five-hundred-word memory of the death of my aunt's dog Mick—

It was still hot for late afternoon, but I kept walking. Mick must have been getting tired; but she bounced along, doing her best to look about as pert as a race horse. My head was down, and I was thinking that I would turn around and head home as soon as I could tear that auction sale sign off the telephone pole down the road. A car passed. It sounded as if it threw a rock up under the

fender. I looked up at the highway. Mick was lying
there. The car did not stop. I went over and picked
her up. I carried her to the shoulder of the road
and laid her down in the dry, gray dust. She was
hardly bleeding, but her side was split open like a
ripe grape, and the skin underneath was as white
and waxy as soap. I was really sorry that it had hap-
pened to Mick. I really was. I sat down in the dust,
and Mick was in front of me. I just sat there for a
long time thinking, and then I got up and went
home. It was almost supper time.

The fact that I'd read *The Catcher in the Rye* a couple
of months earlier may account for the *about* in the
second sentence and the *I really was,* though they are
normal in the context; but it would be hard to maintain
now, in the face of the elaborate syntax required by my
later work, that this early sketch wasn't actually a piece
of ventriloquism—the lips of my memory worked by
Hemingway, or by my notion of Hemingway. This was
remarked on, and mildly lamented, by my instructor,
an otherwise helpful man who would probably have
been better advised to wonder "Why is this boy, visibly
so polar to Hemingway or Hemingway's apparent he-
roes, nonetheless needful of lessons from him, and
lessons in vision not behavior?" (strangely, the man
shot himself three years later). Maybe it's as well that
he didn't. I suspect now that I was responding, at the
butt-end of an adolescence perceived as monstrously
lonely and rejected, to the siren song in the little Hem-
ingway I'd read and that I heard it this way—"If you
can tell what you know about pain and loss (physical
and spiritual damage, incomprehension, bad love) and
tell it in language so magically bare in its bones, so lean
and irresistible in its threnody as to be instantly audible

to any passerby, then by your clarity and skill, the depth and validity of your own precarious experience, you will compel large amounts of good love from those same passers, who'll restore your losses or repair them." And if I'd been conscious of the degree of self-pity involved in that first exchange, I might have been revolted and turned from narrative (as I'd turned, two years before, from drawing and painting). But I was only warned that I "sounded like Hemingway"; and since I knew perfectly well that everyone in America sounded like Hemingway, that was no obstacle. So I had written several sketches and my first real story, "Michael Egerton"—all under the tutelage of Hemingway's voice and stance—before I had read more than one or two of his stories and A *Farewell to Arms*. An "influence" can be exerted by the blinking of an eye, the literal movement of a hand from here to there, five words spoken in a memorable voice; and the almost universal sterility of academic-journalistic influence-hunting has followed from a refusal to go beyond merely symptomatic surface likenesses toward causes and the necessary question "Why was this writer hungry for this; what lack or taste was nourished by this?"

I did go on. One of the exciting nights of my life was spent in early September, 1952, reading *The Old Man and the Sea* in *Life* magazine, straight through by a naked light bulb, in the bed in which I was born (reread now, after years of accepting second-hand opinions on its weakness, it again seems fresh and danger- ous, and though a little rigid, one of the great long stories). I remember reading, admiring, and—better— feeling affection for *The Sun Also Rises* during a course at Harvard in the summer of 1954; and I still have my old Modern Library edition of the first forty-nine stories, with neat stern notes to less than half the stories

in my college-senior's hand—the notes of a technician, and as knowing and disapproving as only a young technician can be, but so unnaturally attentive as to signal clearly that some sort of unspoken love was involved, exchanged in fact—the exchange I began to define above, and to which I'll return. But, oddly, that was it —after 1955, I don't recall reading any more Hemingway till 1963, *A Moveable Feast,* well after I'd written two books of my own—and then not again till 1971 when I reread all I'd covered and the two-thirds I hadn't.

Why? Not *why was I rereading?* but why had I read him in the first place, more than twenty years ago; and why had he helped so powerfully that I felt last summer—and still—this strong rush of gratitude? And why did I put him down so soon? Maybe another piece of Spender's comment will crack the door. He suggested that *A Long and Happy Life* advanced the chief discovery of Joyce and Hemingway, "which was to involve the reader, as with his blood and muscles, in the texture of the intensely observed and vividly imagistic writing." Assuming what I hope is true—that I needn't drown in self-contemplation if I think that out a little, and that I'm not pressing to death a comment made in kindness —what can Spender have meant? I remember, at the time, being especially pleased by his calling the prose "kinetic" which I took to mean concerned with and productive of movement. I don't recall telling Spender, but it had been my premise or faith before beginning *A Long and Happy Life* that by describing fully and accurately every physical gesture of three widely separated days in the lives of two people, I could convey the people—literally deliver them—to you, your room, your senses (I considered *thought* a physical gesture, which it is, though often invisible to the ordinary spectator).

That faith, consciously held, guided the book through two years of writing and seems to me still the motive force of its claim on readers.

Isn't it also Hemingway's faith, in every line he wrote? Isn't it Tolstoy's, Flaubert's? Doesn't it provide the terrible force of the greatest narratives of the Bible? —*Genesis* 22, *John* 21. I'd read those as well, long before my discovery of Hemingway; and from the ninth grade, after *Anna Karenina*, I'd had my answer to the question "Who's best?" But as a tyro, I clearly took light from Hemingway. He was there, alive in Cuba, nine hundred miles from the desk in my bedroom, still writing—ergo, *writing was possible*. The texture of his work, his method, was apparently more lucid than Tolstoy's, unquestionably more human than Flaubert's (at least as I knew them in translation); and everything was briefer and thus more readily usable. But far more important—again I don't remember thinking about it— was what lay beneath that apparent lucidity. He said more than once that a good writer could omit anything from a story—knowingly, purposely—and the reader would respond to its presence with an intensity beyond mere understanding. There are striking examples—the famous one of "Big Two-Hearted River" which is utterly silent about its subject, and now *Islands in the Stream* which has a huge secret embedded in its heart, its claim against love, against life (as terrible as Tolstoy's in *The Kreutzer Sonata* or Céline's, though entirely personal and, like theirs, not dramatized). But what I discovered, detected with the sensing devices no one possesses after, say, sixteen, was both more general and more nourishingly specific—the knowledge that Hemingway had begun to write, and continued, for the reasons that were rapidly gathering behind me as my nearly terminal case of adolescence was beginning to

relent: write or choke in self-loathing; write to compre-
hend and control fear. Loathing and fear of what? Any-
one who has read my early fiction will probably know
(they are not rare fears), and in the only way that
might conceivably matter to anyone but me; nor is it
wise-guy reductive to say that any sympathetic reader
of Hemingway has possessed that knowledge of him
since *In Our Time*—and that such knowledge is pre-
cisely what Hemingway intended, knowledge acquired
from the work, not directly from the life. But the mag-
netic fields of fear in both cases—or so I felt, and feel
—are located in simultaneous desperate love and dread
of parents, imagined and actual abandonment by one's
earliest peers, the early discovery that the certified emo-
tions (affection, love, loyalty) are as likely to produce
waste, pain and damage to the animal self as are hate,
solitude, freedom—perhaps more likely.

But Hemingway's work, at least, is complete and
no damage can be done him or it by one more consid-
eration of his technical procedures and their engines,
their impetus (harm to a dead writer could only be the
destruction of all copies of his work). And, oddly, in all
that I know of the vast body of Hemingway criticism,
there is almost no close attention to the bones of lan-
guage, of the illuminating sort which Proust, for in-
stance, gave to Flaubert. This despite the fact that most
of his readers have always acknowledged that he gave
as passionate a care to word and rhythm as Mallarmé.
The most interesting discussion of his method is in fact
by a writer—Frank O'Connor in his study of the short
story, *The Lonely Voice*—and though it is finally de-
structive in its wrongheadedness and envy, it is near
enough to insight to be worth a look. O'Connor feels
that Hemingway studied and understood Joyce's early
method and then proceeded to set up shop with Joyce's

tools—"and a handsome little business he made of it."
And regardless of the justice of that (it's at least a
refreshing alternate to the usual references to Gertrude
Stein and Sherwood Anderson), it is in O'Connor's de-
scription of the Joyce of *Dubliners* that he casts in-
direct light on Hemingway—

> It is a style that originated with Walter Pater but
> was then modeled very closely on that of Flaubert.
> It is a highly pictorial style; one intended to ex-
> clude the reader from the action and instead to
> present him with a series of images of the events
> described, which he may accept or reject but can-
> not modify to suit his own mood or environment.

The following, however, is as far as he goes toward an
attempt at understanding the motive for such pro-
cedure, in either Joyce or Hemingway—

> By the repetition of key words and key phrases
> . . . it slows down the whole conversational move-
> ment of prose, the casual, sinuous, evocative qual-
> ity that distinguishes it from poetry and is in-
> tended to link author and reader in a common
> perception of the object, and replaces it by a series
> of verbal rituals which are intended to evoke the
> object as it may be supposed to be. At an extreme
> point it attempts to substitute the image for the
> reality. It is a rhetorician's dream.

And finally—

> in neither of these passages [from Joyce and
> Hemingway] is there what you could call a human
> voice speaking, nobody resembling yourself who is

trying to persuade you to share in an experience of his own, and whom you can imagine yourself questioning about its nature—nothing but an old magician sitting over his crystal ball, or a hypnotist waving his hands gently before your eyes and muttering, "You are falling asleep; you are falling asleep; slowly, slowly your eyes are beginning to close; your eyelids are growing heavy; you are—falling—asleep."

Despite the fact that *I* feel strong bonds with the voice in early Hemingway at least, the core of that seems roughly true of both writers—Joyce in the cold dexterity of *A Portrait of the Artist* and Hemingway all his life, though in an entirely different way. Why true? Surely the motives are different and infinitely complex in each case (though one might suspect, especially after Ellman's biography, that Joyce's production of such a distancing method was only one more cast skin of an essentially reptilian nature). If I attempt my own description of Hemingway's procedure (a description largely coincident with what I *felt* as a student and what drew me to him as I began to write), then I can guess more legitimately at motives.

Hemingway's attempt, in all his fiction, is *not* to work magic spells on a reader, locking him into a rigid instrument of vision (in fact, into a movie) which controls not only what he sees but what he feels. The always remarked absence of qualifiers (adjectives, adverbs) is the simplest and surest sign here. Such an attempt—and one does feel and resent it often, in Flaubert and Joyce—is essentially the dream of achieving perfect empathic response, of making the reader become the story, or the story's emotional center at any given moment: Emma Bovary, Gabriel Conroy. And it

is the dream not only of a few geniuses but of a large percentage of readers of fiction—the hunger for literally substitute life. Doomed of course, for the sane at least. But while Hemingway attempts as unremittingly as anyone to control his reader—to station him precisely in relation both to the visible and invisible actions of the story and to the author himself, and finally to trigger in him the desired response (again, to both story and author)—his strategy is entirely his own, and is in fact his great invention (the pure language itself being older than literature). Look at the famous opening of *A Farewell to Arms*—

> In the late summer of that year we lived in a house in a village that looked across the river and the plain to the mountains. In the bed of the river there were pebbles and boulders, dry and white in the sun, and the water was clear and swiftly moving and blue in the channels.

—As classical as Horace—in the sense of generalized, de-localized, deprived of native texture. What size house and what color, built how and of what? What village, arranged how around what brand of inhabitants, who do what to live? What river, how wide and deep? What kind of plain, growing what; and what mountains? Later—considerably later—he will tell you a little more, but very little. If you have never traveled in northern Italy in late summer—or seen the film of the book—you'll have no certainty of knowing how the earth looks above and beneath the action, in this or any other of his works. Or, in fact, how anything or anyone else *looks*. But by the audacity of its filterings, it demands that you lean forward toward the voice which is quietly offering the story—only then, will it begin to yield, to give you what it intends. And the gift will be

what you *hear*—the voices of imagined characters speaking a dialect which purports to be your own (and has now convinced two generations of its accuracy). His early strategy is always, at its most calculated, an oral strategy. If we hear it read, it seems the convincing speaking-voice of this sensibility. Only on the silent page do we discover that it is as unidiomatic, as ruthlessly intentional as any *tirade* of Racine's. For behind and beneath all the voices of actors (themselves as few in number as in Sophocles) rides the one real voice—the maker's. And what it says, early and late, is always this—"This is what I see with my clean keen equipment. Work to see it after me." What it does not say but implies is more important—"For you I have narrowed and filtered my gaze. I am screening my vision so you will not see all. Why?—because you must enact this story for yourself; cast it, dress it, set it. Notice the chances I've left for you: no noun or verb is colored by me. I require your senses." What is most important of all—and what I think is the central motive—is this, which is concealed and of which the voice itself may be unconscious: "I tell you this, in this voice, because you must share—*must* because I require your presence, your company in my vision. I beg you to certify my knowledge and experience, my goodness and worthiness. I mostly speak as *I*. What I need from you is not empathy, identity, but patient approving witness—loving. License my life. Believe me." (If that many-staged plea is heard only intermittently in Hemingway's work after 1940—broken then by stretches of "confidence"—I'd guess that the cause would be the sclerosis consequent upon his success, the success of the voice which *won* him love, worship, a *carte blanche* he lacked the power to use well. Goethe said, "Beware of what you want when young; you'll get it when old." And the memory

of the famished face of the deathbound Hemingway, quilted with adoration and money, is among the saddest and most instructive memories of Americans over twenty-five; his last gift to us.)

I've suggested that a final intention of Hemingway's method is the production of belief in the reader —belief in his total being and vision. Remember that he always spoke of the heavy role of the Bible in his literary education. The role has been generally misunderstood; seen as a superficial matter of King James rhythms, the frequent use of *and*, narrative "simplicity." But look at a brief though complete story from *Genesis* 32—

> In the night Jacob rose, took his two wives, the two slave girls and his eleven sons, and crossed the ford of Jabbok. When he had carried them all across, he sent his belongings. Then Jacob was alone, and some man wrestled with him there till daybreak. When he saw that he could not pin Jacob, he struck him in the pit of his thigh so that Jacob's hip unsocketed as they wrestled. Then he said "Let me go; it is daybreak."
>
> Jacob said "I will not let go till you bless me."
> The man said "What is your name?"
> He said "Jacob."
> The man said "You are Jacob no more but Israel—you have fought gods and men and lasted."
> Jacob said "Tell me your name please."
> He said "Why ask my name?" and departed.
> So Jacob called the place *Penuel*, face of God, "For I have seen God's face and endured"; and the sun struck him as he passed Penuel, limping.*

* Translation by Reynolds Price.

—and then at Erich Auerbach's description of Old Testament narrative:

> the externalization of only so much of the phenomena as is necessary for the purpose of the narrative, all else left in obscurity; the decisive points of the narrative alone are emphasized, what lies between is nonexistent; time and place are undefined and call for interpretation; thoughts and feelings remain unexpressed, are only suggested by the silence and the fragmentary speeches; the whole, permeated with the most unrelieved suspense and directed toward a single goal . . . remains mysterious and "fraught with background." *

There is, give or take an idiom, a profound likeness between the account of Jacob's struggle and any scene in Hemingway; and Auerbach might well be describing Hemingway, not the Bible. I have already implied the nature of the likeness, the specific hunger in Hemingway which was met by Biblical method. Both require our strenuous participation, in the hope of compelling our allegiance, our belief. Here are three passages chosen at random from a continuous supply—the opening of "A Very Short Story":

> One hot evening in Padua they carried him up onto the roof and he could look out over the top of the town. There were chimney swifts in the sky. After a while it got dark and the searchlights came out. The others went down and took the bottles with them. He and Luz could hear them below on the balcony. Luz sat on the bed. She was cool and fresh in the hot night.

* Erich Auerbach, *Mimesis* (Doubleday Anchor Books, 1957), p. 9.

a moment from Thomas Hudson's Nazi-hunt in the Cuban keys:

> They called to the shack and a woman came out. She was dark as a sea Indian and was barefooted and her long hair hung down almost to her waist. While she talked, another woman came out. She was dark, too, and long-haired and she carried a baby. As soon as she finished speaking, Ara and Antonio shook hands with the two women and came back to the dinghy. They shoved off and started the motor and came out.

and—curiously analogous to Jacob's ordeal with "some man"—the almost intolerably charged and delicate exchange between Frederic Henry and his friend the young Italian priest who has visited him in hospital with a gift of vermouth:

> "You were very good to come, father. Will you drink a glass of vermouth?"
> "Thank you. You keep it. It's for you."
> "No, drink a glass."
> "All right. I will bring you more then."
> The orderly brought the glasses and opened the bottle. He broke off the cork and the end had to be shoved down into the bottle. I could see the priest was disappointed but he said, "That's all right. It's no matter."
> "Here's to your health, father."
> "To your better health."

Given the basic narrative strategies of the Old Testament and Hemingway, only the tone of the motives is different—and in the third-person Old Testament the voice is plain command; in Hemingway, a dignified pleading: *Believe!* and *Please believe.* Believe what?

*The thing I know.* What do you know? In one case, the presence of the hidden hand of God; in the other, that his life is good and deserving of your witness, will even help your life. Then, why believe? In one case, simply and awfully, so that God be served; in the other, so that the voice—and the man behind it—may proceed through his life. That is the sense in which both styles are almost irresistibly kinetic. And the reason why they have been two of the most successful styles in the history of literature.

Why did it fail him then?—his work, the literal words in their order on the page. In one sense, it succeeded too brilliantly—won him millions of readers willing to exert the energy and certify the life, some of them willing even to alter their own lives in obedience to what they, understandably though ludicrously, took to be injunctions of the work (there are certainly injunctions, though not to noise and bluster). But for nothing—or too little. In the only sense that can have mattered to him, his vision and its language failed him appallingly. It won him neither the relatively serene middle working-years of a Conrad or a Mann nor the transcendant old age of a Tolstoy, a James, Proust's precocious mastery of a silly life. Nor did it, with all its success in the world, allay even half his daily weight of fear. Immense time and energy were thrown elsewhere in flagging hope—sport, love, companions, drink, all of which took dreadful cuts of their own. Maybe it's permissible to *ask* why the words failed him; but to dabble in answers if one did not at least share a long stretch of his daily life and witness the desperate efforts in their long mysterious complexity is only a game, though a solemn game which can be played more or less responsibly and one which can no longer harm him or the work.

I've indulged already in the early pages of this with a guess, from the gathering evidence of his last four books, about his submerged subject which he found and attempted to float too late, when the search itself—or flight from the search—had dangerously depleted his senses and, worse, prevented the intellectual growth which might have compensated. But the words themselves? and the vision and needs which literally pressed words from him?—were they doomed from the start to kill him? A language fatally obsessed with defending the self and the few natural objects which the self both loves and trusts? A vision narrowed, crouched in apprehension of the world's design to maul, humiliate? Insufficiently surrendered to that design? Whatever the answers (and I'd guess that each is a mysterious Yes), it's clear that he was never capable of the calm firmfooted gaze of the godlike Tolstoy, who at twenty-six was producing from his own military experience, in a story called "The Wood-Felling," narrative so sure of its power as to be a near-lethal radiation—

The wounded man lay at the bottom of the cart holding on to the sides with both hands. His broad healthy face had completely changed during those few moments; he seemed to have grown thinner and years older, his lips were thin and pale and pressed together with an evident strain. The hasty and dull expression of his glance was replaced by a kind of bright clear radiance, and on the bloody forehead and nose already lay the impress of death. Though the least movement caused him excruciating pain, he nevertheless asked to have a small *chérez* with money taken from his left leg. The sight of his bare, white, healthy leg,

when his jack-boot had been taken off and the purse untied, produced on me a terribly sad feeling.*

Or even of the constitutionally hectic D. H. Lawrence, who in fragments from an unfinished novel could see and speak in a language of open trust in man and nature which promises the stamina of his death—

Quickly the light was withdrawn. Down where the water was, all grew shadow. The girl came tramping back into the open space, and stood before the holly tree. She was a slim, light thing of about eighteen. Her dress was of weathered blue, her kerchief crimson. She went up to the little tree, reached up, fingering the twigs. The shadow was creeping uphill. It went over her unnoticed. She was still pulling down the twigs to see which had the thickest bunch of berries. All the clearing died and went cold. Suddenly the whistling stopped. She stood to listen. Then she snapped off the twig she had chosen and stood a moment admiring it.

A man's voice, strong and cheerful, shouted: "Bill—Bill—Bi-ill!"

The donkey lifted its head, listened, then went on eating.

"Go on!" said the girl, waving her twig of holly at it. The donkey walked stolidly two paces from her, then took no notice.

All the hillside was dark. There was a tender flush in the east. Away among the darkening blue and green over the west, a faint star appeared. There came from far off a small jangling of bells —one two three—one two three four five! The

---

* Leo Tolstoy, *Tales of Army Life,* translated by Louise and Aylmer Maude (Oxford, 1935), p. 66.

valley was all twilight, yet near at hand things seemed to stand in day.

"Bill—Bill!" came the man's voice from a distance.

"He's here!" shrilled the girl.

"Wheer?" came the man's shout, nearer, after a moment.

"Here!" shrilled the girl.

She looked at the donkey that was bundled in its cloth.

"Why don't ye go, dummy!" she said.

"Wheer is 'e?" said the man's voice, near at hand.

"Here!"

In a moment a youth strode through the bushes.

"Bill, tha chump!" he said.

The donkey walked serenely towards him. He was a big boned, limber youth of twenty. His trousers were belted very low, so that his loins remained flexible under the shirt. He wore a black felt hat, from under which his brown eyes gazed at the girl.

"Was it you as shouted?" he said.

"I knowed it was you," she replied, tapping her skirt with the richly berried holly sprig.*

Yet Hemingway's work—its damaged tentative voice, for all its large failures, its small ignorances and meannesses—did a great deal, for him and us. Beyond carrying him through an after all long life and conveying an extraordinary, apparently usable portion of that life's texture of pleasure and pain to millions of con-

---

* The surviving fragments are printed in Edward Nehls, ed., *D. H. Lawrence, A Composite Biography*, I (University of Michigan, 1957), pp. 184–195.

temporary strangers, it has left live remains—a body of fourteen volumes which, in my guess, will winnow to eight and then stand as an achievement so far unexcelled in American letters, certainly by no one in his own century.\* For what?—the intensity of their gaze, however screening, at a range of men and dangers which, with the inevitable allowances for private obsession, are as broadly and deeply representative as any but the great masters' (we don't yet possess one); for the stamina of their search, however veiled, through four decades for the demands and conditions and duties of human goodness in relation to other men, beasts and objects, and finally God; and then (strongest but most unprovable, most primitive and mysterious) for the language in which the search externalized itself, his optics and shield, weapon and gift. Gift to whom?

Me, as I've said, who have responded over twenty-five years to what I took to be an asking voice with what I now see was apprenticeship, neither exclusive nor conscious and quickly renegade but clearly the gravest homage I can offer. Useless to him but profound nonetheless. The profoundest—for I also see that I loved his voice and studied its shapes, not for its often balked and raging message but because I, balked and enraged, shared the motives at which I've guessed and, stranger, its two subjects: freedom and virtue. Polar heights, inaccessible maybe to climbers more intent on self-protection (footholds, handholds) than on the climb itself, the route and destination.

Gift also to all other living American writers as obsessed as he with defense of what the self is and what

---

\* My own list, now, would be—*The Collected Stories, The Sun Also Rises, A Farewell to Arms, Green Hills of Africa, For Whom the Bell Tolls, The Old Man and the Sea, A Moveable Feast, Islands in the Stream.*

it knows, any one of whom seems to me more nearly brother to him—in need and diet, dream and fulfill-ment, vision and blindness—than to any other artist in our history, or anyone else's (and, oddly, our avatar of Byron, the proto-American artist). Like it or not, our emblem and master whose lessons wait, patient and terrible.

Gift especially to the young. For it is almost cer-tainly with them that his life now lies. It is easy enough to patronize Children's Classics—Omar, Mrs. Brown-ing, Wolfe, lately Hesse—but any writer's useful sur-vival is in heavy danger when the young abandon him entirely; it is only on them that he stands a chance of inflicting permanent damage (are Milton and Dante effectively alive? can they yet be saved in some form they'd have agreed to?—not by schools, apparently). In all Hemingway's work, until *The Old Man and the Sea* and *Islands in the Stream,* the warnings, if not the pleas, are for them; the lessons of one master, diffi-dently but desperately offered—*Prepare, strip, divest for life that awaits you; learn solitude and work; see how little is lovely but love that.*

—Half the lesson of the desert fathers, and given in language of the desert, bleached, leached to essence. The other half—an answer to W*hy?*— is withheld until the last, and then only muttered. Surely there are young people now, readers and writers—children when he died —to whom he is speaking his dark secret language of caution and love, help and beggary, in the lean voice of an infinitely delicate, infinitely suffering thing. No shield, no help at all of course, to him or us (he never said it would be); yet more—a diamond point that drills through time and pain, a single voice which moves through pain toward rest and presses forward shyly with its greeting and offer, its crushing plea, like that of the

hermit Paul when St. Antony had tracked him through beasts and desert and begged for instruction:

Behold, thou lookest on a man that is soon to be dust. Yet because love endureth all things, tell me, I pray thee, how fares the human race: if new roofs be risen in the ancient cities, whose empire is it that now sways the world; and if any still survive, snared in the error of the demons.*

1971

* St. Jerome, "The Life of St. Paul the First Hermit" in Helen Waddell, ed. and trans., *The Desert Fathers* (Henry Holt, 1936), pp. 47–48.

# POEM DOCTRINAL AND
# EXEMPLARY TO A NATION

### A READING OF
## SAMSON AGONISTES

*A little onward lend thy guiding hand*
*To these dark steps, a little further on. . . .*\*

So BLIND Samson gropes into the scene, the prison yard at Gaza, entreating a silent unnamed guide. That Milton—visualizing for the stage, despite his denial in the preface—must have seen the guide as one of the mutes common in Greek tragedy (a prison guard or a boy) only darkens the irony. Whose hand?—God's. Samson prays unknowingly and, in the first two lines, casts his own fate and predicts the final achievement of his life—the reflection to his people, through the Chorus of Hebrews, of God's light on him. The reeling-in of Samson has begun—he would not come freely—and half of the action of the play will be that catch, that battle on the line of angler and prey; the other half, the lessons that battle deposits in its audience.

But Samson has not yet felt the hook. His first speech, the prologue, begins low, half-numb, monosyllabic, not an outpouring of immediate agony, present

---

\* All quotations from Milton's verse (and those from the note to *Paradise Lost* and the preface to *Samson*) are given in the text of Merritt Y. Hughes, *John Milton: Complete Poems and Major Prose* (Odyssey, 1957).

despair (his response in lines 9–10 to "The breath of
Heav'n fresh-blowing, pure and sweet" is hardly that of
a man in despair)—more nearly a narrative, a scroll of
the spiritual adventures which have brought Samson to
this point in time, this place in relation to God, slowly
unrolled for himself (and conceivably for the mute
guide; when does he depart? is Samson's command
"Yet stay" at line 43 delivered to the guide as well as
himself?). Why unrolled?—for another try at reading
and comprehension, at piercing his night. Why under-
stand?—so that rest can descend. He's wrong—so he'll
move, swim freely toward the ship, the line in God's
hand. But soon he is circling, fighting, the first passion-
ate flight, first aria of grief—

> *Retiring from the popular noise, I seek*
> *This unfrequented place to find some ease;*
> *Ease to the body some, none to the mind*
> *From restless thoughts, that like a deadly swarm*
> *Of Hornets arm'd, no sooner found alone,*
> *But rush upon me thronging, and present*
> *Times past, what once I was, and what am now*

—and has brought himself to his old obsessive ques-
tions—

> *O wherefore was my birth from Heaven foretold*
> *Twice by an Angel*

> *Why was my breeding order'd and prescrib'd*
> *As of a person separate to God,*
> *Design'd for great exploits; if I must die*
> *Betray'd, Captiv'd, and both my Eyes put out. . . .*

Samson seems on the edge of hurling questions at God;
but it is soon clear that he will not even permit himself
the relief of indictment. All the questions return to him-

self; and their answer—"O impotence of mind, in body
strong!"—is his surest instrument of self-torture. If any
question is put to God, it is implied in the lines on
blindness—"Why am I thus bereav'd thy prime de-
cree?"—yet, though the weight of the question breaks
the very structure of the verse itself (from consistent
decasyllables to hexasyllables pressed from him like
sobs), Samson can quickly subsume even blindness
under the wings of his own guilt in the awful grave
image, one which has haunted Milton since the days of
*Comus* and will soon be turned against Samson by the
Chorus:

> *Myself my Sepulcher, a moving Grave,*
> *Buried, yet not exempt*
> *By privilege of death and burial*
> *From worst of other evils, pains and wrongs. . . .*

He is stopped in the tracks of his self-loathing by
the sound of approaching feet, and he ends with the
speculation that Philistines are coming to "insult" and
"afflict" him. He does not know that these are well-
meaning Hebrews (who will nonetheless afflict him
more seriously than Philistines); oddly, he has not
recognized that any human being, friend or enemy, is a
reproach to him now, that to the self-condemned all
fingers point.

So the Chorus enter—presumably fifteen Hebrew
elders, men of Dan, Samson's tribe. (Though Milton
calls the Chorus simply "Danites," there is no classical
precedent to suggest that he may have visualized the
mixture of sexes employed in some modern produc-
tions; and the later speeches of the Chorus on women
make such a mixture ludicrous.) Maybe little use can
be made of the fact; but it is grotesquely touching to
notice that these austere prison-visitors enter on an echo

from the perfumed world of pastoral masque. Their first words—"This, this is he"—recall the first song of *Arcades*, addressed by Milton at age twenty-three to the Countess Dowager of Derby:

> *This, this is she*
> *To whom our vows and wishes bend,*
> *Here our solemn search hath end.*

The first nine lines of the parodos are a reflex picture. The Chorus stand unannounced for a moment to look at their former champion, their hope—to them, an isolated ruin and apparently a despairing one—

> *As one past hope, abandon'd,*
> *And by himself given over. . . .*

The fact that we know him to be in better state than the Chorus does not intrude upon their thrill of horror at the chance to diagnose total disaster. Samson does not hear their words, only their steps, which is as well for him, since they move into the second part of the ode and ask their own many-edged questions—

> *Can this be hee,*
> *That Heroic, that Renown'd,*
> *Irresistible* Samson?

The questions reveal the depth of Samson's fall by reflecting the degree of shock in the Chorus; they suggest a genuine sympathy for Samson and, by tripping them into jubilant memories of the days of his glory, the questions permit the Chorus to give us useful past narrative while simultaneously revealing themselves as men who resort to this brand of self-cheer in the teeth of shock, this savage affirmation of community, as though to say, "We are the men who remember *this*, for whom it was done"—eloquent if not

lovable. Beneath their sympathy, however (though closely related to their sense of self), run strains of bitterness, an ambiguity of purpose in the prison visit (is it possible to visit prison otherwise?), of morbidity in their desire to stare at the fate of a man who might have been their deliverer but failed through his own voluptuousness, and of a contempt (the belly of their pity) for strength without virtue. By the naked ferocity of language and rhythm in their memory of Samson's physical adventures (as contrasted with the spiritual adventures of the prologue)—

> *Who tore the Lion, as the Lion tears the Kid,*
> *Ran on embattled Armies clad in Iron,*
> *And weaponless himself,*
> *Made Arms ridiculous, useless the forgery*
> *Of brazen shield and spear*

—they again take a measure of Samson's fall and affirm the reasons: strength without virtue, force without limit. And in their next movement, falling into Samson's own hexasyllabic grief, they repeat his image of the buried soul and complicate it by seeing his imprisonment as three-fold—Philistine prison, prison of blindness, prison of soul in body. Only in the fourth and last movement of the parodos do they hint at their own involvement in Samson's tragedy. The hint is oblique, glancing, its sharp edge pressed against Samson —"O mirror of our fickle state"—and they end with a return to their cruel theme:

> *But thee whose strength, while virtue was her mate,*
> *Might have subdu'd the Earth,*
> *Universally crown'd with highest praises.*

It might be said in objection that the whole parodos is an aside whose purpose is past-narration and that

the real function of the Chorus as friends "who seek to comfort him what they can" (Milton's description from the prose Argument) does not begin until they are in direct communication with Samson. But the objection cannot face certain problems implied in the tone of the parodos—by the scurrying dactyls of "Let us not break in upon him," which C. S. Lewis has called the sort of verse mice might write, if mice wrote verse; and by the heavy presence of rhyme to the point of jingle. If we recall Milton's note of 1667 on the verse of *Paradise Lost* with its dismissal of rhyme—

> as a thing of itself, to all judicious ears, trivial and of no true musical delight; which consists only in apt Numbers, fit quantity of Syllables, and the sense variously drawn out from one Verse into another, not in the jingling sound of like endings, a fault avoided by the learned Ancients both in Poetry and all good Oratory

—then we are left with three choices: that Milton had changed his mind in the intervening years and was here employing rhyme in a relatively simple ornamental or musical sense; or that *Samson* was written before 1667; or that in *Samson* Milton was making dramatic use of assonance, rhyme, jingle as instruments of plotting and characterization. In any case, it would hold Milton to an absurd consistency (he changed his mind in *Samson* about more important matters than rhyme—such as human will) to insist that rhyme in the choruses marks them as "bad Oratory"; but it is important to state the problem now and, farther on, to attempt a decision.

The first episode begins as Samson announces that he can hear disjointed speech. The Chorus approach and address him in terms which, however typical of Hebraic lament, are hardly apt as consolation—

> *Matchless in might,*
> *The glory late of Israel, now the grief. . . .*

Yet they identify themselves as friends, counselors, who
come with "apt words" to console. And Samson re-
sponds with a definition of friendship—loyalty in ad-
versity—which seems unironic but which has, for us
who heard the parodos, its edge. Like a speaking sphinx,
he displays his misery to them—the sight they have
come to see—and offers them a view of his blindness
different from that in the prologue. There he had ex-
claimed, "O loss of sight, of thee I most complain!"
But, faced by his people, he calls blindness a blessing—
how could one self-wrecked bear to see the world? That
this new tack hints at remnants of self-regard—even
traces of mirror-gazing—is clear from his first question
to the Chorus. He does not ask about his aged father
but about his own reputation in Israel; and he implies
a dreaded but desired answer in—

> *Am I not sung and proverb'd for a Fool*
> *In every street; do they not say, "How well*
> *Are come upon him his deserts?"*

Samson's obsession with earned guilt suggests, through-
out the early episodes, an inverted egotism; but it
never seems self-pity. He prevents that, as here, by re-
turning always to the seed of his folly—

> *Immeasurable strength they might behold*
> *In me, of wisdom nothing more than mean. . . .*

But now—and for the first time—he goes beyond his
own guilt to imply a questioning of God:

> *This with the other should, at least, have pair'd,*
> *These two proportion'd ill drove me transverse.*

More trained than we at spotting heresies, the Chorus pull him up at once—"Tax not divine disposal"—but they feel no need to proceed to a defense of Mysterious Providence. Not yet. They grant, with brisk near-cheeriness, that voluptuousness is no rare crime; and they advise Samson to spare himself self-blame. They cannot resist, however, employing a famous camouflage device to ask him why he married foreign wives. Such choral questions are common enough in Greek tragedy, especially in *Prometheus* and *Oedipus at Colonus* where they are technical conveniences to trigger an actor into narrative or the justification of past action. But Milton is already passing every ancient device through the prism of his needs; and his Chorus do not say, "Tell us why you married Philistine women." They detour—

> *Yet truth to say, I oft have heard men wonder*
> *Why thou shouldst wed* Philistian *women rather*
> *Than of thine own Tribe fairer, or as fair,*
> *At least of thy own Nation, and as noble*

—and add a small firm stroke to their own growing picture.

Samson replies that his foreign marriages were prompted by God to speed Israel's deliverance and again returns to his own weakness (and by now, 220 lines in, Milton has firmly established the crushed density of syntax which will eventually be shared by all characters except perhaps plain Manoa—a language discriminating, distancing them from us—another of his many attempts at a kind of sane historical fidelity and at shielding us, sparing us the threat of direct contact with his own full vision). The Chorus, for the first time, attempt consolation. They ignore his spiraling guilt and indulge in another homely tactic—this

time for raising-the-tone, changing-the-subject—but
their good intention can only fuel three lines; then the
air of Samson's presence and their own deep divisions
force from them the severest condemnation they can
make:

> *In seeking just occasion to provoke*
> *The* Philistine, *thy Country's Enemy,*
> *Thou never wast remiss, I bear thee witness:*
> *Yet* Israel *still serves with all his Sons.*

For once, in a flash that hints at fire under ashes
(there are guilts that even he will not shoulder), Sam-
son refuses the condemnation and transfers it to Israel's
leaders who refused him support when he, single-
handed, slew a thousand Philistines; then he moves into
thoughts on corrupt peoples who refuse God's heroes
and prefer easy bondage to "strenuous liberty."

It is not clear at first that Samson includes the
Chorus among those who failed him; but their re-
sponse shows at least a dodging discomfort (he is still
far more dangerous than they'd planned). They ignore
the present ungrateful rulers of Israel and turn back in
history for a terse and eloquent memory of similar in-
gratitudes to Gideon and Jephtha. By its look on the
page—studded with italic names—the speech may at
first appear decorative or another link between *now*
and *then*; but if we recall how often, in any life,
memory is a refuge from the present, a harbor from er-
ror, and if we notice that the intensity with which they
hurl their eloquence backward finally lands them in a
jingle—

> *Had not his prowess quell'd thir pride*
> *In that sore battle when so many died*
> *Without Reprieve adjudg'd to death,*
> *For want of well pronouncing* Shibboleth

—then we may suspect that what they say, that all they say, becomes a mirror before them.

Samson's reply is produced by his own ruling masochism and by his, as yet, fairly uncomplicated gratitude for company. He accepts without irony the historical comparisons, denies his personal importance and again laments his inability to fulfill God's purpose. All his earlier questions and hints of questions rest now, torpid.

But the Chorus refuse the pause and burst into their first stasimon—"Just are the ways of God." The beginning looks abrupt, an unheralded eruption; but gradually they show the trail of their movement—they are lecturing, homilizing, themselves. They are replying to (not *answering*) the question which has swelled hideously, lethally before them since their first glimpse of blind Samson, the question which they have forbidden Samson to ask—"Why has God so degraded Samson and Israel, and Himself?" Even now, they do not ask the question; but it stands in their midst (and ours) throughout the ode, huge, the pole round which they dance. Their reply, which begins with a firm assertion of the justice and reason of God's ways and proceeds through confident-sounding old-man platitudes on atheism—

> *Unless there be who think not God at all:*
> *If any be, they walk obscure;*
> *For of such Doctrine never was there School,*
> *But the heart of the Fool,*
> *And no man therein Doctor but himself*

—curves, veers as it grows in their throats. The surface of their confidence is uncracked until they attempt a specific defense of God in the matter of Samson; then all their confidence in reason crumbles. They can only

say, "Down Reason then, at least vain reasonings
down." Their answer to the great *Why?* is that the
question must not, cannot be asked—an answer which
is often the last redoubt of the shaken and doubting
pious. How shaken, how doubting, we have yet to dis-
cover. Samson's father Manoa is seen in the distance;
and they break off—rescued—to announce his arrival.

Manoa enters and begins the second episode by
asking the Chorus to direct him to Samson. When they
have pointed the way, Manoa breaks into cries of dis-
belief and recollections of past glory which come more
naturally from a father than, earlier, from the Chorus.
It would be possible to think of these lines as repetition
—signs of the play's senility or, conversely, its early
lack of finish—but surely it is adequate and useful to
notice that Milton, far from carelessly repeating the
parodos, alters the material to the character of the old
father. For instance, Manoa reduces to nine lines (340–
348) the substance of twenty-seven lines of the parodos
(124–150). A chorus obviously are expected to be lyri-
cal, expansive; but the compressed grief of Manoa is
more moving than all the rhetorical sheen of the
Chorus, though his motives soon appear as complex as
theirs, tangled in a specially paternal way. Yet Manoa
himself is soon approaching the questions which Sam-
son approached in the prologue. In fact, by line 356 (ad-
dressing whom?—Samson? the Chorus? the surround-
ing air? he does not specifically address his son until
362), Manoa has come nearer than Samson or the
Chorus to a direct interrogation of God, bitter and
with no trace of rhetoric—

*Why are his gifts desirable; to tempt*
*Our earnest Prayers, then, giv'n with solemn hand*
*As Graces, draw a Scorpion's tail behind?*

And though he sheers off, retains the third person, asks questions *about* God (no one has yet said *You!* to God) Manoa goes on into thoughts that sound very much like orders to the Almighty—

> *Alas! methinks whom God hath chosen once*
> *To worthiest deeds, if he through frailty err,*
> *He should not so o'erwhelm, and as a thrall*
> *Subject him to so foul indignities,*
> *Be it but for honor's sake of former deeds.*

Manoa goes so far toward explicit indictment of God that Samson stops him with a line the Chorus have used against him—"Appoint not heavenly disposition, Father." The Chorus had actually warned Samson, "Tax not divine disposal"; Samson's own wording—with the sense of "Don't give God orders, Father"—lends the warning a filial tone and is the first flash of a warm wit that will color and deepen the relations of Samson and Manoa (and which, not incidentally, provides another secret sign of hope in Samson). But Samson quickly accepts full responsibility for his misery, testifies to the justice of his punishment, gives a long account of his surrender to both his Philistine wives, then declares that his present degradation is not so ignoble as his early servitude—"foul effeminacy"—to women.

Manoa replies with a paternal gravity so understated as to have its own no doubt intentional wit, "I cannot praise thy marriage choices, Son." He agrees to the tragedy of all Samson's mistakes but, in his eminently practical way, reminds Samson that he need not overpay his debt of penitence. Yet for all his healthy expedience, he will not ignore or obscure the greatest of Samson's crimes; indeed, he understands the crime in a way not previously advanced, and with no clear

reason, he mentions it now (is the reason, again, paternal?—"I told you so"?)—Samson is responsible for the degradation of Jehovah and the magnification of Dagon in the eyes of the Philistines (and, perhaps, we may wonder, among some of the notoriously fickle Hebrews?). Samson again accepts the charge; he is especially stricken to have caused "doubt / In feeble hearts," but he is confident that God will triumph over Dagon and without the aid of Samson.

Manoa receives the confidence with such enthusiasm that he seems, as he often does, on the edge of a lyric outburst—

> *these words*
> *I as a Prophecy receive: for God,*
> *Nothing more certain, will not long defer*
> *To vindicate the glory of his name*
> *Against all competition, nor will long*
> *Endure it, doubtful whether God be Lord,*
> *Or* Dagon

—but he stops short and reveals that he has already made overtures to Philistine lords for Samson's release. He, at least, has worked to help his son in the only way he thinks practical. He has understood nothing of the "Prison within Prison / Inseparably dark" which is Samson's announced vision of his own soul (and Manoa will prove righter than anyone in the play now knows).

Samson expresses his preference for prison, his need for punishment, his shame at the thought of returning to his people to be "avoided as a blab." The ugly and comic colloquialism starts out of the, by now, luxuriant and monotonous coils of Samson's self-obsession—the direct hit of a lifelong narcissist who has had time, and the resources, to become the world's author-

ity on some aspects of himself; and who knows himself a blab.

Manoa again urges moderation in all this self-affliction—a little unselfish self-mercy. (Alfred Adler said late in life that the sum of his psychology was "All neurosis is vanity"—a truth available for clear enunciation to these two old Jews; for *Samson* is the most profoundly Jewish of great extra-Biblical poems.) Perhaps, he says, God will forgive; perhaps God intends that Samson return now to Israel to seek forgiveness. But Samson again refuses; he will seek pardon but not freedom. He recalls the obnoxious pride of his free days when he walked Israel "like a petty God"; he remembers himself in the lap of Dalila (*sees*—all Samson's memories are intensely visual; and the most obtuse of Eliot's charges against Milton is a lack of visual acuity) as "a tame Wether"—a castrated sheep—and in this ultimate image of his physical degradation, Samson aligns himself with Oedipus and Cornwall (in blinding Gloucester) by viewing blindness as a surrogate castration.

At this new depth, the Chorus rush into six lines on Samson's temperance in respect to wine. The tack seems abrupt to the point of authorial awkwardness (and is one of the passages exhibited by those who think the play unfinished); but in fact the few lines do considerable work—work which is both in-character and which further reveals character. For instance, Samson and Manoa have catalogued exhaustively all Samson's betrayals of God. The Chorus, silent but attentive for two hundred lines, remember the one vow which Samson never broke—the central command that a Nazarite should separate himself from wine and strong drink—and they rush in with it now, a gift, at the first opening. And at first they appear to have suc-

ceeded, at least in changing the subject. Samson follows them with six lines on his exclusive use of water; and the pleased Chorus expand into a more general condemnation of strong drink, a thumping Prohibition tract in five lines.

But Samson cannot be diverted for long. With the consummate skill of his narcissism, he employs the diversion itself as a pivot back into self-blame—

> *But what avail'd this temperance, not complete*
> *Against another object more enticing?*

—and he meditates upon the possible *use* of his returning home to be "A burdenous drone; to visitants a gaze, /Or pitied object." He seems to say that here in prison he at least has work—the drudgery which earns his bread and pays on his debts of guilt. It will be a thousand lines—moments before the catastrophe—until Manoa affirms that God will not leave Samson "Useless, and thence ridiculous"; but the Chorus have already hinted at the equation *useless* = *ridiculous* in the parodos—

> *weaponless himself,*
> *Made arms ridiculous, useless the forgery*
> *Of brazen shield and spear*

—and Samson begins here dimly to share an article of Milton's lifelong faith that the truly ridiculous is the useless. It is an article which will become a cornerstone of Samson's reconstruction. Samson, though, is a failed judge, not a prophet. He cannot see that foundations are present on which God is building, that the hook is in his mouth; so he delivers now the nine lines which, for all the calm of their surface, are Samson's—the play's, Milton's—deepest gaze toward despair, its ultimate nadir, the crisis of the disease of being Samson, to be followed by death or recovery:

*All otherwise to me my thoughts portend,*
*That these dark orbs no more shall treat with light,*
*Nor th' other light of life continue long,*
*But yield to double darkness nigh at hand:*
*So much I feel my genial spirits droop,*
*My hopes all flat, nature within me seems*
*In all her functions weary of herself;*
*My race of glory run, and race of shame,*
*And I shall shortly be with them that rest.*

Manoa briskly but accurately diagnoses false despair, the product of less than fatal mental anguish; he urges his son to wait calmly and hear "healing words" from the Chorus (who, a third of the way in, have hardly offered healing) while he goes off to argue a ransom.

Alone again with the Chorus, Samson rouses from his brief calm (why now?—surely a response to his father's presence, now that presence is safely withdrawn) and attempts to dive still deeper in a long aria, a monody on psychic torment which is as authoritative a report as any in literature—

*Thoughts my Tormentors arm'd with deadly stings*
*Mangle my apprehensive tenderest parts,*
*Exasperate, exulcerate, and raise*
*Dire inflammation which no cooling herb*
*Or med'cinal liquor can assuage,*
*Nor breath of Vernal Air from snowy Alp*

—but is firmly doomed, if its purpose is death, a rush toward self-destruction. The bottom, as Eliot said, "is a great way down"; but Samson has reached bottom some thirty lines before—the bottom of himself, at least, beyond which lies silence—and is now being lifted, with ghastly slowness, on the shards of his old vices: self-esteem, narcissism, the eloquence of the two

—toward what he cannot imagine (*we* know). He implies a last tired questioning of God; then, sure of his total isolation, ends in a simple prayer, "speedy death."

Except for their brief sally on temperance, the Chorus have stood silent for more than three hundred lines. In reading, it is easy to forget their mute presence; but they have stood throughout, listening, absorbing, responding impotently as they wait. And the content of their second stasimon, which they now launch, is a clear delayed-action graph of their continued responsiveness. Their previous ode had brought them dangerously near an abyss; and since then they have witnessed the agonized exchanges between Samson and Manoa—Manoa's hard-headed practicality and cruel paternal accuracy circling, powerless, round Samson's growing voluptuous despair. They have just heard Samson rending his inner horror, as with nails at a fresh scar, and trailing into the spent prayer for death.

So the ode begins calmly, taking its first note from Samson's weariness, with a movement on patience, commended by the wise "as the truest fortitude." It seems for a while that they are working themselves into the sort of stoic comfortless advice which might be expected of a Chorus, especially of the Chorus who delivered the parodos of this play—a swatch of plain-dull. And just as it seems that they are indeed knuckling-under for a siege of masochism, trouble threatens—

> But with th'afflicted in his pangs thir sound
> Little prevails

—and the dam falls, an outpouring which is the first great shout in a play that has, till now, been conducted in a prison-hush, a shout at first of wonder more than anger, printed as an exclamation not a question:

> *God of our Fathers, what is man!*
> *That thou towards him with hand so various,*
> *Or might I say contrarious,*
> *Temper'st thy providence through his short course,*
> *Not evenly, as thou rul'st*
> *Th'Angelic orders and inferior creatures mute,*
> *Irrational and brute.*

They are thinking of great men—Samsons—not themselves; and it is their first completely sympathetic speech (in both senses—the first in which they are feeling *with* Samson as friends and in which they are entirely likable as men). The ordeal of the last few hundred lines has brought them a long way from their early two-edged "consolation"; and they stand stripped of selfishness and petty sadism, of delusion, and contemplate God's visible use of His great men—

> *Yet toward these, thus dignifi'd, thou oft,*
> *Amidst thir height of noon,*
> *Changest thy count'nance and thy hand, with no*
>     *regard*
> *Of highest favors past*
> *From thee on them, or them to thee of service.*
>    *Nor only dost degrade them, or remit*
> *To life obscur'd, which were a fair dismission,*
> *But throw'st them lower than thou didst exalt them*
>     *high,*
> *Unseemly falls in human eye. . . .*

—"Unseemly falls in human eye": there is a moving delicacy of fairness in their choice of adjective (throughout the ode, they are kept from hysteria chiefly by their struggle to be fair). They do not call God unjust or evil; but they call some of his visible acts "unseemly." They come this near the brink—and Samson must

know that it is he, the spectacle of his life, who has brought them this near to "diffidence of God, and doubt"—but they stop. It is among their oldest reflexes, that they hesitate to make explicit accusation of God. They have drawn their general picture of the miseries of the debased great; but they have not forced themselves (or allowed themselves to race) to the final connection, to point to Samson and say to God, "Here is the man." And it seems that they cannot; for now they begin a chastened, hedging prayer—

> *So deal not with this once thy glorious Champion,*
> *The Image of thy strength, and mighty minister.*

Even here, at their most sympathetic, they ask for the wrong gift—that God comfort Samson, not that He again use Samson. Then they plunge to the point—

> *What do I beg? how hast thou dealt already?*
> *Behold him in this state calamitous, and turn*
> *His labors, for thou canst, to peaceful end.*

So Samson has brought them—they have let themselves be brought, "heads without name"—not perhaps to doubt of God's existence but surely to literal "diffidence," lack of trust in His promises of justice, a retreat to the mean, demeaning (though, for all we know, accurate) ethics of their first stasimon: "Who made our Laws to bind us, not himself." If the Chorus were forced by events to continue speaking now or to make the play's next action, it is not possible to predict where they might end—at the mill with Samson? or as suicides? or (far more likely) back home at their chores, the bitterer for their trip, the more "useless" thence "ridiculous" (to whom?—to God, at least). And if Samson were forced now to fill a silence, could he do more than exhale?

Rescue again arrives—the Chorus can break off to announce an arrival, and in a tone radically, almost ludicrously, new:

> *But who is this, what thing of Sea or Land?*
> *Female of sex it seems,*
> *That so bedeckt, ornate, and gay,*
> *Comes this way sailing*
> *Like a stately Ship*
> *Of Tarsus, bound for th' Isles*
> *Of Javan or Gadire*
> *With all her bravery on, and tackle trim,*
> *Sails fill'd, and streamers waving,*
> *Courted by all the winds that hold them play,*
> *An Amber scent of odorous perfume*
> *Her harbinger, a damsel train behind. . . .*

—Dalila, of course; and the tired wit of the initial description (a full-rigged ship is a common metaphor for an overdressed woman) and their references to her as a "thing," as "it," are meant to tell us more about the Chorus than Dalila, though the fact that they move in fifteen lines from ridicule to implied tribute is one index to Dalila's beauty (and another elaborately visualized stage-direction; still another is often ignored —Dalila comes with "a damsel train," a silent chorus of beauties who stand in reinforcement of her power and meaning throughout the episode):

> *Yet on she moves, now stands and eyes thee fixt,*
> *About t' have spoke, but now, with head declin'd*
> *Like a fair flower surcharg'd with dew, she weeps*
> *And words addrest seem into tears dissolv'd,*
> *Wetting the borders of her silk'n veil. . . .*

Her first words—"With doubtful feet and wavering resolution/I came"—raise the central question about

this third episode: why is Dalila here? The question has parts—first, why does Dalila think she is here? (the others are, why does Samson think she is here?; why the Chorus?; and why God?). And that is unanswerable, overall (though more or less answerable at any given moment); for Dalila herself does not know all her reasons for coming and, like the Chorus', they are both good and bad. Goethe interrupted Crabb Robinson, who was reading the scene to him, to say, "See the great poet! he *putt* her in right!"—to which W. P. Ker added, a century later in *The Art of Poetry*, "Dalila . . . is so far in the right that Samson cannot be thoroughly in the right when he argues against her."

The question, again, is not, "Is Dalila right?"—it will be fatal to God's purpose if Samson accepts her offer—but "Is Dalila sincere in her offer to care for Samson 'At home in leisure and domestic ease' "? If we answer No (and No throughout the scene)—and if Milton's answer is No—then Dalila becomes a simple flat character, a monster of nearly incredible proportions who wants Samson in her power again to torture as everyone has tortured damaged beasts. If we answer Yes—with Goethe and Ker—then she becomes instantly a richer, more mysterious character, a truer woman (and incidentally throws further light on the silliness of the choral bluster at her exit). The nearest approach to accuracy would be to answer, "Both." Surely her initial offer is "sincere"—sincere as she can make it. She feels some remorse for her part in the ruin of her husband; she would like to make recompense in the only way she knows—in bed (and her sense of Samson as superb *rider* is rank throughout):

*Here I should still enjoy thee day and night*
*Mine and Love's prisoner, not the* Philistines',
*Whole to myself, unhazarded abroad*

and

> *Life yet hath many solaces, enjoy'd*
> *Where other senses want not their delights*
> *At home in leisure and domestic ease. . . .*

But what she has not reckoned with—and never understands—is that she is simultaneously both herself and a pawn to a foreign God. She comes as Dalila (who might conceivably have been accepted with honor and with good results for the subjected Israelites) and as the Old Temptress to Body (who must now be repelled to prove old weakness dead and to exercise new strength, new grace); and when that unconscious complexity of role collides with Samson's own new seething complexities—old vices being made new strengths through contact with the cruelty, stupidity, pathos and desperate need of the Chorus—she loses grip on all her various mounts and rides off in several reckless directions at once, though she retains to the end the courage and splendor of her own multiplicity:

> *At this who ever envies or repines*
> *I leave him to his lot, and like my own.*

It is her final display of mixed motives that provokes the flood of abuse poured on her by the Chorus and Samson as she departs. Samson declares, "God sent her to debase me"—and the inaccuracy of the second half of the claim does not destroy the truth of the first, that Dalila was literally a minister from God and that her ministry has worked or is working—but the Chorus, having first dismissed her as "a manifest Serpent," acknowledge the power of Dalila:

> *Yet beauty, though injurious, hath strange power,*
> *After offense returning, to regain*
> *Love once possest, nor can be easily*

*Repuls't, without much inward passion felt*
*And secret sting of amorous remorse.*

That they attribute her power simply to her "beauty"
—presumably her physical allure, though they call it
"strange"—does not conceal their new confusion in the
face of the rapidly complicating spectacle of Samson's
fate, a spectacle more complex at the start than they
were equipped to watch or comprehend. And the truth-
ful ambiguity of these lines is a credible preparation for
the quick and ludicrous resolution which they achieve
in the following ode, the third stasimon.

To call their resolution ludicrous is to announce,
before examining, a solution to the problem—what are
we to make of the attitude to women and marriage
which the Chorus express? The ode was customarily
cited, into the early twentieth century (and in the face
of the triumphant salvatory femininity of Eve in *Para-
dise Lost* and of the strong, not entirely defeated,
armaments granted to Dalila), as one of the prime texts
on Milton's own misogyny. But here, if ever, we must
remember Milton's statement on the understanding of
drama—

> we must not regard the poet's words as his own,
> but consider who it is that speaks in the play, and
> what that person says; for different persons are in-
> troduced, sometimes good, sometimes bad, some-
> times wise men, sometimes fools, and they speak
> not always the poet's own opinion, but what is
> most fitting to each character.*

That, and a study of what is on paper, the irreducible
words, seem to license if not require a procedure like

* Milton, *Defensio Prima*, S. L. Wolff, trans., in F. H.
Patterson, ed., *The Works of John Milton* (Columbia, 1931–38),
VII, 307.

this. Assuming that *Samson* was written, or at least finished, after *Paradise Lost* and that Milton still held to the strictures on rhyme pronounced in the note to the epic, then it would be difficult to imagine a passage more guilty, under these strictures, of "wretched matter," injudiciousness, triviality: the opening eight lines with their six repetitions of the *it* rhyme—which is complicated and recalled in "gifts," "mix'd" and "infix'd"—and the nine closing lines with their heavy tolling. So, remembering that few things in literary study are more dangerous than the identification of humor in relatively old material, especially material in which humor is not normally expected (how many laughs has, or had, the *Oresteia?* the book of *Job?* the Gospels?), we might decide that a reading like this is as plausible as any. The ode is purely dramatic; it expresses sentiments, obeys codes proper to a group of Hebrew elders—the general Old Testament view of women and marriage; in fact, the prevailing view in the world today. (Whether they are also the sentiments of John Milton in the 1660s is another, not particularly relevant, question; they were certainly not his sentiments twenty years earlier when, in his divorce tracts, he elaborated a vision of marriage as mutual love, the profoundest courtesy, which is only soiled and diminished, though not obliterated, by the present voice of the Chorus.) It is possible, however—and this is where the jingling and thudding of the third stasimon, its rhythmic anticipations of Gilbert and Sullivan, define its tone—that the Chorus themselves do not really believe all they say, that they overstate their scorn of women's wiles and over-assert their marriage rights in the attempt to strengthen Samson against any remaining desire to follow Dalila, to confirm him in his violent treatment of her—and to do the same services

for themselves (they have, after all, seen and briefly succumbed to Dalila; and the very violence of Samson's final rejection confirms his own awareness of danger). Whatever the case, there is again a playful tone of relief as another arrival permits a change of subject; and in the brief exchange which follows, Samson loses patience with the still-pedantic Chorus for the first and only time—

CHORUS   *But had we best retire, I see a storm?*
SAMSON   *Fair days have oft contracted wind and rain.*
CHORUS   *But this another kind of tempest brings.*
SAMSON   *Be less abstruse, my riddling days are past.*

The newest visitor is Harapha, a Philistine giant who gives us some notion of the awfulness of Samson in his own strongman "petty God" phase. The episode is built as a shouting-match between Samson and Harapha—Samson repeatedly challenging the bully to single combat, with all the odds to Harapha, and Harapha weaseling. The scene, and most of its verse, are as deadly for modern readers as similar matches in Homer, Shakespeare or on the playgrounds of their childhoods —no one could wish it a syllable longer (though serious actors might clarify its points)—and a close reading here would be tedious, windy and unrewarding. But the results of such a reading would show that Samson has experienced, early in the episode or before it, a radical revival of confidence in self and in God. When Harapha accuses Samson of having fought of old with magic power and protection, Samson replies—

*I know no spells, use no forbidden Arts;*
*My trust is in the living God who gave me*
*At my Nativity this strength, diffius'd*
*No less through all my sinews, joints and bones,*

> *Than thine, while I preserv'd these locks unshorn,*
> *The pledge of my unviolated vow*

—and when Harapha observes that the living God hardly seems to live here, has abandoned his chosen hero, Samson can accept a part of the charge and revise it—

> *All these indignities, for such they are*
> *From thine, these evils I deserve and more,*
> *Acknowledge them from God inflicted on me*
> *Justly, yet despair not of his final pardon*
> *Whose ear is ever open; and his eye*
> *Gracious to re-admit the suppliant;*
> *In confidence whereof I once again*
> *Defy thee to the trial of mortal fight,*
> *By combat to decide whose god is God,*
> *Thine or whom I with Israel's Sons adore.*

Harapha of course avoids the fight and departs, still huffing, eighty lines later, with Samson's even healthier, grislier challenges ringing at his heels; but the question about the episode remains—why and how has Samson moved from the despair of the ghastly monody through the clenched near-hysteria of his rejection of Dalila to this sane vigor, this lip-curled smiling excitement? —For two reasons and in two ways: he is drawn now, reeled-in rapidly by God who is ready to end *this* story; and he has comprehended for the first time through the action of the day—and specifically through the choral response to that action (the various odes)— the already disastrous effect he has had upon his own people, the Chorus. Not simply the fact that now they are vassals of the Philistines but that they are spiritually stunned, perhaps lost, and that they lack his own heroic resilience to rescue themselves. There is, almost cer-

tainly, a third reason, wild and loose—with all the fresher inspirations that arise in Harapha's wake comes also a knowledge of the old black chance, Harapha might kill him:

> *But come what will, my deadliest foe will prove*
> *My speediest friend, by death to rid me hence,*
> *The worst that he can give, to me the best.*

But if Milton is aware of the rattling of that, like seed in a gourd, the Chorus are not. Their own response to Harapha, and Harapha's effect on Samson, is whole and simple. They were roused by the sheer noise of the episode and its indications of rebirth in Samson; and after a few quick exchanges with Samson (including their only successful levity in the play, "His Giantship is gone somewhat crestfall'n"), they launch impulsively into a praise of heroic action, the impulse being surely the great smile registered in the opening movement, that of parched ground bathed by rain—

> *Oh how comely it is and how reviving*
> *To the Spirits of just men long opprest!*
> *When God into the hands of thir deliverer*
> *Puts invincible might*
> *To quell the mighty of the Earth. . . .*

In the one verb "puts" they flash a moment of perception (they still see Samson as a largely passive receptacle of God's strength, used or abandoned at His mysterious will); otherwise, the first nineteen lines of their fourth stasimon are, minus expected ferocity, the sort of song appropriate to the early days of Samson's glory. But the sentiments clang brassily now. Samson has not yet *acted*—not an act visible to his waiting people— and the chances for significant action are apparently all but non-existent. So their excitement has pushed

them past hard fact; they have not caught up (how could they?) with the changes rapidly occurring in, arriving in, Samson's soul; and they soon realize the tactlessness of their paean to "invincible might." The change to sobriety and decorum is signaled by a "but" —"But patience is more oft the exercise/Of Saints." They think it likely that Samson's blindness may finally force him to resignation and the company of martyrs "Whom Patience finally must crown." But they are not sure—their prediction is not a prediction but a guess; does their tentativeness throughout the ode, even in the over-confident opening, explain the relative absence of rhyme?—and their doubts are strengthened by sight of the approaching Public Officer.

The Officer orders Samson to come to the Philistines' solemn feast. Samson refuses on two grounds— Hebrews are forbidden to attend pagan rites, and he will not perform blind for the sport of his captors. The old pride, again, is not broken but is now *used*, not abused; it has a new face—no longer the narcissism of a strongman but the offended dignity of one who still values the shards of honor remaining to him.

The Officer departs, lowering; and the Chorus urge Samson to reconsider. It is a long-delayed return to their promised offer of "counsel" and a curious one— they want Samson to go to the feast; why? It has been suggested that the Chorus are again attacking Samson's sense of his own specialness, his chosen-ness; but two simpler (and more likable) forces seem stronger—the Chorus, like Samson, are drawn now by God's plan (as satellites to Samson or as the central body?) and they fear for their own safety if Samson refuses. Samson, in argument with them, continues to refuse until they exclaim in what sounds more like parental exasperation than anger, "How thou wilt here come off sur-

mounts my reach."

But Samson dimly knows. In the most difficult
lines of the play, he reverses his decision—

> *Be of good courage, I begin to feel*
> *Some rousing motions in me which dispose*
> *To something extraordinary my thoughts.*
> *I with this Messenger will go along,*
> *Nothing to do, be sure, that may dishonor*
> *Our Law, or stain my vow of Nazarite.*
> *If there be aught of presage in the mind,*
> *This day will be remarkable in my life*
> *By some great act, or of my days the last.*

For any reader who can accept the idea of divine
inspiration, no convincing will be needed—Samson has
been inspired, and *now*. The only question is, how
specifically inspired?—does Samson know the details of
the rest of his fate? And that is unanswerable. For a
reader who cannot—how has he read this far?—these
lines, this moment, will no doubt seem dramatically
unacceptable. We might argue for Samson that no sud-
den change of heart is involved, that the entire be-
ginning and middle of the play (all his encounters,
and chiefly that with his only constant human com-
panions throughout—the Chorus) have constituted an
education for Samson, long-delayed but successful; in
the silence between lines 1380 and 1381, he accepts
the logical (though probably still dark) demands and
duties of that education. He is truly passive, a listener
not a speaker; he is caught. And, laying aside for now
any question of afflatus, how else could Milton have
treated such a turn?—through a multiplication of visi-
tors and episodes? a longer episode here with the Cho-
rus in which they and Samson might specify the na-
ture of their now-clarified mutual dependence and

duties? In fact, Samson now knows what he needs to know; the Chorus do not, but they will have more time to learn than Samson (because a large part of what they learn will *be* Samson). What we as readers do not know (or will not learn in the next four hundred lines) or will refuse to accept is, Milton might say, the fault of our weakness—that will hurt us ("All wickedness is weakness"); but Milton never promised safety. In short, Samson has detected, or suspected, the "guiding hand" which he had implored (of a mute) in the first line of the play and has surrendered to the suspicion. The one thing which he cannot doubt is that he is guided, pulled, toward *rest*—his goal from the first: any direction from here lies rest. The hand of grace—God's hand—seems paternal again or (disturbingly) maternal.

So when the Officer returns as expected with a sterner command, Samson obeys with lines that build quickly to a comic near-fawning—who could have imagined, even ten lines before, that such a response would be both credible, acceptable and right?:

*Because they shall not trail me through thir streets*
*Like a wild Beast, I am content to go.*
*Masters' commands come with a power resistless*
*To such as owe them absolute subjection;*
*And for a life who will not change his purpose?*
*(So mutable are all the ways of men). . . .*

But that is for the Philistines, in his office as their "Mummer." The Officer, pleased with compliance, guesses that Samson may now indeed earn his freedom and gives him time for words with his friends.

For them both it is farewell. Despite mutual hedgings, the loopholes left for survival, their last exchange has the already-posthumous calm of many final partings. Samson does not allude to his suspicion of Provi-

dence in the summons. He prepares them instead for the possibility of his death at the hands of the Philistines and warns them that, come what will, they may find themselves in danger for his sake—that he gives them no more definite warning, or command to flee, seems to confirm the vagueness of his inspiration, the totality of his surrender. His people, like himself, he leaves in the hands of God, not even troubling to remind them of the fact. His last direct word, to them and us, rightly concerns his honor—

> *Happ'n what may, of me expect to hear*
> *Nothing dishonorable, impure, unworthy*
> *Our God, our Law, my Nation, or myself;*
> *The last of me or no I cannot warrant.*

But the Chorus, always an observer of forms, send benediction with, and after, him (does he exit abruptly at line 1426 or slowly enough to hear them?). This fifth, and briefest, stasimon reveals that the Chorus are also apprehensive of some divine act. They do not dare to be explicit; they only commend Samson to God (Whom they again, and calmly, affirm deserving of glory), invoke the angel of his birth to guard him, and again recall his past. In relation to their own capacities, they have had to come as far as Samson—from their ambivalent parodos, their untested but tub-thumping certainties, their desperate collapses—to this hushed expectancy. Samson has led, or at least brought, them. That he may have led them to the brink of a pogrom does not scatter them now; the mice of the parodos have stoutened and stand. They can end now —the first ode they really finish—to meet the return of Manoa.

He enters "With youthful steps," full of his day's work; Samson's ransomed freedom appears to be at

hand—two-thirds of the Philistine lords have agreed (one group for "Private reward," another "having re-duc't/Thir foe to misery beneath thir fears"). The Chorus express their joy in the hope. Then the dialogue is broken by a noise—which the Chorus accurately identify as a Philistine shout of pleasure at the sight of their famed enemy. The exchange continues with Manoa's slightly self-congratulatory affirmation of will-ingness to bankrupt himself for his son. To which the Chorus respond generously and without irony in lines that, though a simon-pure example of "choric com-ment" (the only such in the play), are transformed by their new calm and passionate sympathy—

> *Fathers are wont to lay up for thir Sons,*
> *Thou for thy Son art bent to lay out all;*
> *Sons wont to nurse thir Parents in old age,*
> *Thou in old age car'st how to nurse thy Son,*
> *Made older than thy age through eyesight lost.*

And their praise ignites Manoa to a further vision of his role—as attendant to the freed Samson whom he now sees powerfully, seated at home:

> *And on his shoulders waving down those locks,*
> *That of a Nation arm'd the strength contain'd*

—and to an ironic wager on Samson's future utility to God which crystallizes at last the ideas of *use/useless-ness, esteem/ridicule* which have hung suspended since the beginning of the play—

> *And I persuade me God had not permitted*
> *His strength again to grow up with his hair*
> *Garrison'd round about him like a Camp*
> *Of faithful Soldiery, were not his purpose*
> *To use him further yet in some great service,*

> *Not to sit idle with so great a gift*
> *Useless, and thence ridiculous about him.*

The Chorus again second the hopes and explain their participation in Manoa's hopes and joy, "In both which we, as next, participate." "As next" implies "of kin"— the Chorus, who introduced themselves as "friends and neighbors," are now moved to go even beyond the tribal bond and claim *relation*.

At that moment—and surely with the full knowledge and intent of both God and Milton—the catastrophe occurs. Manoa begins a thankful reply but, after six words, breaks off to register a second noise—"Horribly loud, unlike the former shout." In the thirty lines before the arrival of the Messenger, Manoa and the Chorus speculate on the nature of the catastrophe and the safest course of action for themselves; and it is worth noticing that this Chorus stands its ground—it is they who advise Manoa to "keep together here." In place, they indulge again the gift, so visible in the parodos, for depiction of events which they have not witnessed—events, in this case, have not occurred as they imagine, and will not—

> *What if his eyesight (for to* Israel's God
> *Nothing is hard) by miracle restor'd,*
> *He now be dealing dole among his foes,*
> *And over heaps of slaughter'd walk his way?*

But a witness arrives. It is important to remember a fact of which little is made in the lines but which would presumably be clear, through costuming, on-stage—the Messenger is, as the Chorus announce him, "An *Ebrew*, as I guess, and of our Tribe." For many urgent reasons Milton could not have sent the Chorus itself to the doomed arena; but the survivor and testifier,

the witness and historian of Samson's triumph and death, is another kinsman, a man (or boy) of Dan. He begins his report, the longest speech of the play, with a few facts about himself—that he had come to Gaza on business early this morning but, the business hardly begun, had heard rumors of Samson's appearance and, though piteous of his state, "minded / Not to be absent at that spectacle." Then he tells the famous story, adding numerous pictorial details to the Biblical account which tell us more about Milton's vision than the Messenger's, especially in his account of Samson's last words. In *Judges* they are given (after a brief prayer that he be strengthened to avenge his eyes), bare and awful—"Let me die with the Philistines." Milton's Messenger heard them thus—

> "*Hitherto, Lords, what your commands impos'd*
> *I have perform'd, as reason was, obeying,*
> *Not without wonder or delight beheld.*
> *Now of my own accord such other trial*
> *I mean to show you of my strength, yet greater;*
> *As with amaze shall strike all who behold.*"

(—"As reason was." What reason? We partly know; will be told more by the next hundred lines, the end of the play; part will be secret shared by Samson and God —or kept by God.) And the Messenger's expansion of *Judges* 16:23—"Then the lords of the Philistines gathered them together for to offer a great sacrifice unto Dagon"—suggests a specific desire by Milton to stress Samson's success in creating the conditions for the freedom of his people:

> *Upon the heads of all who sat beneath,*
> *Lords, Ladies, Captains, Counsellors, or Priests,*
> *Thir choice nobility and flower, not only*
> *Of  this but each* Philistian *City round.* . . .

Indeed, when the Messenger concludes four lines later—with a final reminder that Samson has "inevitably" destroyed himself—it is to the previous spectacle of dead overlords (and, presumably, Dalila?) and potential freedom that the Chorus respond initially. For nine lines the full Chorus define this "dearly bought revenge" as the fulfillment of Samson's work—"The work for which thou wast foretold to *Israel*." In the hundred remaining lines of the play, they will learn—or come to understand—that Samson's "work" was neither so simple nor so simply achieved; but for now, their joy volts through them, flinging them into their final full ode, which for the first time they sing antiphonally—Milton indicating their division into Semichoruses. And the division seems designed to point their development from hateful joy to calmer discovery.

The first Semichorus, in perhaps the most extraordinary language of the play (arguably, of Milton's work), sings a hymn of victory, ferocious and exultant, as has often been suggested, with the old Hebraic joy of the songs of Miriam and Deborah. So impressive is it in its bald utter power—

> *Among them hee a spirit of frenzy sent,*
> *Who hurt thir minds*

—that readers have generally failed to ask an urgent question, intended by Milton: are the Chorus "right"? (or the seven or eight men who constitute the half)? Not that Milton intends us to import later notions of pity and mercy into material which he has struggled to keep chronistic; but aren't we meant to see, as the play and the joy wind down, that the tone of the reaction is mistaken, inaccurate?—that exultation is an imprecise response to Samson's victory, a defamation of its nature, committed innocently, no doubt, but committed?

In fact, Samson himself is barely thought of in the first Semichorus; and then only as "thir destroyer."

The second Semichorus, to point the omission, begins with Samson—"But he though blind of sight" —and upon that builds an elaborate mythopoeic meditation. Enormous amounts of commentary now exist which attempt to chart the image as it metamorphoses through snake and eagle to phoenix—

> *His fiery virtue rous'd*
> *From under ashes into sudden flame,*
> *And as an ev'ning Dragon came,*
> *Assailant on the perched roosts,*
> *And nests in order rang'd*
> *Of tame villatic Fowl; but as an Eagle*
> *His cloudless thunder bolted on thir heads.*
> *So virtue giv'n for lost,*
> *Deprest, and overthrown, as seem'd,*
> *Like that self-begott'n bird*
> *In the* Arabian *woods embost,*
> *That no second knows nor third*

—but even the most restrained comments have only pointed to the function of the ode for us, the audience of the play. T. R. Henn in *The Harvest of Tragedy* has seen it as "designed to provide this slowing down expansion and realignment of Samson's death into a mythology of its own." Certainly that is a part of the function for the Chorus as well (and Manoa will make similar efforts in his last speech); the Chorus of Sophocles' *Antigone* make a parallel effort as Antigone is led off to death—

> *Such was the fate, my child, of Danae*
> *Locked in a brazen bower,*

> A *prison secret as a tomb,*
> *Where was no day.**

But its main function, *for them,* is further expression—
and discovery in expression, of their total final attitude
to Samson and his work. And if their ornate resort to
dragons and the phoenix seems too quickly formalized
and frigid, then that is not simply because they are
Semitic tenants of a Greek-controlled building but be-
cause *that is what they feel,* and are coming to know—
Samson was always a man apart, chosen before his birth
by God to liberate His people, isolated from those peo-
ple by his boisterous pride and excess and by their an-
cient indifference, isolated still further from all human-
ity by blindness, imprisonment and obsessive guilt, and
now in death rapidly thrust backward into the safety of
history, fable, poetry; never truly their kinsman at all,
however recently they have wished to claim him. So,
though the divided ode is a number of remarkable
things, it is not a lament. They never lament Samson
nor does his father; and this human and dramatic omis-
sion has misled a number of readers into an assump-
tion that the play ends "gloriously" not tragically
(*gloriously for whom?* we will have to ask later).

In fact, so little does the ode resemble any of the
numerous types of traditional lament that Manoa's in-
terruption—"Come, come, no time for lamentation
now, / Nor much more cause"—seems a last example
of the brisk and often obtuse "practicality" of the old
man. The first lines of his last speech are given over—
after the quick "*Samson* hath quit himself / Like *Sam-
son*"—to a catalogue of the practical results of Samson's
death: "years of mourning" to the Philistines, to Israel

---

* Sophocles, *The Theban Plays,* translated by E. F. Watling
(Penguin, 1947), p. 151.

conditional "Honor . . . and freedom." Manoa is do-
ing a sum, and the answer which he reaches is the most
famous lines of the play—

> *Nothing is here for tears, nothing to wail*
> *Or knock the breast, no weakness, no contempt,*
> *Dispraise, or blame, nothing but well and fair,*
> *And what may quiet us in a death so noble.*

Armed with that, he can then give orders—they must
find Samson's body, wash off its "clotted gore," bear it
silently home (*silence* for safety? or because lament
would be meaningless?) where he can raise over it a
fitting tomb and monument. Only now does he grant
himself (and us) a moment's mercy, in his last old-man
prophecy—

> *Thither shall all the valiant youth resort,*
> *And from his memory inflame thir breasts*
> *To matchless valor, and adventures high:*
> *The Virgins also shall on feastful days*
> *Visit his Tomb with flowers, only bewailing*
> *His lot unfortunate in nuptial choice,*
> *From whence captivity and loss of eyes.*

The Chorus end the play, as a chorus does in all
but three of the surviving Greek tragedies. Initially,
they seem to respond to Manoa, affirming that "All
is best"; and as they proceed and end the play, they con-
struct a stanza, their first—fourteen lines, rhyming
A B A B C D C D E F E F E F—which might seem, in its or-
der (nearly a sonnet), an obeisance to tradition: that
Greek tragedies end with hieratic choral formulae
which state calm wisdom, or at worst, a dignified take-
it-or-leave-it. But all Greek tragedies don't—*Prometheus*
and *Agamemnon*, for instance, end in terror (admit-
tedly provisional endings as the first or second parts of

trilogies)—and a study of this last song in *Samson* will
show that, while formally resembling its ancient origi-
nals, it attempts, and performs, more elaborate work
—on-going not summary—than any single speech in
surviving Greek drama: it defines the degree to which
the play is what Milton said it was, a tragedy and a
dreadful one; it defines the spiritual progress of the
Chorus; defines at last their use as the central character
of the play; and sums the full potential of meaning
which Milton saw inherent in the Greek dramatic form
—a potential that had drawn him like magnetic-north
since his college years.

What they sing is—

> *All is best, though we oft doubt,*
> *What th' unsearchable dispose*
> *Of highest wisdom brings about,*
> *And ever best found in the close.*
> *Oft he seems to hide his face,*
> *But unexpectedly returns*
> *And to his faithful Champion hath in place*
> *Bore witness gloriously; whence* Gaza *mourns*
> *And all that band them to resist*
> *His uncontrollable intent;*
> *His servants he with new acquist*
> *Of true experience from this great event*
> *With peace and consolation hath dismist,*
> *And calm of mind, all passion spent.*

What they seem to say are four things—God moves so
mysteriously that we often fear His complete abandon-
ment; but always He returns (or *has* always returned)
and vindicates Himself and His people (His servants
by choice not merit); and from such a vindication as
we have witnessed today, we learn new things, discover
that by watching we acquire "true experience" (the

hero acquires the same, plus death)—we learn to take
consolation in the faith that events are "ever best found
in the close"; and our dying heroes are our means of
seeing a close, a finished action; we learn the meaning
of patience. And this much we know we have learned
(for this one time, if not permanently) from a given
and finished act—the hand and line of God revealed in
Samson's last struggle and surrender, to answer our
dark questions.

What questions?—all those summed in the second
stasimon and answered through the play: what is man
that God should use him so? (use him *how?*—as He
has used Samson and his Danite neighbors). Part of
God's answer is to split the question—"Which man?
There are kinds and My interest in them varies." So
they restate the question—"Why use Samson thus?"
God says, "Three reasons—for My good, his good, your
good." They say, "What did he do for each of us
three?" God says, "Helped to perfect us." They say,
"Please explain." God says, "He fulfilled My will, his
own (which had come to coincide with mine); and he
taught you who you are." They say, "Who are we?"
God says, "My servants." They say, "What service
then?" God says, "Faith and patience to wait till the
close." *

So the Chorus are happy, and with sufficient cause
(though the darkness in some of those answers is more
threatening than they seem now to notice). But is
Samson? No—dead, crushed, "Soak't in his enemies'

---

* I am aware of imputing to Milton the heretical notion of
a perfectible God and can only say that I feel in the play a
powerful undercurrent in that direction—that God Himself
learns, grows through His heroes. Milton had, after all, studied
Aeschylus all his life and a perfectible growing God is the corner-
stone of both the *Prometheia* (as generally conjectured) and the
*Oresteia.*

blood," in the prime of life, saved only through physical and spiritual humiliation, and destroyed by his salvation. A wiser, saner, more obedient servant, he might have lived for decades and judged his people well, rearing sons as heirs (how odd that he, a whoremonger, should be barren, both in *Judges* and Milton). Now he must leave them with nothing but memory and what they can make of it, a complex example and the *conditions* for political freedom. For all the questions that are answered, then, a huge one remains, unasked by the Chorus or any actor—the minimal question which the audience, at least, of any tragedy must ask before full comprehension can begin: "What does this tragic action cause to happen; what is its end result; what, in the world, is changed because of this action? Often in Greek tragedy—*Seven Against Thebes, Oedipus the King, Antigone*—the terrible answer is, "Nothing is changed." The tragedy occurs in a vacuum; we see a great catastrophe—the self-mutilation of Oedipus, the deaths of Antigone and Eteocles—but we do not *hear* it. The Chorus encircle the suffering hero, witness his agony, perhaps lament—but they are ultimately untouched, unchanged. And it is that silence at the heart of such tragedies—as though great rocks had fallen into gorges, silently for lack of hearers—which makes them so nearly unbearable.

Yeats seems to have investigated only one of the potential aspects of his "emotion of multitude" when he said (in the essay of that name)—

The Greek drama has got the emotion of multitude from its chorus, which called up famous sorrows, even all the gods and all heroes to witness, as it were, some well-ordered fable, some action separated but for this from all but itself. . . . The

> Shakespearean Drama gets the emotion of multi-
> tude out of the sub-plot which copies the main
> plot, much as a shadow upon the wall copies one's
> body in the firelight.

He speaks only of what might be called positive multi-
tude—that audience which absorbs the hero's drama,
takes his shock, conducts the current onward to us, sur-
rogate witnesses but learners like them. Surely, though,
there is negative multitude as well—which witnesses
and rejects. And it is the chief measure of Milton's
originality in *Samson* (for it really does not resemble
any Greek play, except in form), and almost certainly
his chief reason for choosing the Greek receptacle, that
he found he could achieve positive and negative multi-
tude by his unprecedented use of the Chorus. (Why
should he have wished to achieve both kinds?—be-
cause, whenever he wrote the play, the relations of such
polarities were the urgent burden of his curiosity and
his knowledge: the relations of a great man, vertical
and horizontal, with heaven and earth.) * We have al-
ready noticed his achievement of positive multitude—

---

* I have studied, I think, all the arguments against the tradi-
tional dating of *Samson* as Milton's last finished work (from
A. H. Gilbert who would have Milton begin it just out of college,
to W. R. Parker, who spreads it through Milton's late thirties
and early forties, well before the start of *Paradise Lost*); and I
was once attracted by their audacity. But the weight of my par-
ticular nineteen years' reading of the poem has not let me accept,
for long, a theory which sees *Samson* as anything but the final
product of Milton's maturity, begun and finished after the two
epics. I could give, and elaborate upon, a number of reasons—its
unprecedented and unfollowed verse, its architecture (which
bears no resemblance to his early Italianate-operatic ideas of
drama as sketched in the Trinity manuscript), its extraordinary
view of human will (an *impaired* will, I think; by no means
totally free)—but the strongest for me is the most personal,
therefore least defensible: that it stands so alone—from all his

Samson's tragedy causes the last speech of the Chorus
and, more, the restoration of faith and patience which
shines through the speech. But there is something left
over, the unviolated isolation of Samson to the end and
the hard fact that he was required to give eyes, free-
dom, life, for men like this—

> *the common rout,*
> *That wand'ring loose about*
> *Grow up and perish, as the summer fly,*
> *Heads without name no more remember'd*

—men who may "sympathize," who may even come to
perceive and make partial and temporary use of the
great action done for them but who cannot accompany
him on his awful journey or reach him with their inter-
mittent jingling sympathy, only with their wavering
hostility and the desperation to which his spectacle
drives them.

It is that *left-over*, the bitter residue of waste at the
end that keeps the play a tragedy. It settles so heavily,
for all the song, that we do not need to see Samson's
body again, borne in state toward home, mutilated far
past the ghastly norm we accepted at the start; or to be
reminded that no word is said in the length of the play
about heaven or hell or any other afterlife in which
Samson might join Damon and Lycidas in laving his
locks to the choiring of saints (at best, he rests in the
brown air of Sheol—"The dead praise not the LORD,
neither any that go down into silence." Psalm 115:17);
or to guess from past history or the sequel in *Judges*
and Josephus that Samson's people will again not seize

---

other work, however grand—in finality of mastery, in perfect
identity of thought and form and language as to set it unmis-
takably last, a terminus.

the chance for freedom. (Is the end of *Lear* heavier?—
lighter, surely; a relief by comparison.) And, with all
that, the sense that to win even so much, God had to
rig the match, hook Samson against his will by brutal
grace and draw him cruelly in through the monstrous
deeps of his past.

Yet Milton, in his preface, claimed catharsis for
his ending and laid over Aristotle's definition his own
hope and vision—

> Tragedy, as it was anciently compos'd, hath been
> ever held the gravest, moralest, and most profitable
> of all other Poems: therefore said by *Aristotle* to
> be of power by raising pity and fear, or terror, to
> purge the mind of those and such like passions,
> that is to temper and reduce them to just measure
> with a kind of delight, stirr'd up by reading or see-
> ing those passions well imitated.

Still, a purge, though it may palliate, cannot erase or
cancel. God's name is I AM; tragic man's, I HAVE
BEEN. In his *Form and Meaning in Drama*, H. D. F.
Kitto has offered an expansion and correction of Aris-
totle which coincides wholly with the burden of *Sam-
son*. He devotes most of his argument to a distinction
between the tragedy of character (which was Aristotle's
Macedonian misapprehension of Athenian art) and
what Kitto calls "religious drama" and is able at last to
make this summary—

> In fact, what this religious drama gives us is
> rather Awe and Understanding. Its true Catharsis
> arises from this, that when we have seen terrible
> things happening in the play, we understand, as
> we cannot always do in life, *why* they have hap-

pened; or, if not so much as that, at least we see that they have not happened by chance, without any significance.

Awe and understanding—they seem unarguable as the products, the effects, of *Samson*, both the play and the man. And the effects are exerted over two distinct audiences—the Chorus and us. For one of the supreme achievements of Milton was at last to have made a perfect object (the last previous approach had been *Lycidas*, thirty-odd years before), one requiring no external audience, fit *or* few—the audience exists in the play itself: the Chorus. No other tragedy in the Greek form—with the possible exceptions of the *Suppliants* and *Prometheus* of Aeschylus and the *Bacchae* of Euripides—contains a Chorus so involved in the action, with so much at stake in the fate of the hero, so nearly the "hero" itself. Not only does the Chorus in *Samson* speak a fourth of the lines—27%—but its urgent role is implied in the title. *Agonistes* is a noun descriptive of an athlete contending in public games (an *agon* being a contest)—freely, but accurately, a wrestler.

*Samson Wrestling.* Both history and poetry are filled with secret wrestlings—the grandest of all is the oldest, *Genesis* 32—and Samson's bout might well have been secret, he and Jehovah in a cell alone. That loneliness is clearly implied in *Judges*. But in Milton's vision, he wrestles before an audience—and like all athletes, partly because of, partly for, the audience (there are always private motives and issues). If Samson is Milton's subject, the Chorus is his object—God's object. The Chorus and us; for the play strives to serve us as Samson serves his people, to show us how enormously and darkly but indubitably, unanswerably, God "made our Laws to bind us, not himself." That we can sit—a

second audience, much like the first—and also watch the contest and deduce again its rules (announced at Creation) is one of the privileges and dangers of having survived Milton. That we—nations of men—have not heard and answered his play, the delivery of his promise at age thirty-three to write a poem "doctrinal and exemplary to a nation," is the heaviest stone on the body of Samson, only the latest of centuries of proof that a part of his final victory was ridiculous, because partly useless. Old Manoa hoped God would not leave Samson "Useless, and thence ridiculous." God, and man, partly did.

1957, 1971

# FOUR ABRAHAMS,
# FOUR ISAACS
# BY REMBRANDT

## (NOTES BEFORE A NOVEL)
## THE TEXT - GENESIS 22

God tested Abraham. He said to him "Abraham!"
Abraham said "Sir."

God said "Take Isaac the son you love and go to
Moriah. There burn him to me on the hill I will show
you."

The next dawn Abraham saddled his ass, took two
of his slaves and his son Isaac and, chopping wood for
the fire, set off toward the place God was showing.

Three days out Abraham saw the place still far
ahead. He said to his slaves "Wait here with the ass. I
and the boy will go up and worship and then come
back."

Then Abraham took the wood and loaded it on
Isaac. The flint and the cleaver he carried himself in
his own hands. The two of them climbed on together.

At last Isaac spoke. "Father."

"Here, Son."

Isaac said "You have wood and flint but no sheep."

Abraham said "Son, God will furnish the sheep."

The two of them climbed on together and came to
the place God was showing Abraham. Abraham built
an altar there. He stacked the wood. He bound his son
Isaac. He laid him on the altar on the firewood. He
reached for the cleaver to kill his son.

But an angel of God spoke from heaven. "Abraham! Abraham!"

"Here," he said.

The angel said "Do not touch the boy. Now I know you fear God since you did not grudge me the son you love."

Abraham looked up and saw a ram, horns caught in briars. He went and took the ram and burned it instead of his son to God. Then Abraham called the place *Yahweh Yireh*, God provides.*

## 1. ABRAHAM CARESSING ISAAC
## AN ETCHING, CIRCA 1638

If the boy is five, the man is a hundred and five. He looks eighty. The boy's name *Isaac* signifies *Laughter*. His mother Sarah laughed when she overheard God tell her husband, over lunch by the terebinths of Mamre, that she—old she, barren all her life and now bone-dry—would conceive a son in pleasure and bear him safely. Laughed in derision but bore the son and —seeing him, knowing the joke was on her—had the grace to say "God has brought me laughter" and name the boy that. The man's name *Abraham* signifies *The Father is Exalted.*

This morning—mid-morning by the westward shadows—they both think they're doing that. Exalting the father—the man exalting God by living his life, the boy his father by trusting him with laughter as he lolls on his lap, the pit of his small arm above his father's sex. The man smiles slightly. Exalting, laughing, trusting, waiting. They both think they're waiting.

The man waits in total ease, in winter velvets, in

* Translation by Reynolds Price.

stifling sun. It cannot touch him. He is not on guard,
not cocked for ambush. No visible slaves and he's not
even armed. He thinks he is waiting for his future—
generations thick as stars (nations, kings) to swarm
onward through this boy's trimmed sex toward endless
time, a blessing to the earth, all sons of Abraham, exalt-
ing the father. It has all been promised, sealed by
Abraham with a sacrificial heifer, she-goat, ram, dove,
pigeon; and circumcision of himself and all his men.
Sealed by God with the tardy gift of this boy, growing
Laughter.

The boy in his fancy dress—almost a jester's: cut
sleeves, belled tassels—is oblivious as all boys are to
heat. He already knows the news (every camp slave
knows it; wears it as livery). He does not know pre-
cisely that the very seeds are waiting in the dry tight
buds of his fork, only that he waits to become the
promised funnel who will pour the future. He has heard
of no conditions or reservations—none have been ex-
pressed, no fine print in the contract—so he laughs to-
ward the east and the sun, holds his apple.

And so the old man has brought an artist to etch
them, to honor their calm waiting, preserve it for their
sons. And both have taken this natural pose outdoors
at the southwest corner of the house on a bench near
flowers. The pose is the essence of their patient assur-
ance. *History by the tail, an apple in the hand—and a
joke, at that*. The man and the artist both think—no
cause to doubt—that the man's right hand rings the
boy's throat in love, to turn him toward the image
growing on the plate.

The light of day doubts. Negeb sun, pounding
yards of Dutch velvet, has laid behind the man a
shadow like stain, with a mindless blind face. It can-
not offer warning—would alter its message if they

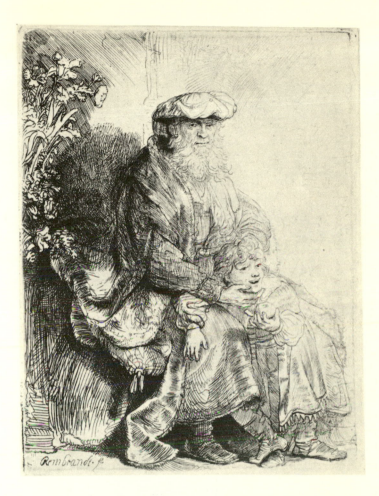

1. "Abraham Caressing Isaac," an etching by Rembrandt,
circa 1638
(*Courtesy of The Pierpont Morgan Library*)

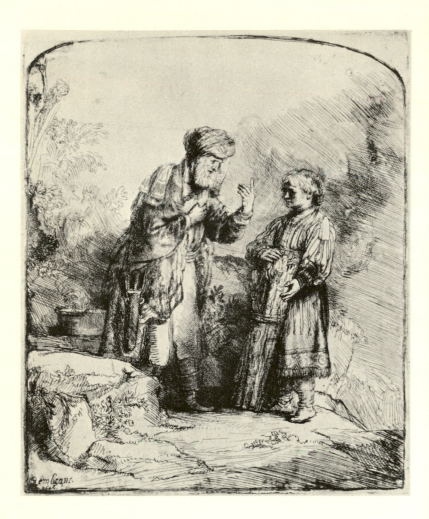

2. "Abraham and Isaac on Moriah," an etching
by Rembrandt, 1645
(*Courtesy of The Pierpont Morgan Library*)

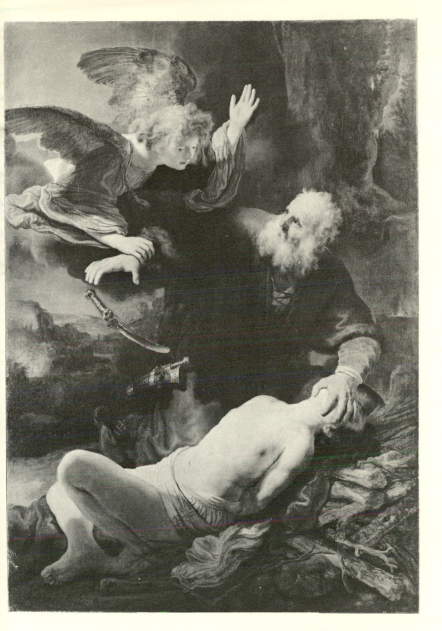

3. "The Rescue of Isaac," an oil by Rembrandt, 1635
(*Courtesy of The State Hermitage Museum*)

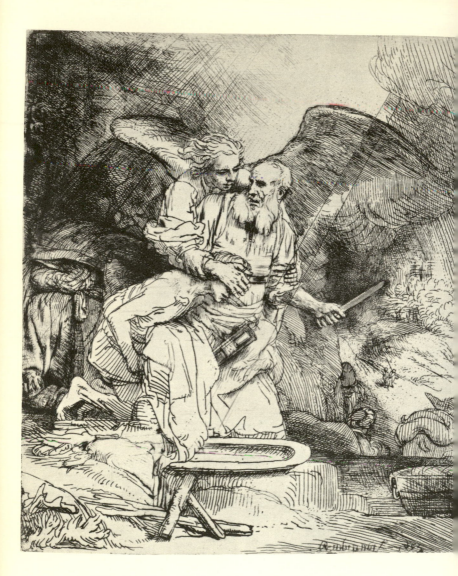

4. "The Sacrifice of Isaac," an etching by Rembrandt, 1655
(*Courtesy of The Pierpont Morgan Library*)

turned to see. It has come from God and knows He is stoking up to speak again.

He has changed His mind—His awful prerogative —thinks the boy a bad idea, too successful a rival, a giggling vessel for a giggling eternity. He thinks He will say "Burn the boy to Me"—enough of she-goats, pigeons—then have the old fool to Himself again for another few years of lunches by the terebinths, mutton and dates. Then cancel history, stop laughter. Silence.

The high flowers also know what waits, but also don't warn. Their forward lean is for better hearing— they strain to catch the news, early waves of the silent world for which they've yearned. A few vipers, scorpions. The news is launched.

At the edge of the picture, edge of day, He is speaking—"Abraham." The sound rushes toward them, arrives.

## 2. ABRAHAM AND ISAAC ON MORIAH

### AN ETCHING, 1645

If the boy is eleven, the man is a hundred and eleven. He looks ninety—bent shoulders, swollen fingers and though (by the shadows) it is clearly midmorning and (by the foliage) summer, his right hand is drawing a shawl tighter round him. He is cold though his clothes are the same as before. Only three changes—a turban not a cap, a neck chain of authority, a short sword on his right. The boy wears his childhood jester's dress—or a new larger copy—cut sleeves, bottom tassels (though the bells are gone) and soft boots that can't have been right for the trip. Whoever dressed him didn't know his destination.

He is strong. He holds the wood he's borne up the mountain and he does not pant. He has watched his father set the firepot down and turn and has asked the question that has grown these three days—"Father, you have wood and flint but no sheep." Not a question, a statement, final inventory that reveals him a victim— to himself, last to know. Eleven years old. Not old enough even to enter the Temple (when there'll be a Temple, eight hundred years hence on this same rock). The tight dry balls still high in his loins, a year from working. The seed not only not waiting but not there.

The man answers now—"Son, God will furnish the sheep"—pointing skyward, home of trouble. (Or is trouble condensing in the dark behind the boy, a complicated shadow made by nothing in sight, not cast by sun? God in a smoke, watching?) The gesture up is the only apology the old man can make. Neither of them looks to the handy altar—stone at the left, garlanded with weeds, as ready as all natural objects to witness, assist if needed in a death.

The boy knows however. His eyes have clouded, crouched backward darkly. *The sheep is me.* He had finally hoped that it might be a slave, till they left the slaves.

The man knows the boy knows, thinks he'll surrender. He has not even posted slaves as guards.

The boy is going to run. About-face and run. The way is just behind him, a quick trail down. He will, and will escape. He is seeing, this instant, that his father offers it—his only chance—that his father is too old to hold even him; that his father has worn too many clothes; that his own jester's dress is full and light, designed for speed; that the slaves, if they see him at all, will not care.

The old man would see it if he'd pipe-down and look—the boy's face dark as the growing shape behind

him. If he'd ever done more in his life than listen—inner voices, upper voices, shunting whole shoals of kin round the Middle East like herring.

In a moment though he'll see. Or feel. The boy will have thrown the sticks against his old thin ankles and be halfway down Moriah. He will see, feel, know —that one victim's gone and will not be caught. Not by him, his slaves, his God. That this boy, lost, will die in the desert, food for kites. But that he—old man— must swear two slaves to silence, then shuffle home, dodder out a tale for Sarah and the whole grieving camp; must mumble it the rest of his time, day and night, to any idle passer, while he dreads the arrival of the vision in his head—a saved savage Isaac: grown, able, armed, strengthened by another God and bent on the death of his ancient father. His heart's blood, drained by night into sand, Sarah sleeping beside him oblivious, untouched, re-awarded motherhood in morning light.

But Isaac will be bones—the son he loved, Laughter.

### 3. THE RESCUE OF ISAAC
### AN OIL, 1635

The boy is fifteen, the man a hundred and fifteen. He looks a fairly hearty eighty-five. And is fairly sensibly dressed for the scene. The boy has agreed to strip to his drawers, has agreed that his hands be tied behind him, and freely reclines on a bed made of sticks and his folded clothes. He spreads trusting knees on loins that function quite adequately now, though only for himself a year or so yet. A long hippy high-naveled boy who knows two things—that the man's palm is hot; that his own narrow chest is broadened, flattered, by the

brown gold light of late afternoon. He writhes up to catch it, pour it round on his throat, tits, belly.

The two have been waiting.

For what?

The sticks for the pyre know the game is rigged. They've been carefully fire-proofed by offstage hands. Even the landscape northward is green and expects gentle rain to lay the dust for their smooth trip home; expects smiling passengers, loose with relief, who'll pause for wayside snacks from arbors, drinks from springs.

The man and the boy had performed their scene and were awaiting an entrance—angel rescue. The boy had drawn four breaths through those fingers wet with nerves and had thought "My face is covered for the picture." His brief unpleasantness, the man's arthritic lurch, are responses to nothing more dangerous than bad timing. The old man had churned to the climax prematurely. No thunderclap of rescue. So he (Frank Morgan? Ethel Barrymore?) had thought "What now? Hone the knife again?" (a lovely knife that will not cut butter; a set in fact—note the dagger still sheathed) and was sawing the air, his old ticker pounding, when the winged youth fell in through the backdrop— "Halt!"

Saving, stunning, both cast and audience—of whom, the painter wears the biggest grin, having most to gain. Guilders.

## 4. THE SACRIFICE OF ISAAC
### AN ETCHING, 1655

The boy is seventeen, the man a hundred and seventeen. He looks a strong ninety. Both are in ear-

nest. The man has removed his turban and coat, thrown them down on the ledge at his right (at the end will he stand and assume them slowly or, howling, abandon them; flee in his smock?). The boy, having watched the man disrobe and roll back sleeves on arms appallingly strong for his age (wrists like thick cocks), has taken the scent of the day at last. Three days' silent mystery ended this morning—morning light—ended by sight of the old man's arms. More of his father's body than he's ever seen, and now will see no more. He has not wasted breath asking after a sheep but has silently stripped to his plain loose drawers, laid his robe on the man's right knee as an apron, then knelt on the man's gapped loins, above the man's sheathed knife so oddly there (what is in the man's belt, at the boy's mouthlevel?— a second knife?). The loins he was promised to perpetuate—and now is able, fuller of life than he'll ever be again—but won't.

He is choosing this. The boy is choosing to die— silent, uninformed, not sentenced even. He is trying still to think of a reason, not for his father's will but his own. *Why do I let him?*—but he cannot think. Old enough to pass on his father's seed, to found whole nations, he is too young to know an answer to his question.

His picture knows, his chin, neck, arms—*I want to die at my father's hands.* Otherwise, lean as he is— runner's calves, runner's ankles and feet—he could have drawn the offered knife, killed the madman, killed the slaves eavesdropping on the next ledge down (set there as guards), killed the ass, killed the two men strolling in middle distance. Or killed the man, vaulted the overdressed slaves and sought rescue from the two men strolling who stand a fair chance of being angels at least, if not God and an angel, and will promptly

congratulate, award him his lineage, full birthrights,
perquisites. Or maybe kill him instantly where he
stands, panting, pleading (shade trees just beyond
them). Kill him with a look as He killed the boy's
Cousin Lot's wife for less.

The boy is choosing this—against his will, he still
thinks.

The old man was not sure until this moment. The
command, four days ago, had stove him in; the three
days' silent trip had seemed total agony, each step to-
ward scalding duty. And each movement till now. The
ritual placing of slaughter tools—firepot, bloodbasin,
triangle of sticks (are the tongues on the lower left fire
or weeds?). Disrobing, sitting, arranging the sheath,
witnessing the boy's quick peel to white flesh. He had
thought this would be the moment he'd feel—that sight
of the boy's flesh, *his*, made by him, would still his arm,
freeze it, strengthen him to set his own face against
God, say No and die. Or survive and retrace the steps
of forty-two years back to Haran, assume his old worship
of the frozen moon goddess in his own father's tracks.
The promise refused.

But he bore the sight, bore the feel of the boy
when the boy spread his robe as a kindness on his lap
and knelt dumbly forward on the withering seed. Bore
the brush of the boy's dry lashes on his palm as he
reached out to blind him. Then felt himself locked into
will, not refusal; knew the boy was lost. Thought as he
drew the razor knife in silence, "His will not mine,"
meaning God's. Promise canceled. He looked only
down, could watch the ready boy. No sound but the
wheezing slaves below, the ass's munch. Hum of the
boy's blood in loins, throat. He moved the knife for-
ward, knew at last—*My will, mine.*

Then slashes of hard light, rush of wings, calm

hands on his arms, a face pressed toward him, "Abraham! Do not touch the boy." More slashes of light—typical harsh mercy.

Another angel, no flaming minister, young himself, the face of a farmer (and a farmer's foot, dark, beneath the armed hand), concerned, gentle, restraining him gently.

Useless. Too gently. The strong two want this.

The man is going to kill the boy.

1971

# REYNOLDS PRICE

Born in Macon, North Carolina in 1933, Reynolds Price attended North Carolina schools and received his Bachelor of Arts degree from Duke University. As a Rhodes Scholar he studied for three years at Merton College, Oxford, receiving the Bachelor of Letters. In 1958 he returned to Duke where he teaches for one term each year in the Department of English. There he began and completed A Long and Happy Life, which was published in 1962 and received the award of the William Faulkner Foundation for a notable first novel. In 1961 he again traveled to England where he worked for a year at the stories which were published in 1963 as The Names and Faces of Heroes. His second novel A Generous Man appeared in 1966; his third Love and Work, in 1968; his second volume of stories Permanent Errors, in 1970. In the same year his fiction received an Award in Literature from The American Academy and The National Institute of Arts and Letters. The citation read, "His gifts are a vigorous intelligence, a strongly individual perception of the nature—both physical and psychological—of a given time and place, of the variety in kind and intensity of human relationships. Over all his prose fiction there is a poet's daring and control."